THE
NATIONAL
COOKBOOK

THE
NATIONAL
COOKBOOK

NATIONAL GALLERY COMPANY, LONDON

This book is dedicated to the memory
of Shaun Gilmore, former Executive Chef
at The National Dining Rooms, who was
tragically killed in an accident in April 2008.
Most of the recipes you read in this book
were created by Shaun.

All photographs © Dan Jones except page 6 © Imperial War Museum,
London (D12973) and page 8 © Kris Kirkham

First published in Great Britain in 2009
by National Gallery Company Limited
St Vincent House, 30 Orange Street
London WC2H 7HH
www.nationalgallery.co.uk
ISBN: 978 1 85709 425 5
525528

British Library Cataloguing-in-Publication Data.
A catalogue record is available from the British Library.
Library of Congress Control Number: 2008920589

Publisher: Louise Rice
Editorial team: Jeni Wright (Food Writer), Norma MacMillan (Food Editor)
and Jan Green, for National Gallery Company
Production: Jane Hyne and Penny Le Tissier
Design and art direction: Smith & Gilmour, London
Food photography: Dan Jones
Recipe index: Hilary Bird

Printed in Great Britain by Butler Tanner & Dennis Ltd, Frome, Somerset
Reproduction by Altaimage, London

Thanks are also due to Astrid Athen and Tom Patterson from the Photographic
Department at the National Gallery for special photography.

Front cover illustration: David Holmes

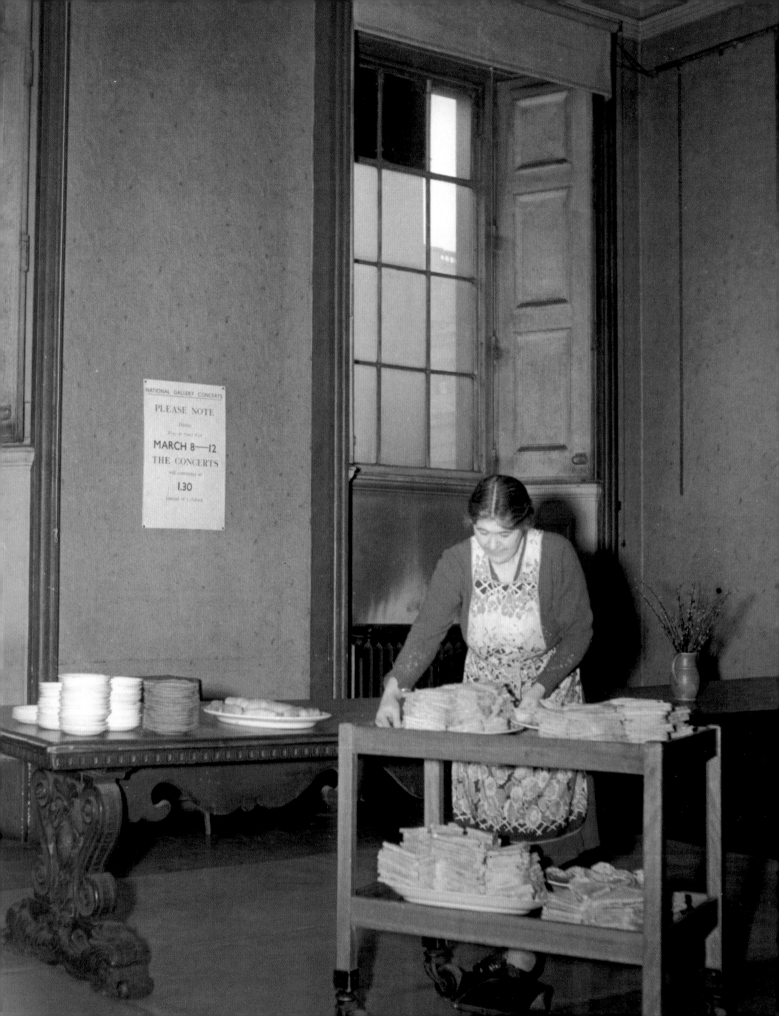

FOREWORD
Nicholas Penny, Director, The National Gallery

When the National Gallery was founded in 1824, it was deliberately situated 'in the very gangway of London', and was to be open not only to all ranks and classes of people, but 'to the indolent as well as to the busy – to the idle as well as the industrious'.

At the time, however, opportunities for indolence were extended only so far: no catering facilities were provided for visitors – although among the Gallery's records in its early decades are accounts of sandwich papers littering the rooms and one startling picture of a family seated on the floor to eat a meal and cheerfully offering a drink of gin to the Keeper. There was a stern distinction between public amenities and commercial enterprise, which restricted retail opportunities of all sorts for well over a century, and perhaps it was also felt that it would be impossible to meet the needs of visitors from widely different social backgrounds.

The basic requirement of a snack and a coffee after a couple of hours at a temporary exhibition, or the convenience of a place to rest and chat over a meal with the old friend we have agreed to meet in front of Van Gogh's *Sunflowers*, have been acknowledged for decades now as essential facilities in a public museum or gallery. Over the same period, a revolution in attitudes towards food in Britain coincided with the extension and transformation of Victorian buildings by modern architects, and the canteen, often in the basement, has been everywhere replaced by the smart café and restaurant.

Oliver Peyton arrived at a moment when it was cosmopolitan to value the local, and sophisticated to cherish the traditional and the pure and simple. In recent years he has served the Gallery's public exceptionally well, providing superb food in imaginative but never pretentious dishes and in settings that suit both the young tourist in a rush and those who prefer some ceremony and quiet. That pleasurable association of food with the sensory pleasure experienced in front of great paintings pervades this book.

INTRODUCTION
Oliver Peyton

I have always believed that the people who produce great art and great food are cut from the same cloth. I have been lucky enough in my life to meet both and there always seems to me to be a passion and a way of seeing the world that defines them from the rest of us. Through the ages food and art have always been easy bedfellows.

The roots of this book come from The National Dining Rooms at the National Gallery where we have used seasonal produce since it opened in 2006. In creating this cookbook we had to stand back and look at each season in its entirety. This process really struck home to me how distinct and bountiful the seasons are in Britain and how evocative these dishes are to each.

I always try to eat seasonally – asparagus in spring, broad beans in summer, goose in winter and so on. When I was young and living in the country we ate seasonally out of necessity. As I grew up and moved to the city, all sorts of produce became readily available – strawberries in March, new potatoes year round – and even with the best intentions in the world my relationship with the seasons diminished. This book has inspired me and left me with a greater determination to understand the role the seasons play in our lives and to eat accordingly.

The book is not a retrospective or statement about British cooking. Rather these are dishes that we put on the National Dining Rooms menu, dishes I like and our guests like, some simple, others slightly more complex. The thing that determines all these recipes is the quality of the ingredients. If you fill a Victoria sandwich with organic cream rather than pasteurised cream the difference in taste is amazing. It has been important for me to keep the book as honestly British as I could but it's not exact, and there is no need to follow my choice of ingredients slavishly. For example, panko breadcrumbs are suggested in the recipes because I think they are the best, although you can use traditional breadcrumbs if you prefer.

This trend in cooking our indigenous produce is long overdue – and rests on the once-neglected fact that the British climate and landscape are perfect for the production of first-class ingredients. From the clear, cold waters that surround us, to the tapestry of green that – as any flyer knows – still marks out much of the country, our seas, soil and waterways are abundant and increasingly sensibly harvested.

Recent years have seen a sea change in what is available to the shopper. Farmers' markets, farm shops, butchers and other suppliers have sprung up, offering a range of foods many of our parents' generation witnessed only in decline. Now, for example, chefs can go to any one of five excellent suppliers of smoked eel. Rare breeds have been first saved, and then bred, offering a depth of flavour and texture that supermarket meat can never offer. It has been a very British alliance of trailblazing young cooks, farming diversification, and the craft and skills kept alive by groups such as the Women's Institute, offering a long overdue reconnection between the rural and the urban – a chain many thought broken beyond repair.

Our recipes offer food we hope you will want to cook and eat at home. The primacy of the ingredient over technique in British cooking is both its distinction – though one shared by, say, Japanese cuisine – and one of its main attractions to the home cook. Yes, the recipes are based on restaurant dishes, but there are no complex cooking techniques needed, nor labour-intensive methods. Many require little more than sympathetic assembly. And while discovering and learning the skills needed for more demanding recipes is part of the charm of gastronomy, the cook should never be stressed – if one part of a recipe in this book is unrealistic, due to time or other limitations, simply leave it out.

It's always a pleasure to walk through the rooms of The National Gallery on my way to The National Dining Rooms; I hope this book gives you a tiny glimpse of that experience and that you will be inspired to come and visit us soon.

Joachim Beuckelaer, active 1560–1574
The Four Elements: Earth **(detail), 1569**

A rich display of apples, pears,
peaches, plums, grapes and berries.

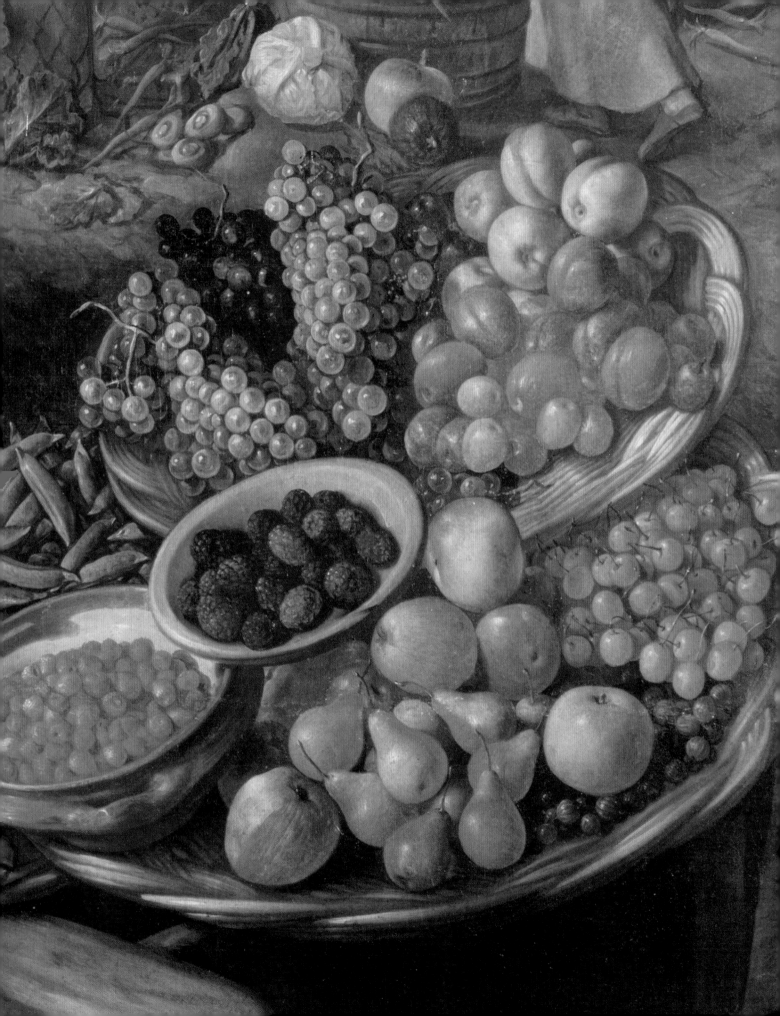

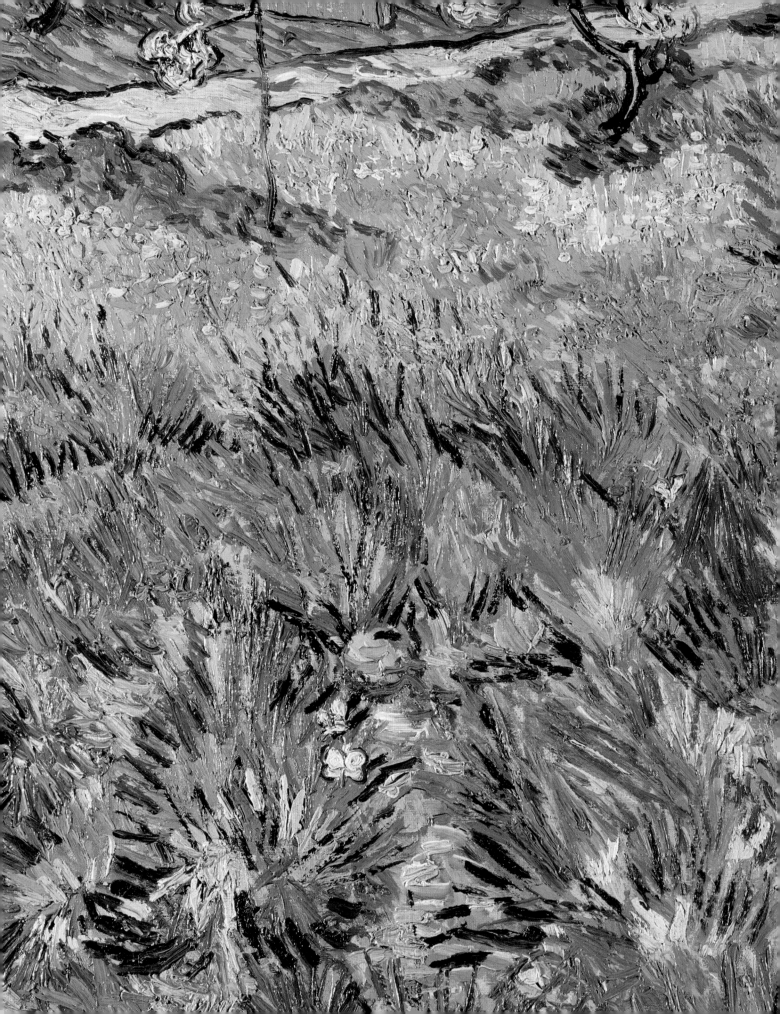

SPRING

SUMMER

AUTUMN

WINTER

Vincent van Gogh, 1853–1890
Long Grass with Butterflies (detail), 1890

Van Gogh was a patient at the asylum
at St-Rémy, near Arles, from 1889 to 1890,
where he worked in the grounds. He described
the 'abandoned gardens' in which 'the grass
grows tall and unkempt, mixed with all kinds
of weeds'.

People living overseas often say that what they miss most about Britain is the seasons, and often they will be thinking of one in particular – spring.

Spring seems a long way off during the chilly depths of February. But by the time April approaches, early mornings are no longer dark and gloomy, and there is a hint of the promise of the season ahead. As the days grow longer and the weather warms, it is the landscape emerging from hibernation, with all the scents and colours of this season, that means spring has arrived for the cook.

Baby vegetables are especially rewarding in spring. They cook quickly and are the perfect backdrop to any seasonal meat. Baby leeks, spring onions and wild garlic appear in April, with asparagus and fresh new potatoes in May, and soon a menu choice of simple, optimistic food is before us. The intensity of newly growing herbs – rosemary, chives and mint – adds to a palette that is both full of flavour and of fresh colour.

Monkfish, wild trout and sardines are soon on sale, joining lamb, rabbit and duck to make up a seasonal larder that offers the very best of British produce. On warmer days, eating outside in an awakening garden becomes a pleasant option, and winter can be forgotten.

FOR THE LEMON AND HERB FRITTERS

30g fresh chervil, stalks removed

15g fresh flat-leaf parsley, stalks removed

100g soft butter

Finely grated zest of ½ lemon

1tbsp lemon juice

36 young asparagus spears

Vegetable oil, for deep-frying
 and roasting

4 lemon wedges, to serve

FOR THE COATING

125g panko breadcrumbs

50g plain flour

2 eggs, beaten

SERVES FOUR

ASPARAGUS WITH LEMON AND HERB FRITTERS

There's a short period in the asparagus season when the spears have a deep, rich green colour, so look out for it then to enjoy it at its best. Here the silky softness of the asparagus is accentuated by the crispness of the breadcrumb-coated fritters, and the butter oozes sensuously on to your plate as you cut into them.

1 Cut any woody ends off the asparagus, then peel the spears with a vegetable peeler, starting about 4cm down from the tips.

2 Make the fritter mixture. Blitz the herb leaves in a food processor with the remaining ingredients and seasoning to taste until very smooth and green. Cover a baking sheet with non-stick baking parchment. Pipe eight fingers of the herb butter on to the paper, the same size as the asparagus spears. (Put the butter in a freezer bag and cut off a corner to match the diameter of the asparagus, then pipe.) Freeze until firm, about an hour.

3 Blitz half of the breadcrumbs in the food processor until very fine and powdery, then mix with the other half and spread out on a tray. Dip the frozen fingers of herb butter in the flour, then in the beaten egg and, finally, the breadcrumbs. Repeat with egg and crumbs to make a double coating. Keep the fritters in the fridge.

4 When you are ready to cook and serve, set the oven at 160°C. Heat 500ml oil until hot in a large, deep frying pan or wok.

5 Coat the asparagus in 1tbsp oil on a roasting tray and roast for 6–8 minutes until just tender and the tips get a little colour. Meanwhile, deep-fry the fritters in the oil for about 3 minutes or until crisp and golden brown. Remove with a slotted spoon and drain on kitchen paper. Season the asparagus after roasting. Serve straightaway, with the fritters and lemon wedges.

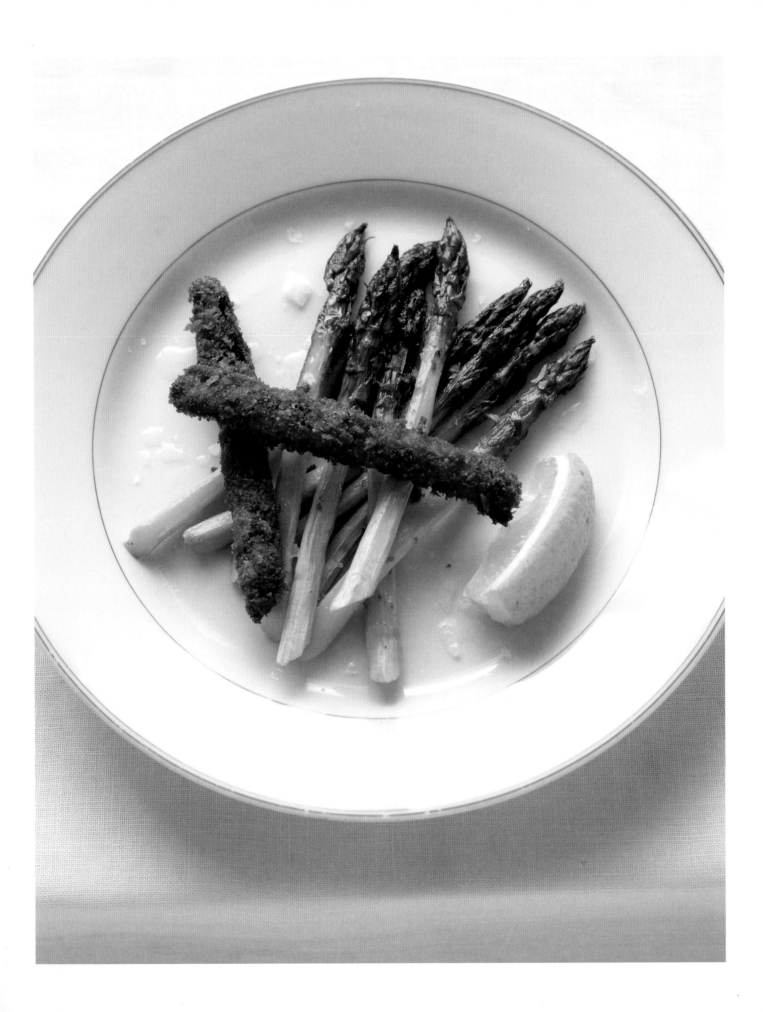

8 pancakes (page 256)

FOR THE FILLING
25g butter
600g baby leeks, thinly sliced
4tbsp dry white wine
4tbsp whipping or double cream
85g soft goat's cheese

FOR THE HAZELNUT PASTE
100g hazelnuts
90ml vegetable oil

SERVES FOUR

BABY LEEK AND GOAT'S CHEESE PANCAKES

Leeks and goat's cheese, two great ingredients from Wales, are made for each other. Don't be afraid of goat's cheese – shop around for a strong one that will hold its own against the onion flavour of the leeks and make its presence felt in the warm and creamy filling.

1 Make the filling. Melt the butter in a saucepan over a low heat, add the leeks and sweat with the lid on for 10 minutes. Add the wine and reduce until nearly dry, then add the cream and boil to reduce until sticky. Add pepper to taste and allow to cool.

2 Make the paste. Combine the nuts and oil in a frying pan and cook over a medium heat until the nuts start to turn golden. Immediately transfer to a bowl to stop the cooking. Leave to cool slightly, then pulse in a food processor with a pinch of salt until chunky.

3 Set the oven at 180°C, and lightly butter a baking dish that will fit eight rolled-up pancakes side by side.

4 Divide the leek mix among the pancakes, spooning it along one side, and crumble the goat's cheese on top. Roll up the pancakes and place seam-side down in a single layer in the dish. With a spatula or the back of a spoon, spread hazelnut paste over the top of each pancake. Bake for about 6 minutes or until heated through and crisp. Serve hot.

250g soft butter
About 400g smoked mackerel fillets
Lemon juice
Tabasco sauce
Cayenne pepper

FOR THE COMPOTE
1 Cox apple
1 ripe Comice or Conference pear
½ cinnamon stick

SERVES FOUR

POTTED MACKEREL WITH FRUIT COMPOTE

Mackerel is the poor relation of the sardine. This is a great pity because mackerel are really abundant around the coasts of Britain, and they have a wonderful, intense flavour. Potting them with butter is one of the most successful ways of serving them, and here the fruit hidden underneath provides a surprising contrast. To make a thoroughly British *bruschetta*, serve on thick chunks of toasted bloomer or other white bread.

1 Make the compote. Peel, core and finely dice the apple and pear, then place in a pan with the cinnamon and 1tsp water. Cook over a low heat, stirring occasionally, until the fruit breaks down to become soft and mushy. This should take about 20 minutes. If the compote gets too dry, add a little more water. Set aside to cool.

2 Meanwhile, make the clarified butter for the topping. Melt 100g of the butter slowly in a heavy saucepan over a low heat. Skim off the froth from the surface, then very carefully pour the golden liquid into a bowl, leaving the sediment behind in the bottom of the pan (discard the sediment).

3 Remove the skin from the mackerel and rub the fish into a bowl with your hands, pulling out the little bones when you come across them. Beat the remaining 150g butter into the mackerel. Mix well, then add a little lemon juice, Tabasco and cayenne. Taste and add more if you like, plus a little salt if you think it is needed.

4 Remove the cinnamon from the fruit and divide the fruit equally among four pots (about 200ml capacity). Top with the mackerel and cover with the clarified butter. Chill in the fridge for about 3 hours or until the butter is set (the potted mackerel can be kept in the fridge for up to 3 days).

FOR THE MAYONNAISE

2 eggs

2tbsp smooth mild mustard

1tbsp lemon juice

2tsp each finely chopped fresh basil
 and flat-leaf parsley

1tsp each finely chopped fresh dill
 and chervil

Good pinch each of cayenne pepper,
 white pepper and salt

250ml vegetable oil

20 live large Dublin Bay prawns

50ml white wine vinegar

1 carrot, diced

1 leek, diced

1 celery stick, diced

Finely shredded crisp lettuce,
 to serve

SERVES FOUR

DUBLIN BAY PRAWNS WITH A HERB MAYONNAISE

For the ultimate in flavour and succulence, Dublin Bay prawns should be cooked live. This is the best way to bring out their fresh taste, and it's also why they're served naked with just a small pot of mayonnaise for dipping. Anything more would detract from the prawns themselves.

1 Make the mayonnaise. Blend all the ingredients except the oil in a food processor, then gradually add the oil through the funnel until the mayonnaise is thick and smooth. Keep in a covered container in the fridge for up to 3 days.

2 Cook the prawns. Bring 2.5 litres water to the boil in a large pan with the vinegar and diced vegetables. Drop the prawns into the boiling liquid and simmer for 2 minutes.

3 Drain the prawns in a sieve and hold under the cold tap until they are cool enough to handle. Twist off the legs and heads, then crack the hard shells on the tails and peel them away. Remove the black vein from the back of each prawn.

4 Serve the prawns warm with a garnish of shredded lettuce, and the mayonnaise in small bowls for dipping.

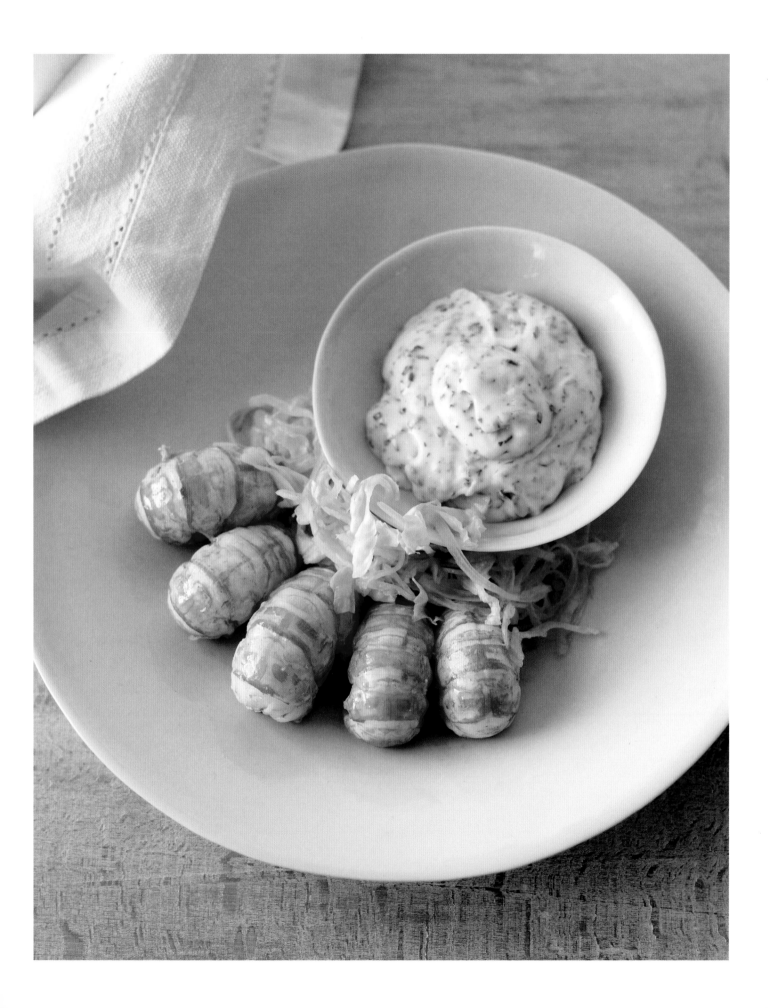

30g hazelnuts
4 unsmoked bacon rashers (without rinds)
1 head of curly endive (pale inner leaves only)
200g smoked eel
½ bunch of fresh chives, cut into 2cm lengths

FOR THE DRESSING
6tbsp hazelnut oil
4tbsp rapeseed oil
2tbsp tarragon vinegar
4tsp smooth mild mustard

SERVES FOUR

SMOKED EEL SALAD

We have a long history of smoking fish in Britain, yet not all of it is good. One common problem is over-smoking, but with eel this is rarely the case. Eel is a rich, dense fish, and the smoking is delicate. It should be eaten more often – there's plenty of it about, and it makes an excellent starter with a well-dressed salad.

1 Preheat the grill to medium. Spread out the nuts in the grill pan and grill for a few minutes until toasted, shaking the pan frequently to prevent the nuts from burning. Remove the nuts from the pan and set aside to cool. Grill the bacon on the grill rack for about 5 minutes or until crisp. Remove the bacon, leaving the grill on.
2 Crush the nuts coarsely with the flat of the blade of a large cook's knife, and cut or crumble the bacon into pieces. Separate the endive leaves and toss with the nuts and bacon in a bowl.
3 Cut the eel into 6cm pieces, discarding any skin and bones, then grill for a minute or two until warmed through. Meanwhile, whisk the dressing ingredients in a jug or bowl with seasoning to taste.
4 Pour the dressing over the salad and toss to coat the leaves, then place the eel on top. Scatter the chives over and around.

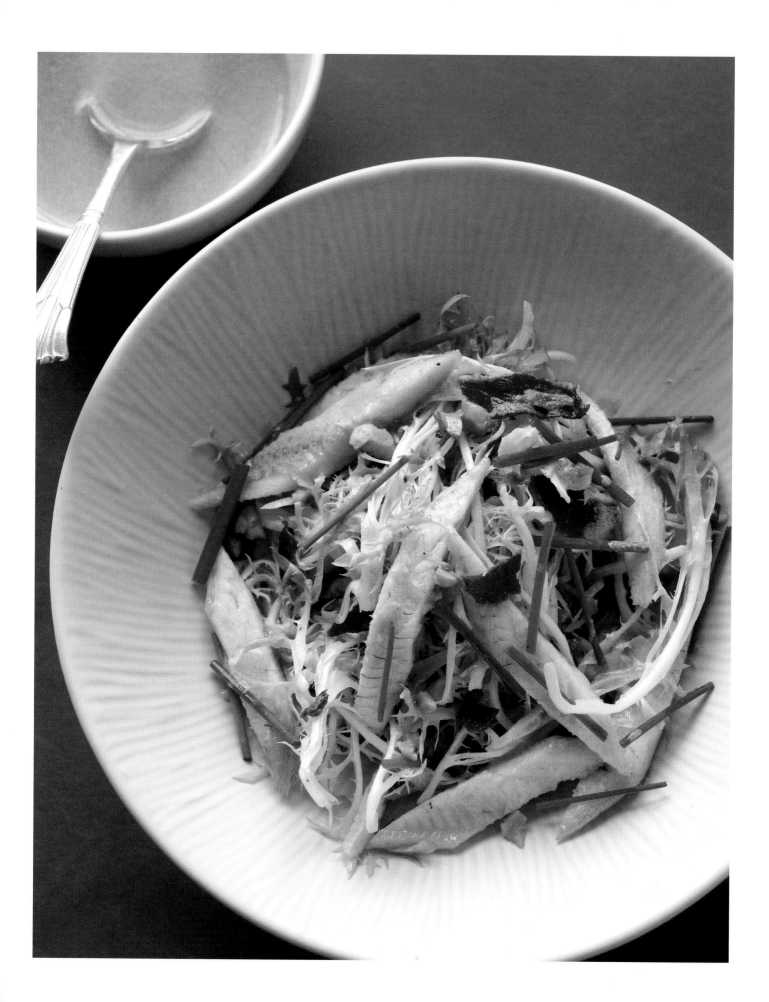

4 eggs
150g sausagemeat
150g minced pork
1 small onion, finely chopped
1tsp finely chopped fresh sage

FOR THE COATING AND COOKING
4tbsp plain flour
1 small egg, beaten
About 85g panko breadcrumbs
Vegetable oil, for deep-frying

MAKES FOUR

SCOTCH EGGS

The key to a good-looking Scotch egg is the pristine white around the yellow yolk, with no hint of a grey ring, and the way to guarantee this is to shell eggs straight after boiling, then immerse them in cold water. To set home-made Scotch eggs apart from the synthetic-looking ones you see in the shops, you must use a good-quality sausage that contains at least 75 per cent meat. Any flavour will do, even wild boar if you like, but some fat is essential or the mix will be dry.

**Master of Moulins (Jean Hey),
active 1483 or earlier – about 1500
*Charlemagne, and the Meeting
of Saints Joachim and Anne
at the Golden Gate* (detail),
about 1500**

The parents of the Virgin are shown embracing at the Golden Gate, outside the walls of Jerusalem. It was at this meeting that Mary was held to have been miraculously conceived.

1 Hard-boil the eggs by covering them with cold water in a saucepan, bringing the water to the boil and simmering gently for 9 minutes. Lift the eggs out and hold under cold running water until cool enough to handle, then remove the shells and immerse the eggs in a bowl of cold water.

2 Spread the flour out on a large flat plate or tray and season with salt and pepper. Drain the eggs and pat dry, then roll them in the flour until evenly coated.

3 Mix the sausagemeat and pork in a bowl with the onion, sage and plenty of seasoning. Divide the mixture into quarters. To coat each egg, flatten a piece of sausagemeat on the palm of your hand, place an egg in the centre and gather up the meat to enclose the egg completely. Seal the joins well, and smooth and pat into shape.

4 Coat the Scotch eggs in the remaining seasoned flour and then in the beaten egg. Finally, coat them thoroughly in breadcrumbs.

5 Heat oil in a deep-fat fryer or heavy saucepan to 180°C. Lower the eggs into the oil and deep-fry for 6–8 minutes until crisp and golden. You may have to fry in batches, depending on the size of your pan. Drain on kitchen paper and serve warm or cold.

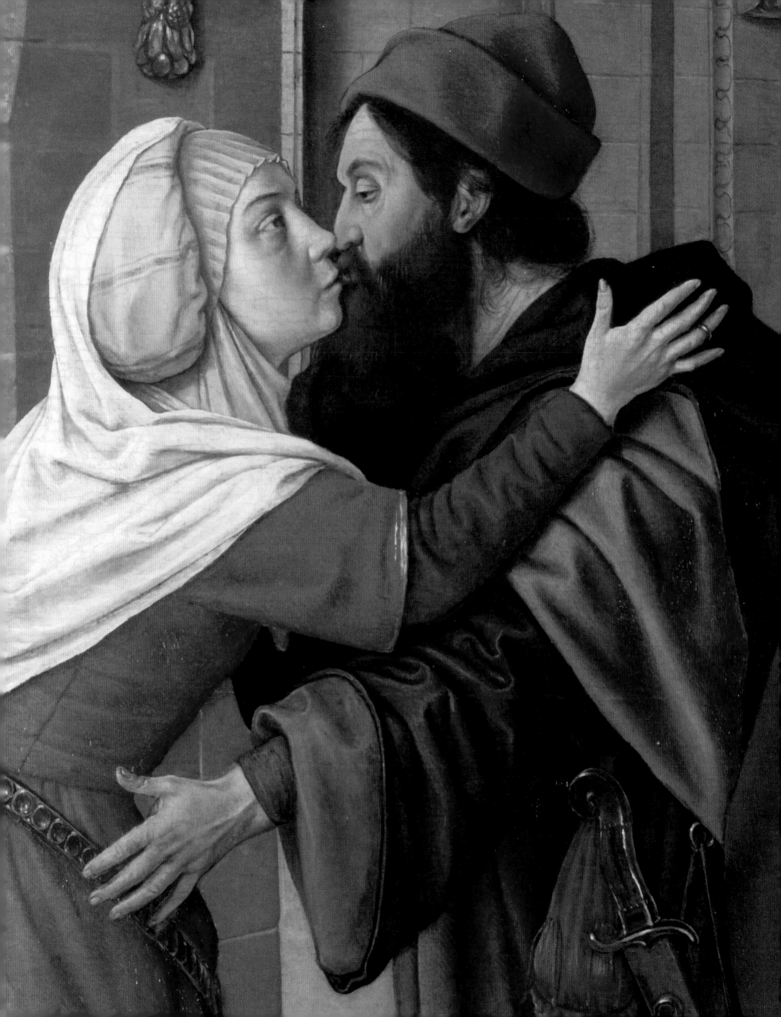

4 wild sea trout fillets with skin, weighing
 about 150g each
Snipped fresh chives
Coarse sea salt and cracked black pepper

FOR THE COMPOTE
300g young rhubarb, diced
Pared zest of ½ large orange
75ml red wine vinegar
150ml ruby port
175g caster sugar
Pinch of cayenne pepper

SERVES FOUR

SLOW-BAKED TROUT WITH RHUBARB COMPOTE

Slow cooking at a low temperature has always been a good thing for meat, and now we've discovered that it also works well with fish. Here the slow-cooked trout has moist, tender flesh and great depth of flavour, while the zesty rhubarb compote enlivens the dish without overshadowing the taste of the fish.

1 Make the compote. Combine all the ingredients except the cayenne in a saucepan and bring to a simmer, then immediately remove from the heat and leave to stand at room temperature for about 30 minutes. Tip the compote into a sieve set over a bowl and let the juice drain through for about 15 minutes. Purée the pulp from the sieve in a blender until smooth, adding some of the drained juice if the purée is too thick. Pour into a pan and season with salt and the cayenne. Set aside.

2 Set the oven at 100°C, and lightly grease a baking tray. Place the trout skin-side up on the tray and bake for 20 minutes. Remove from the oven and peel back the skin, then scrape off any discoloured or brownish-red sediment from the top of the fish. Replace the skin to keep the fish warm.

3 To serve, warm the compote, then spoon a small mound in the middle of four warmed plates. Remove the skin from the trout and place the fish on top of the compote. Sprinkle with chives, sea salt and cracked black pepper, and serve straightaway.

4 halibut steaks on the bone, weighing
 about 250g each
2tbsp vegetable oil
Colcannon (page 261)

FOR THE SHRIMPS
100g butter, diced
½tsp ground mace
200g Morecambe Bay brown shrimps
Pinch of cayenne pepper

SERVES FOUR

HALIBUT STEAKS WITH MORECAMBE BAY SHRIMPS

Serving halibut on the bone shows what a great fish this is, and you get a far better flavour and texture from cooking it this way – fillets can so easily become overcooked and dry. The Morecambe Bay shrimps accentuate the flavour of the halibut, but if you can't get them, or you feel like a change, you can use peas instead. They go really well with halibut.

1 First, clarify the butter for the shrimps. Melt the butter slowly in a heavy saucepan over a low heat. Skim off the froth from the surface, then carefully pour the golden liquid into a clean pan, leaving the sediment behind (discard the sediment).

2 Set the oven at 170°C. Season the halibut steaks with salt and lots of pepper. Heat the oil in a large ovenproof frying pan over a medium to high heat until hot. Sear the steaks on one side until golden brown and crisp, about 4 minutes. Flip the steaks over and transfer the pan to the oven. Cook for about 6 minutes or until the flesh moves away easily from the bone (less time if the steaks are thinner than 2.5cm).

3 To finish, add the mace to the clarified butter and heat gently for 1 minute. Add the shrimps and warm through, stirring to combine with the butter but taking care not to break them. Season with the cayenne and salt to taste.

4 Serve the fish on mounds of colcannon, with the shrimps and butter spooned over and around.

500g small clams, such as carpet shells

2tbsp vegetable oil

1 shallot, finely chopped

100ml dry white wine

8–12 red gurnard fillets with skin, weighing 600–700g in total

2tbsp plain flour

30g butter

100g St George's mushrooms or oyster mushrooms, sliced

100ml whipping or double cream

400g wild garlic leaves or baby spinach leaves

SERVES FOUR

PAN-ROASTED RED GURNARD WITH WILD GARLIC AND CLAMS

Gurnard is the T-bone steak of fish. Chunky like halibut and monkfish, it has a strong enough flavour to hold its own against the pungency of the garlic in this dish. The season for wild garlic only lasts a few weeks, so go mad with it when you can. It's powerful, but it doesn't linger on the palate like garlic cloves do.

1 Scrub the clams clean under cold running water. Discard any that are open, or that do not close when tapped on the work surface.

2 Heat a large saucepan until hot, then add 1tbsp of the oil and cook the shallot for about 2 minutes. Add the clams and wine, cover the pan tightly and cook until the shells open, which will take about 5 minutes. Lift out the clams and set aside, discarding any that are still closed. Strain and reserve the cooking liquid.

3 Dust the fish fillets with the flour on the skin side only.

4 Heat half of the butter in a flameproof casserole and cook the mushrooms for about 3 minutes or until soft. Add the cooking liquid from the clams and boil to reduce by half.

5 Heat a large frying pan (or two pans) over a medium heat and add the remaining oil and butter. Season the fish and cook, skin-side down, for 2 minutes. Turn the fish over and cook for 2 minutes.

6 While the fish is cooking, add the cream to the mushrooms and boil for 1 minute, then place the clams in the pan and top with the wild garlic. Cover and cook for about 2 minutes or just until the garlic leaves wilt.

7 When the fish is cooked, turn it over on to its skin side again and remove from the heat. Serve the mushrooms, clams and garlic in four warmed bowls, topped with the gurnard.

Berthe Morisot, 1841–1895
Summer's Day (detail), about 1879

Close to, the ducks in this deliberately sketchy painting are hardly recognisable, but come into focus at a distance.

60 baby sardines
60g panko breadcrumbs
50g chopped roasted hazelnuts
10g fresh flat-leaf parsley leaves, chopped
Finely grated zest of 1 lemon
4 lemon wedges, to serve

FOR THE PARSLEY OIL
50g fresh flat-leaf parsley, stalks discarded
100ml rapeseed oil

SERVES FOUR

SARDINES WITH A NUT CRUST AND PARSLEY OIL

English sardines are wonderful, especially when they're young and tiny – then you can cook and eat them whole. Whitebait and sprats can also be treated the same way. This recipe is the epitome of seasonal cooking, because there's only a very short time in the year when you can eat sardines heads, tails, bones and all. At all other times, you'll have to chop off their heads.

1 First make the parsley oil by puréeing the parsley and oil in a blender until smooth. Strain through a fine-meshed sieve into a jug or bowl.

2 Set the oven at 200°C. Cover one or two baking sheets with non-stick baking parchment.

3 Wash and dry the sardines. Mix the crumbs, nuts, parsley and lemon zest together, and season with salt and pepper. Place the sardines on the paper, arranging them close together in one layer, and sprinkle with the crumb mixture.

4 Flash in the oven for 4–5 minutes until the crumbs are golden brown, swapping the sheets over halfway if you are using two. Serve hot, with the parsley oil and lemon wedges.

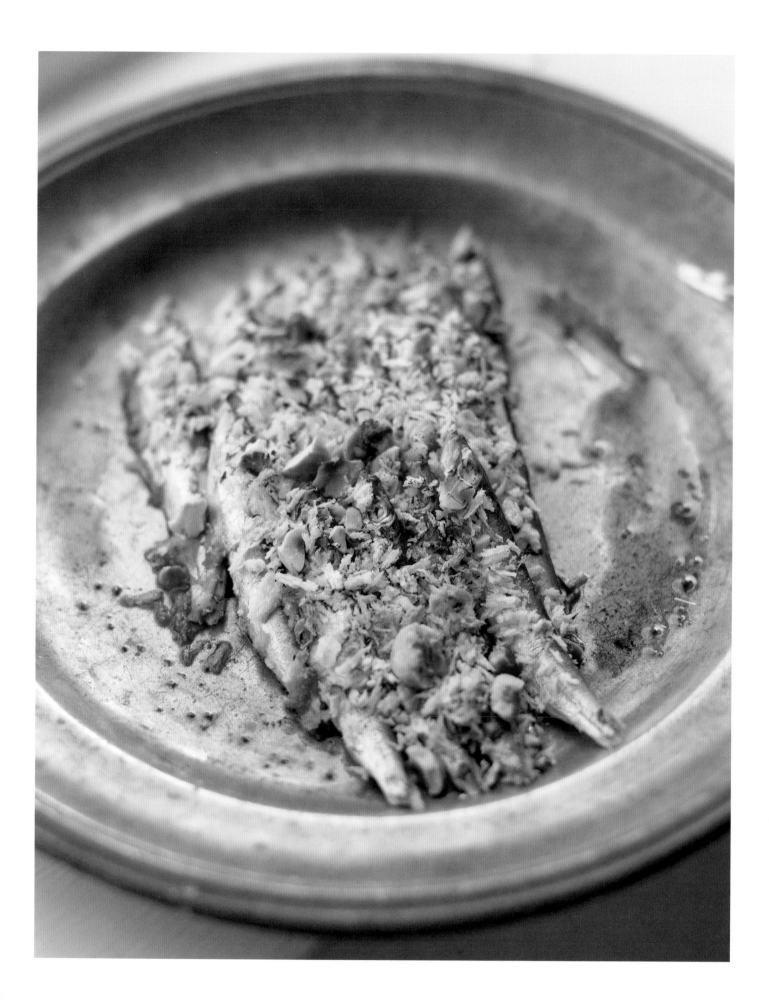

1kg mussels
1tbsp vegetable oil
50g shallots, chopped
2tbsp dry white wine
Large bunch of fresh flat-leaf parsley
 (about 40g), stalks and leaves separated
4 pieces of boned and skinned monkfish
 tail, weighing 125–150g each
Large knob of butter
600g baby spinach leaves, wilted in butter

FOR THE TOPPING
50g bloomer or other white bread
 (without crusts)
50g shallots, chopped
1tbsp vegetable oil
1 hard-boiled egg, shelled and chopped
Finely grated zest of 1 orange

SERVES FOUR

ORANGE-CRUSTED MONKFISH WITH MUSSELS AND SPINACH

A crust always makes fish a little bit special, and here the addition of a small amount of orange zest gives an element of surprise. The finished result is a show-stopping dish with wonderful contrasts in texture and flavour.

1 Scrub the mussels clean under cold running water and remove the beards; discard any mussels that are open, or that do not close when tapped on the work surface. Heat the oil in a saucepan and cook the shallots with a little salt until soft. Add the mussels, wine and parsley stalks. Cover and cook for about 5 minutes or until the shells open. Drain the mussels, reserving the broth; discard any mussels that have not opened. Set 12 mussels aside for the garnish. Remove the remaining mussels from their shells and chop finely.

2 Make the topping. Soften the bread with a few spoonfuls of the mussel broth, then mash with a fork. Mix in the chopped mussels. Cook the shallots in the oil with a little salt until soft, then stir into the mussel mix with the egg and orange zest. Chop 1tbsp of the parsley leaves and stir into the mix with seasoning to taste.

3 Set the oven at 170°C. Place the monkfish on a buttered roasting tray and surround each piece with a thick collar of foil to come 4cm above the fish. Spoon the topping on the fish to come level with the foil, folding the foil down if it is too tall. Pour the remaining broth around the fish. Bake for about 8 minutes or until the fish feels tender when pierced in the centre with a skewer.

4 Season the hot spinach, pile in the centre of four warmed bowls and place the monkfish on top. Spoon the broth over and around. Garnish with the reserved mussels and remaining parsley leaves.

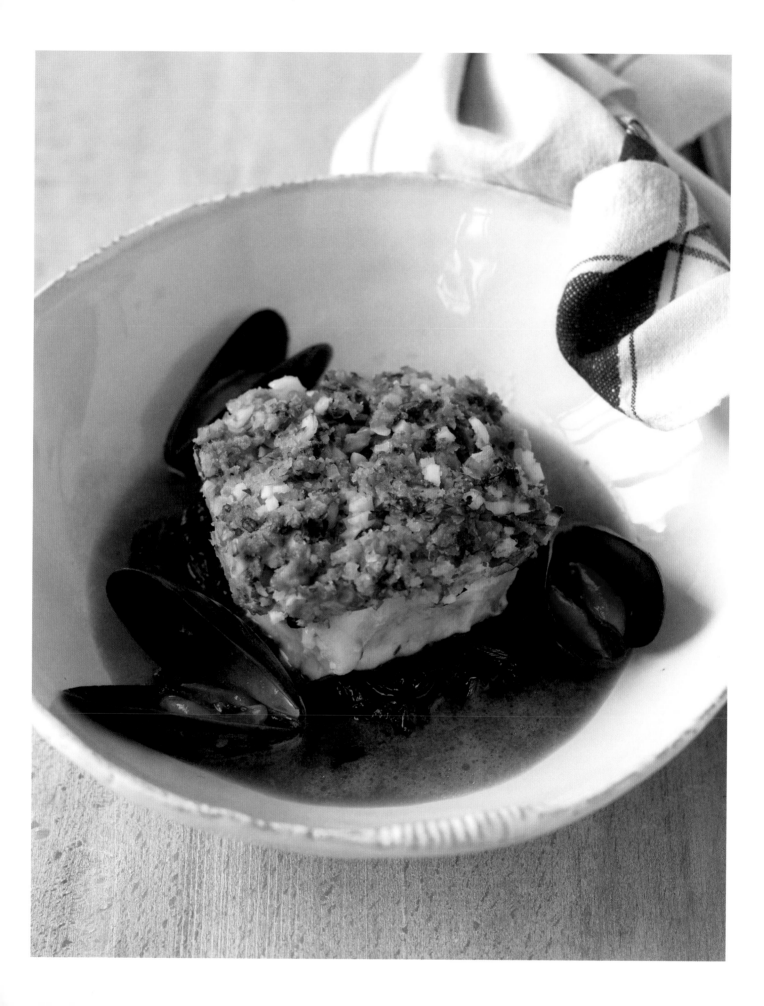

85g pearl barley
30g fresh rosemary sprigs, tied together with string
150g young carrots, cut into matchsticks
1 lemon, scrubbed and dried
4 boneless lamb leg steaks, weighing about 200g each
Vegetable oil, for brushing
100g butter, diced

SERVES FOUR

LAMB WITH BARLEY, CARROTS AND LEMON

New season's lamb is all about flavour, and you shouldn't mess with it. It's best served with simple accompaniments, like the pearl barley here. Barley is a grain that should be used more often. It absorbs flavours well, and makes a good backdrop for other stronger-tasting ingredients.

Thomas Gainsborough, 1727–1788
Mr and Mrs Andrews **(detail), about 1750**

The lightness and informality of this portrait of Robert Andrews and Frances Carter – he in his baggy hunting jacket, she in a beautifully painted jacket and skirt of a clear light blue – makes it one of Gainsborough's enduringly popular early works. The painting of Mrs Andrews's lap is unfinished, and space may have been reserved for a child, yet to be born (the couple eventually had nine).

1 Rinse the barley in cold water until the water is clear. Tip the barley into a saucepan and pour in 1 litre cold water. Bring to the boil, skimming, then cover and simmer for about 15 minutes or until tender. Add the rosemary and 1tsp salt, and leave to cool.
2 Put the carrots into a saucepan of cold water and bring to the boil. Simmer for 1–2 minutes until tender, then drain and plunge into a bowl of iced water. Leave to cool, then drain and set aside.
3 Put the whole lemon in a saucepan of cold water and bring to the boil. Drain, then repeat the boiling process two more times. Drain and leave to cool. Cut off the ends and cut the lemon into slices about 5mm thick. Cut each slice into four triangles.
4 When you are ready to serve, set the oven at 220°C. Heat a frying pan until hot. Brush the lamb steaks with oil, sprinkle with salt and quickly brown on both sides in the hot pan over a high heat. Transfer the lamb to a roasting tray and roast for 15 minutes for medium-rare meat. Remove from the oven and leave the lamb to rest for 10 minutes under a loose sheet of foil.
5 Meanwhile, drain the barley, reserving the liquid. Remove the rosemary and put the barley in a clean pan over a low heat. Mix in the butter a little at a time, adding some of the reserved liquid if the barley seems dry. When it is hot, add the carrots and toss to warm through. Add the lemon and seasoning to taste.
6 To serve, divide the barley equally among four warmed plates. Thickly slice the lamb, place on top of the barley and drizzle over the roasting juices.

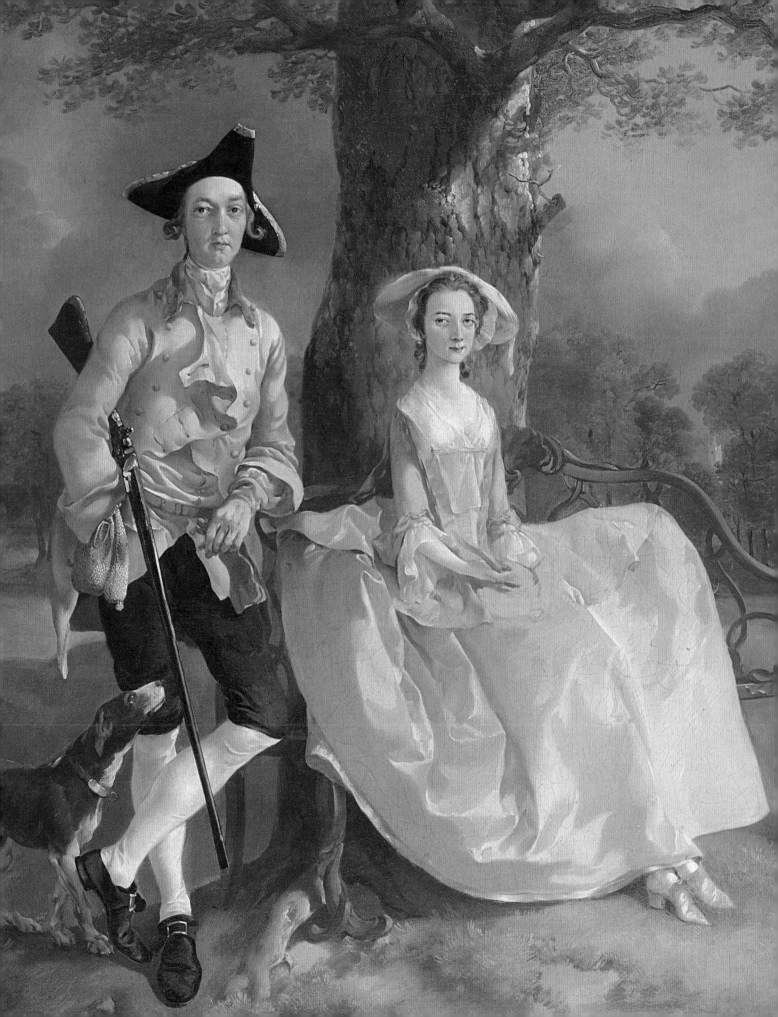

4 duck breasts, weighing about 225g each
Potato and apple fritters (page 261), to serve

FOR THE GLAZE
2 shallots, sliced
20g butter
250ml dry cider
150ml hot chicken stock
1tsp clear honey

SERVES FOUR

CIDER-GLAZED DUCK BREASTS

Cider is always good with rich meats like duck, and together with the honey in this dish it caramelises the skin to make it sweet and crisp. Take time to melt out the fat under the skin at the beginning, so the skin will be as good to eat as the succulent and tender meat beneath.

1 Make diamond cuts in the skin and fat on the duck breasts, taking care not to cut into the flesh. Heat a large, heavy frying pan (or two pans if the breasts won't all fit into one) until medium-hot. Season the breasts well, then place skin-side down in the pan and sear until the skin is crisp and the fat has melted out. This should take about 5 minutes. Be careful not to burn the skin – lower the heat if necessary.

2 Turn the breasts skin-side up and sear for 1 minute over a high heat. Remove and place skin-side up on a rack in a roasting tin. Pour the duck fat into a bowl.

3 Set the oven at 180°C, and make the glaze. Cook the shallots in half of the butter until soft. Stir in the cider and boil to reduce by two-thirds, then add the stock and honey. Reduce again by half. Add the rest of the butter and remove from the heat.

4 Spoon 1tbsp glaze over each breast, and place the duck in the oven. Cook for 12 minutes, coating the breasts with more glaze halfway. This timing will cook the duck to medium doneness, depending on the thickness of the breast. Rest the duck for at least 3 minutes after you take it out of the oven.

5 Reheat the remaining glaze. Slice each duck breast into three and serve straightaway, with extra glaze spooned over and around and the fritters on the side.

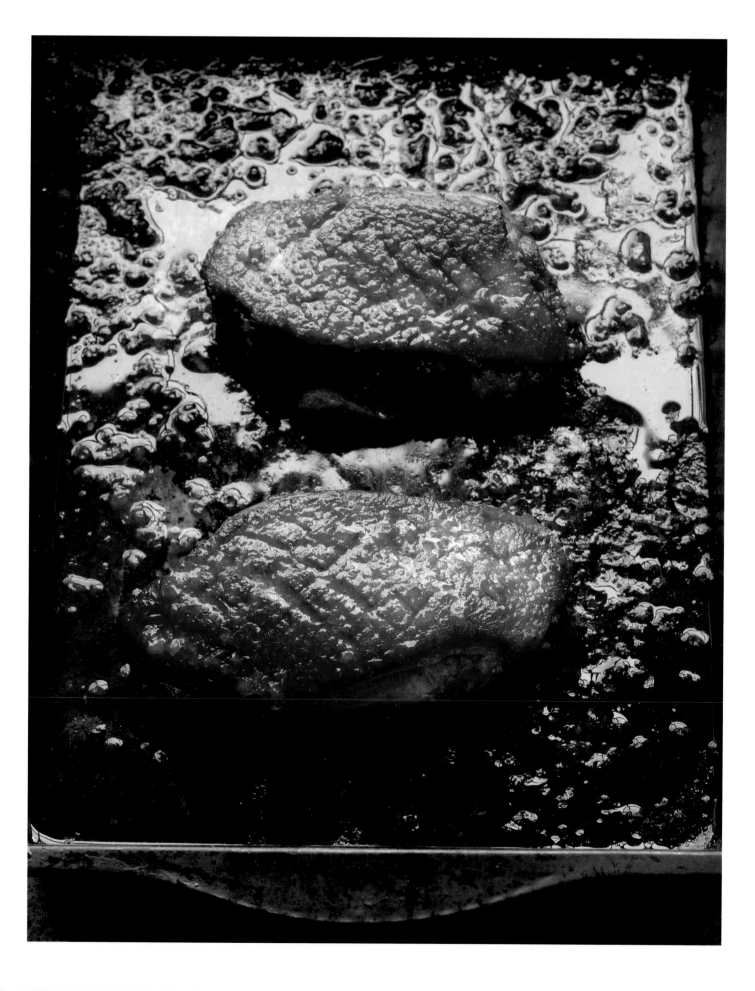

4 slices of calf's liver, weighing about 175g each
1tbsp plain flour
1tbsp vegetable oil
25g butter, diced
100ml ruby port
125ml hot beef stock
4 pickled walnuts, diced

FOR THE MASH
6 large floury potatoes (Maris Piper, King Edward
 or Desirée), peeled and cut into chunks
75g butter, diced
150ml whipping or double cream

SERVES FOUR

PAN-SEARED CALF'S LIVER WITH PICKLED WALNUTS

Good calf's liver is all about the cut, which must be thick. This is the key to preventing overcooking, so make sure you buy nice thick slices that are silky and smooth. For a change from pickled walnuts you can use thick chunks of cooked bacon or gammon instead – choose unsmoked or it will overpower the flavour of the liver.

1 Make the mash. Put the potatoes into a saucepan of salted cold water. Cover and bring to the boil, then simmer for 15–20 minutes until tender. In a separate pan, melt the butter with the cream. Drain and mash the potatoes, then return to the pan and beat in the butter and cream until smooth. Season to taste. Cover the pan and keep the mash in a warm place.

2 Dust the liver with the flour and plenty of seasoning. Heat a frying pan over a medium to high heat until hot, then add the oil. When the oil is hot, add the liver slices with the butter and fry for 2–3 minutes until the butter is foaming and golden brown. The liver will be pink in the centre, but you can cook it for slightly longer if you prefer it done more. Remove the liver from the pan and keep warm.

3 Add the port to the pan, scraping the bottom to release any bits that have stuck. Boil to reduce by half, then add the stock and reduce by a third. Add the walnuts and seasoning to taste. Return the liver to the pan and warm through briefly while you reheat the mash. Serve straightaway.

Théo van Rysselberghe, 1862–1926
Coastal Scene **(detail), about 1892**

Clusters of white dots sprinkled across the picture surface form swirling decorative patterns, giving the painting an animated, almost dancing quality.

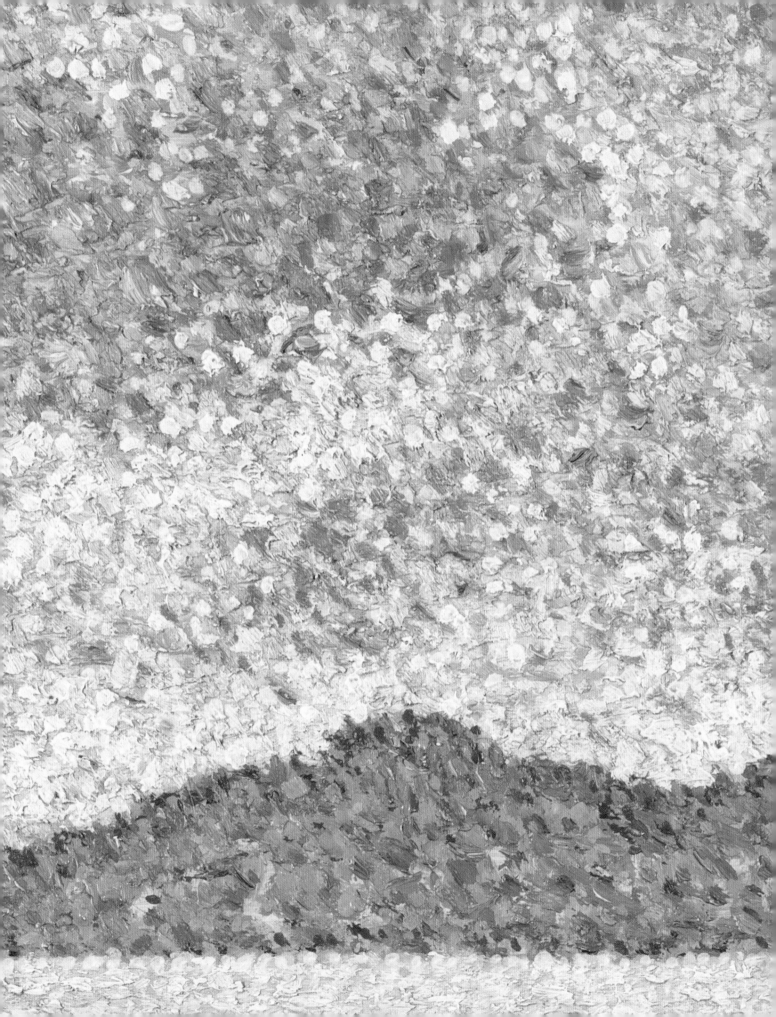

1kg middle neck lamb chops
1tbsp vegetable oil
3 onions, sliced
1tbsp plain flour
600ml hot lamb or chicken stock
1tsp Worcestershire sauce
1 bay leaf
2 sprigs of fresh thyme
600g waxy potatoes (Charlotte, Nicola or Cara),
 peeled and thickly sliced
Large knob of butter

SERVES FOUR

LANCASHIRE HOTPOT

Over the years, this humble dish has evolved almost beyond recognition.
It used to have oysters in it, when they were an affordable, everyday food.
There's nothing to stop you adding your own embellishments if you like –
sliced leeks, carrots and turnips are all good vegetables to put in the pot.

1 Remove any excess fat from the chops. Heat the oil in a wide
flameproof casserole (about 2 litres) over a medium to high heat.
When the oil is so hot that you can see a blue haze rising, add the
chops. Quickly sear until browned on both sides, turning once.
Remove the chops and set aside.

2 Turn the heat down to low under the casserole and add the
onions. Sweat with the lid on for 10–15 minutes until they are
soft and lightly browned. Meanwhile, set the oven at 170°C.

3 Sprinkle the flour over the softened onions, then slowly pour
in the stock, stirring all the time until a smooth sauce is formed.
Add the Worcestershire sauce and seasoning to taste and simmer
for 1 minute. Return the chops to the casserole and tuck in the
bay leaf and thyme.

4 Arrange the potato slices on top of the chops to cover them,
overlapping the slices slightly. Season the potatoes and dot with
the butter. Cover the casserole with a tight-fitting lid, then
transfer to the oven and cook for 1 hour.

5 Remove the lid and continue cooking the hotpot for 30
minutes, increasing the heat to 200°C for the last 15 minutes
to give the potatoes a golden colour. Serve hot.

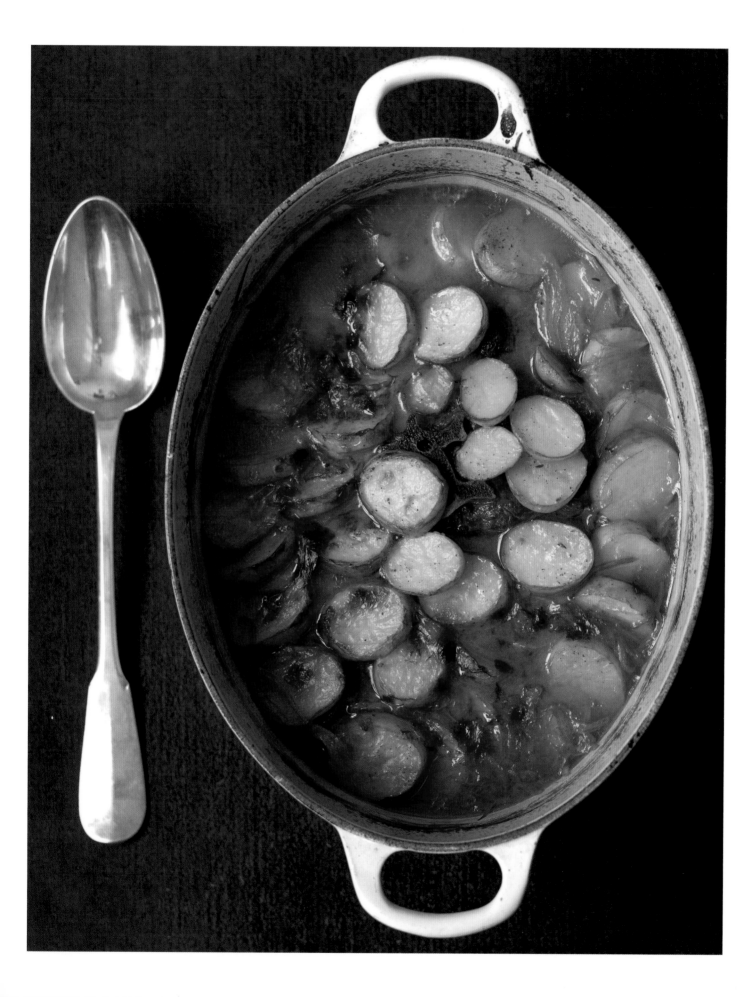

1 rabbit
25g butter
225g smoked streaky bacon rashers (without rinds), diced
1 onion, sliced
500ml hot rabbit or chicken stock
200g young, slim baby carrots, trimmed and scrubbed
2tsp chopped fresh sage
300g good-quality puff pastry (preferably made with butter)
Milk, to glaze

SERVES FOUR

RABBIT PIE WITH SPRING CARROTS

There are some dishes that are so simple they're just meant for every day, and this is one of them. Once you've got the rabbit in the pot and the pastry on top, all you have to do is pop the pie in the oven and it will take care of itself.

1 Cut the legs from the rabbit, and cut the saddle into four pieces (or ask your butcher to do this). Heat a flameproof casserole until very hot and quickly brown the liver and kidneys from the rabbit. Remove and set aside. Melt the butter in the casserole and fry the bacon over a medium heat until the fat runs. Remove the bacon and reserve. Add the rabbit pieces to the casserole and brown all over for about 5 minutes. Remove the rabbit. Add the onion to the pan, cover and sweat gently for a few minutes until soft.

2 Return the rabbit to the casserole with liver, kidneys and bacon. Pour in the stock and add seasoning to taste. Bring just to the boil. Lower the heat, cover and simmer gently for about 45 minutes or until the rabbit is tender. Remove from the heat and leave to cool.

3 Meanwhile, put the carrots into a saucepan of salted cold water and bring to the boil. Drain and refresh under cold running water.

4 Remove the rabbit from the cooking liquid and pull the meat from the bones, keeping the pieces of meat as large as possible. Strain the stock and boil until reduced to 275ml. Put the meat in a pie dish (about 1 litre) with the carrots, sage and reduced stock.

5 Roll out the pastry on a floured surface to about 5mm thick. Cut out a lid for the pie dish plus a strip to go around the rim. Moisten the rim of the dish and press the strip on to it, then moisten the strip and place the lid on top. Trim the edge, and press and crimp to seal. Make a hole in the centre of the lid. Leave the pie to rest for 15 minutes. Meanwhile, set the oven at 190°C.

6 Brush the pastry lid with milk, then bake the pie for about 35 minutes or until the pastry is golden brown. Serve hot.

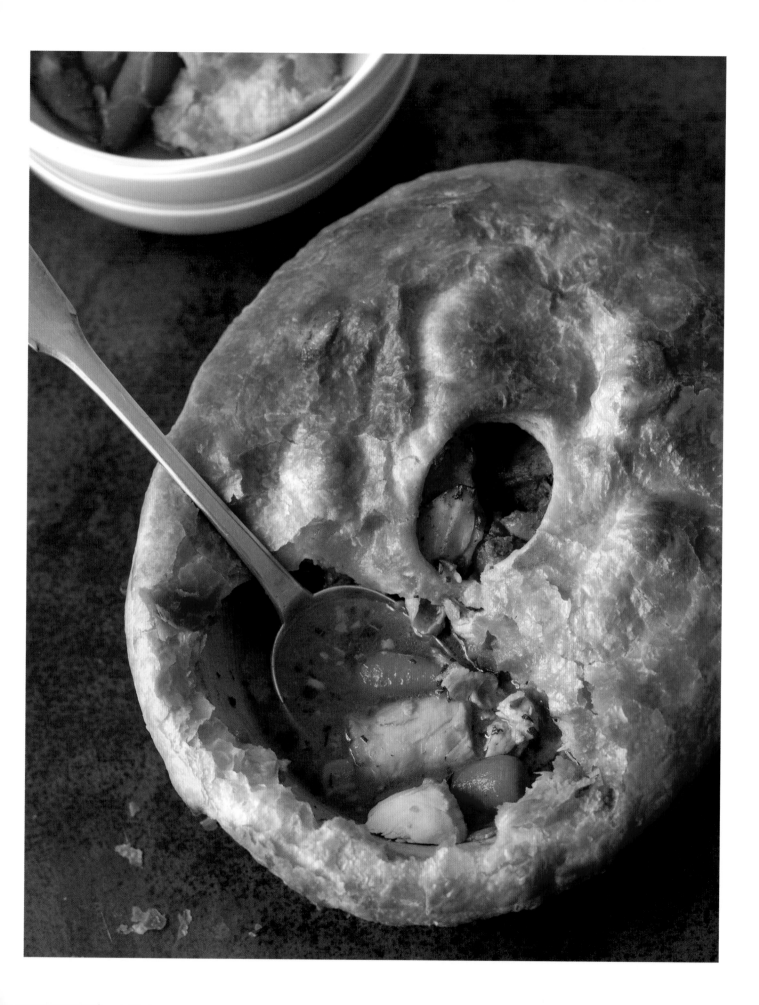

2tbsp vegetable oil
1 onion, finely chopped
25g butter
450g leftover mashed potatoes
225g cooked spring cabbage, shredded or chopped

FOR THE CREAMED SPINACH
500g spinach leaves
50g butter
1tbsp white sauce (page 253) or double cream
125ml double cream
Freshly grated nutmeg

SERVES FOUR

BUBBLE AND SQUEAK WITH CREAMED SPINACH

This cheap dish is traditionally made with leftover cabbage and mash, but you can make it from scratch with fresh ingredients and add different things to it, whatever is to hand. In winter you could use sprouts instead of cabbage, and it's also good with cheese, especially grated strong Cheddar or crumbled blue Stilton. Some people like to turn it over and over and make it into a hash. Or you can flatten it like a cake and coat it with flour, then cook it first on one side and then on the other. As long as it's nice and crisp – that's what matters most.

Follower of Robert Campin, 1378/9–1444
The Virgin and Child before a Firescreen (detail), about 1440

The view through the window is a feature of early Netherlandish painting. The realistic details, not all easily visible to the naked eye, include a row of shops, horsemen, and men with a ladder fighting a fire.

1 First prepare the spinach. Plunge the leaves into a large saucepan of salted boiling water and push them under the surface, then drain and immediately transfer to a bowl of iced water to stop the cooking. Drain thoroughly and squeeze out as much water as possible. Chop finely and set aside.

2 Heat the oil in a large frying pan. Add the onion and cook over a low heat until soft. Add the butter and wait until it melts, then add the potatoes and cabbage and mix well. Fry over a medium to high heat for 15–20 minutes until tinged golden brown, turning the mixture over occasionally.

3 Meanwhile, finish the spinach. Melt the butter in a saucepan, add the spinach and cook for 3 minutes. Add the white sauce and cook for a further 2 minutes, stirring well. Pour in the cream, increase the heat and cook for about 5 minutes or until the spinach is quite dry but still creamy. Add nutmeg and seasoning to taste. Serve straightaway, with the bubble and squeak.

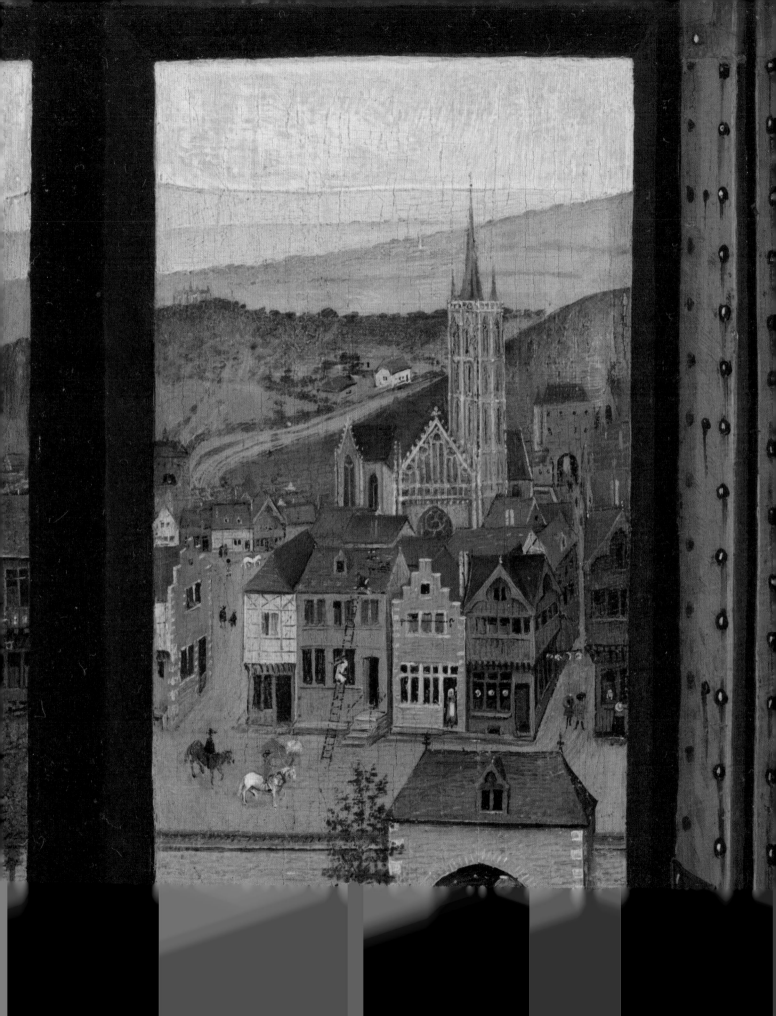

1 garlic clove, roughly chopped
2.5cm piece of fresh root ginger, peeled and roughly chopped
Large bunch of fresh coriander (about 40g), stalks and leaves separated
250g purple sprouting broccoli, stalks trimmed
About 6tbsp vegetable oil

FOR THE FRITTERS
5–6 carrots, grated
2 eggs
50g plain flour
1tsp caster sugar
½tsp ground cumin

SERVES FOUR

CARROT FRITTERS WITH PURPLE SPROUTING BROCCOLI

These fritters are a British take on Japanese tempura, and you can vary them according to what's in season – grated butternut squash makes a good alternative in the autumn and winter months. The dish is great for children because they'll eat their vegetables without realising it.

1 Set the oven at 180°C. Make the batter for the fritters by mixing the carrots, eggs, flour, sugar and cumin in a bowl with ½tsp salt. Set aside.

2 Blitz the garlic, ginger and coriander stalks to a paste in a food processor.

3 Plunge the broccoli into a saucepan of salted boiling water, bring back to the boil and simmer for 1½ minutes. Drain and refresh under cold running water, then drain again and pat dry.

4 Pour about 4tbsp oil into a deep frying pan, just to cover the bottom, and place over a medium to high heat until hot.

5 Meanwhile, heat 2tbsp oil in a roasting tray on top of the stove, add the paste and sizzle for 1 minute. Add the broccoli and toss well to coat with the paste. Transfer the roasting tray to the oven and roast the broccoli for 5–6 minutes.

6 Stir the batter, then drop a tablespoon at a time into the hot oil in the frying pan. Fry for a couple of minutes on each side or until set and golden brown. There should be 12–16 fritters in total, which can be made in batches according to the size of your pan, and then kept warm in the oven while you cook the remainder.

7 Remove the broccoli from the oven and toss with the coriander leaves. Serve on four warmed plates, topped with the fritters.

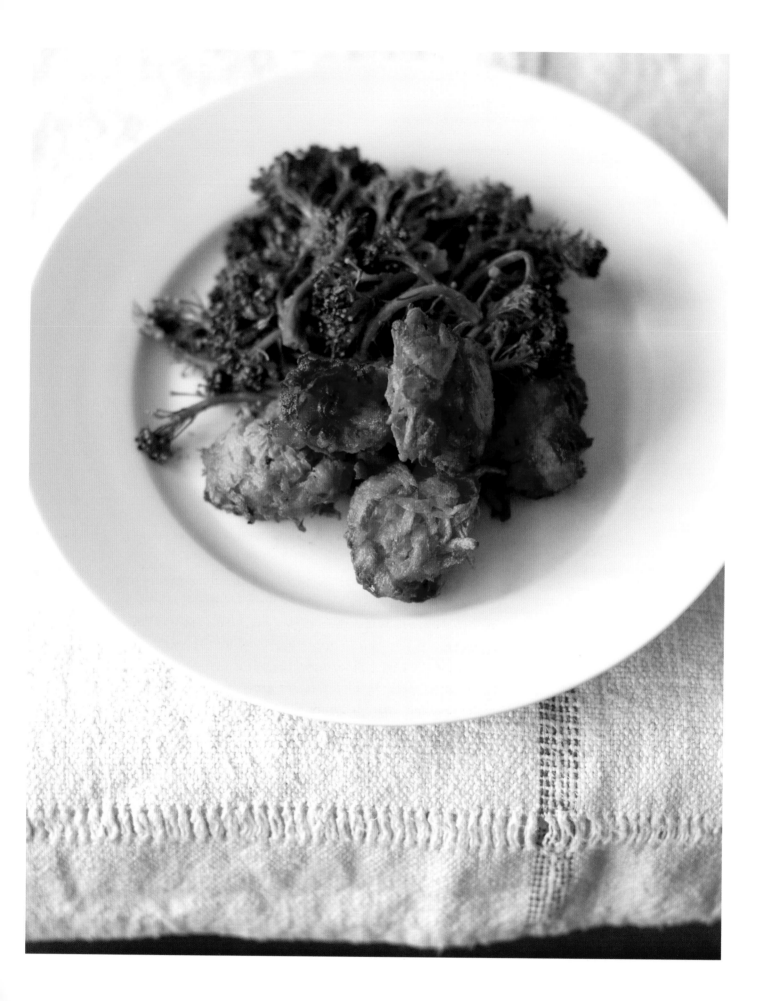

400g spring greens
Knob of butter
2tbsp vegetable oil
10g new season's fresh (wet) garlic
 cloves, crushed
500g young asparagus spears

FOR THE CHEESE SAUCE
300ml milk
20g plain flour
20g butter
25g mature Cheddar cheese, grated
25g creamy Lancashire cheese, grated

FOR THE TOPPING
50g panko breadcrumbs
50g chopped walnuts

SERVES FOUR

CHEESE-COATED ASPARAGUS WITH SPRING GREENS AND GARLIC

Take great care not to overcook the asparagus and greens in this gloriously rich dish. They need to be quite crunchy, to give a contrasting texture to the cheese sauce. When it's young, Lancashire cheese is surprisingly creamy and moist.

1 Make the sauce. Put the milk, flour and butter in a saucepan over a low heat. Bring just to the boil, whisking constantly to make a smooth sauce. Simmer gently for 5 minutes, then add the cheeses and whisk until melted. Season to taste and remove from the heat.

2 Set the oven at 160°C, and grease a baking dish (about 25 × 18cm and 5cm deep). Combine the crumbs and walnuts for the topping.

3 Trim the spring greens and discard any damaged outer leaves as well as the tough core. Finely shred the leaves and wash under cold running water. Melt the butter and oil in a large sauté pan, add the garlic and sauté for 30 seconds. Add the shredded greens, cover and cook until wilted and tender. Remove from the heat. Drain off any excess water from the sauté pan and season the greens well.

4 Cut any woody ends off the asparagus, then plunge the spears into a saucepan of salted boiling water. Bring back to the boil and simmer for about 5 minutes or until tender. Drain and immediately plunge into a bowl of iced water to stop the cooking; drain again.

5 Place half of the greens in the baking dish and cover with half of the asparagus. Reheat the cheese sauce and pour half over the asparagus. Repeat the layers of greens and asparagus, arranging the spears in the opposite direction to those in the first layer. Cover with the rest of the cheese sauce and top with the breadcrumb mixture. Bake for about 20 minutes or until the topping is golden brown. Serve hot.

Nicolas Lancret, 1690–1743
A Lady in a Garden taking Coffee with some Children (detail), probably 1742

The family group is unseen; the focal point of the setting is a stone vase filled with roses on an elaborate pedestal, with trailing honeysuckle.

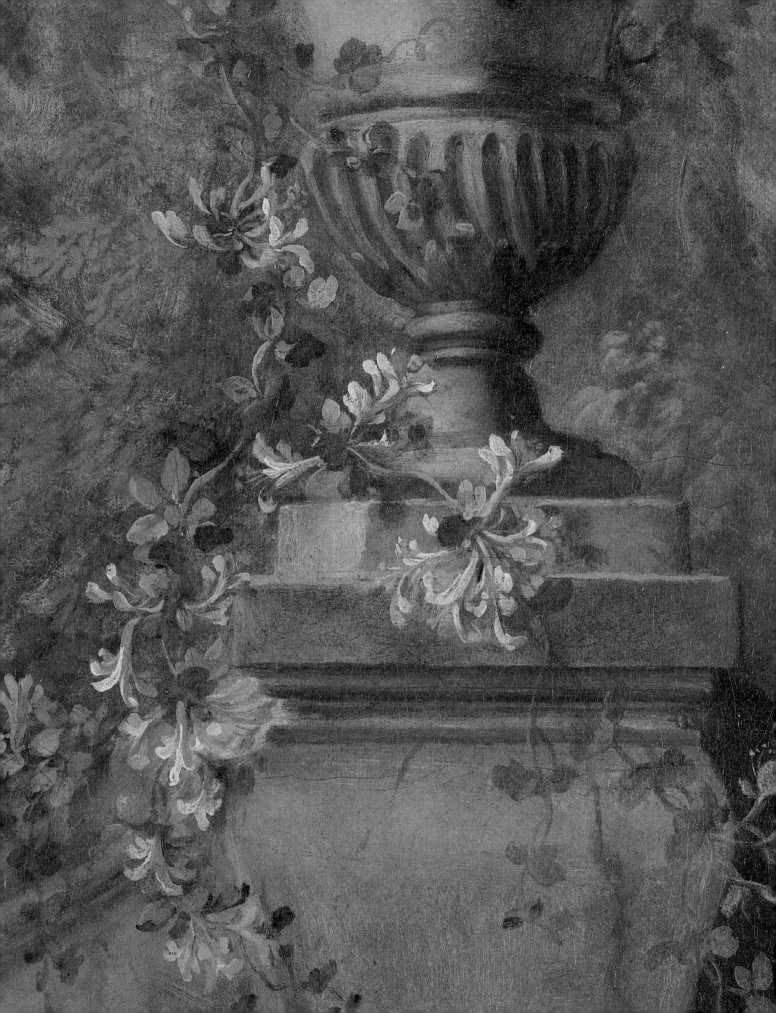

450g good-quality puff pastry
(preferably made with butter)
Milk or beaten egg yolk, to glaze

FOR THE FILLING
2tbsp vegetable oil
1 large onion, sliced
275g well-trimmed broccoli florets
225g Stilton cheese

FOR THE WHITE SAUCE
250ml milk
¼ onion, peeled
½tsp fresh thyme leaves
20g butter
20g plain flour
½tbsp chopped fresh flat-leaf parsley

SERVES FOUR

BROCCOLI AND STILTON PASTIES

Stilton is one of the world's finest cheeses, but it's seldom used in cooking for fear that its strong flavour might be overpowering. In fact there are many different types, and for this dish a creamy, smooth Stilton is the one to choose. With the broccoli providing colour and texture, the cheese lends these pasties a rich and comforting feeling, making them a deeply satisfying dish.

1 Make the filling. Heat the oil in a frying pan over a medium to high heat and sauté the onion for about 6 minutes or until caramelised. Meanwhile, drop the broccoli florets into a pan of salted boiling water and bring back to the boil, then drain and refresh under cold running water. Drain well again and pat dry.

2 Make the sauce. Bring the milk slowly to the boil in a heavy saucepan with the onion and thyme. Remove from the heat and strain into a jug. Melt the butter in the saucepan over a low heat, sprinkle in the flour and cook for 2 minutes, stirring. Slowly add the milk, increasing the heat to medium and whisking after each addition to make a smooth sauce. Simmer gently for 3–5 minutes, stirring often, then remove from the heat and stir in the parsley.

3 Crumble the cheese into a bowl and mix with the onion and broccoli, then add enough of the sauce to give a creamy consistency. Add seasoning to taste.

4 Set the oven at 200°C with a heavy baking sheet inside. Roll out the pastry on a floured surface until 5mm thick, then chill in the fridge for 10 minutes. Cut out four discs, each 20–23cm in diameter. Brush the edges with water. Spoon one-quarter of the filling on to one half of each disc, then fold the other half over. Trim the edges, and press and crimp to seal. Make three small slits in the top of each pasty and brush with milk or egg yolk. Place the pasties on the hot baking sheet and bake for 15–20 minutes until golden brown. Serve hot or cold.

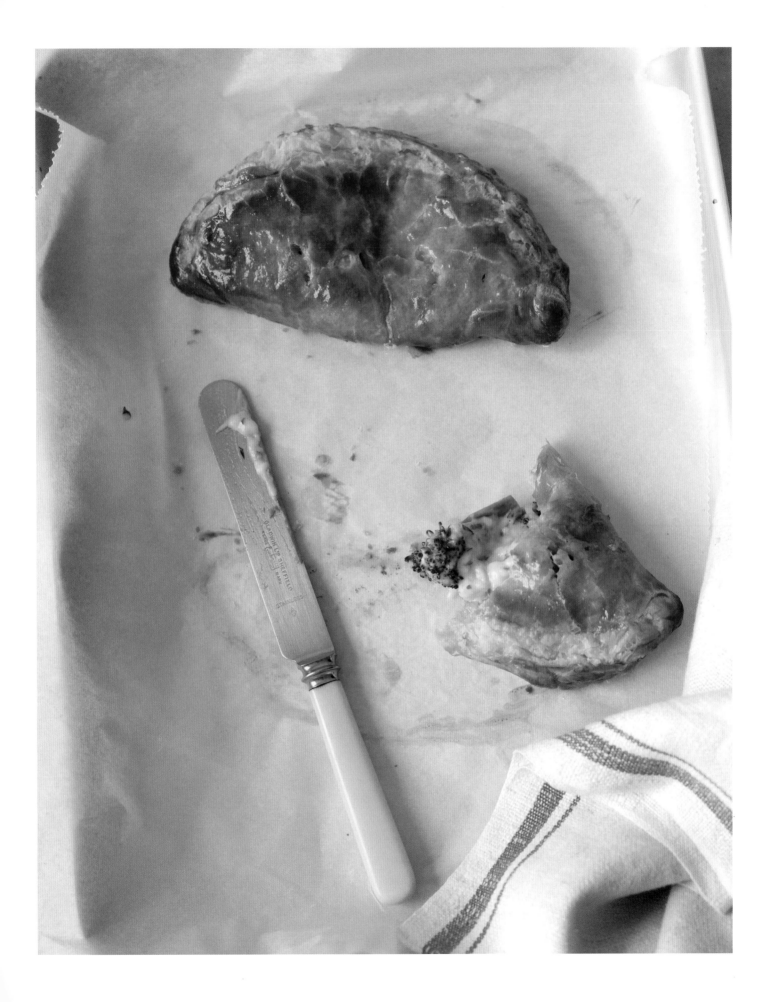

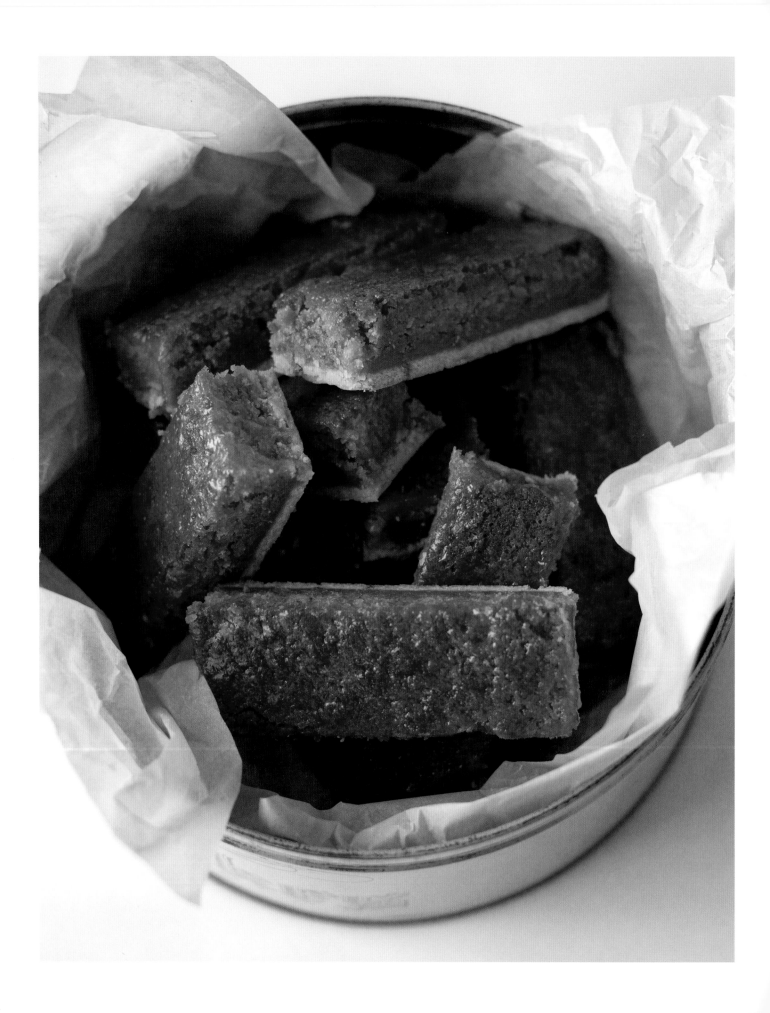

300g shortcrust pastry (page 257)

FOR THE FILLING
300ml double cream
2 eggs
1 egg yolk
800g golden syrup
200g fresh white breadcrumbs
125g ground almonds
Finely grated zest of 2 lemons

MAKES TWELVE BARS

TREACLE TART

Despite its name, treacle tart is not made with treacle at all but with golden syrup – a staple ingredient in most British larders. Nobody lays claim to the original recipe, and it's not a pudding that causes much debate. You either love it or loathe it. Getting the filling right is tricky, as all too often it's stiff and stodgy. The secret is to use lots of syrup.

1 Roll out the pastry thinly on a floured surface and use to line a Swiss roll tin measuring about 30 × 20cm and 4cm deep. Trim the edges, and prick the bottom all over with a fork. Chill in the fridge for at least 30 minutes.

2 Set the oven at 190°C. Mix the cream, eggs and egg yolk together in a bowl. Warm the syrup in a pan over a gentle heat, then add the breadcrumbs, almonds and lemon zest. Remove from the heat and mix in the cream and eggs, then pour into the pastry case.

3 Bake the tart for about 30 minutes or until the pastry is crisp and golden around the edges and the filling feels set in the middle when gently pressed. Cool in the tin before cutting into bars.

300g shortcrust pastry (page 257)
Beaten egg, to seal

FOR THE FILLING
3tbsp cornflour
50g caster sugar
Finely grated zest and juice
 of 2 large lemons
2 egg yolks
45g butter, diced

FOR THE MERINGUE
2 egg whites
115g caster sugar

SERVES SIX

LEMON MERINGUE PIE

Over the years, this pie has fallen out of fashion in favour of the French *tarte au citron*. This is strange really, as who can resist the golden-tinged, crisp peaks of meringue that make the pie look so charming and taste so good?

Henri Rousseau, 1844–1910
Surprised! **(detail), 1891**

Rousseau claimed that he had gained knowledge of the jungle while serving as a regimental bandsman in Mexico in the 1860s, but in fact his paintings were probably inspired by visits to the botanical gardens in Paris, and by prints.

1 Roll out the pastry on a floured surface and use to line a 20cm loose-bottomed tart tin placed on a baking sheet, letting the surplus pastry hang over the edge of the tin. Prick the bottom of the case all over with a fork, then let rest in the fridge for half an hour.
2 Set the oven at 180°C. Line the bottom and sides of the pastry case with a disc of greaseproof paper. Fill with baking beans or uncooked pulses or rice. Bake for 10 minutes. Lift out the paper and beans. Brush the pastry case with beaten egg, then bake for another 10 minutes. Leave to cool slightly.
3 Reduce the oven to 150°C. Put the cornflour and sugar in a bowl and mix to a smooth paste with 5tbsp cold water. Pour 200ml cold water into a saucepan, add the lemon zest and heat to almost boiling. Pour in the cornflour paste, whisking all the time until incorporated. Remove from the heat and whisk in the egg yolks, lemon juice and butter. Return the pan to a gentle heat and cook, stirring, until the mix thickens, taking care not to let it boil.
4 Trim off the surplus pastry from the edge of the pastry case using a sharp knife. Pour in the lemon filling and spread it out evenly.
5 Make the meringue. Put the egg whites in a clean bowl and whisk until stiff. Beat in the sugar 1tbsp at a time. Spread the meringue evenly over the lemon filling. Make sure the meringue goes right to the edge of the pastry case, to seal in the filling. Bake the pie for about 40 minutes or until the meringue is crisp and golden brown.

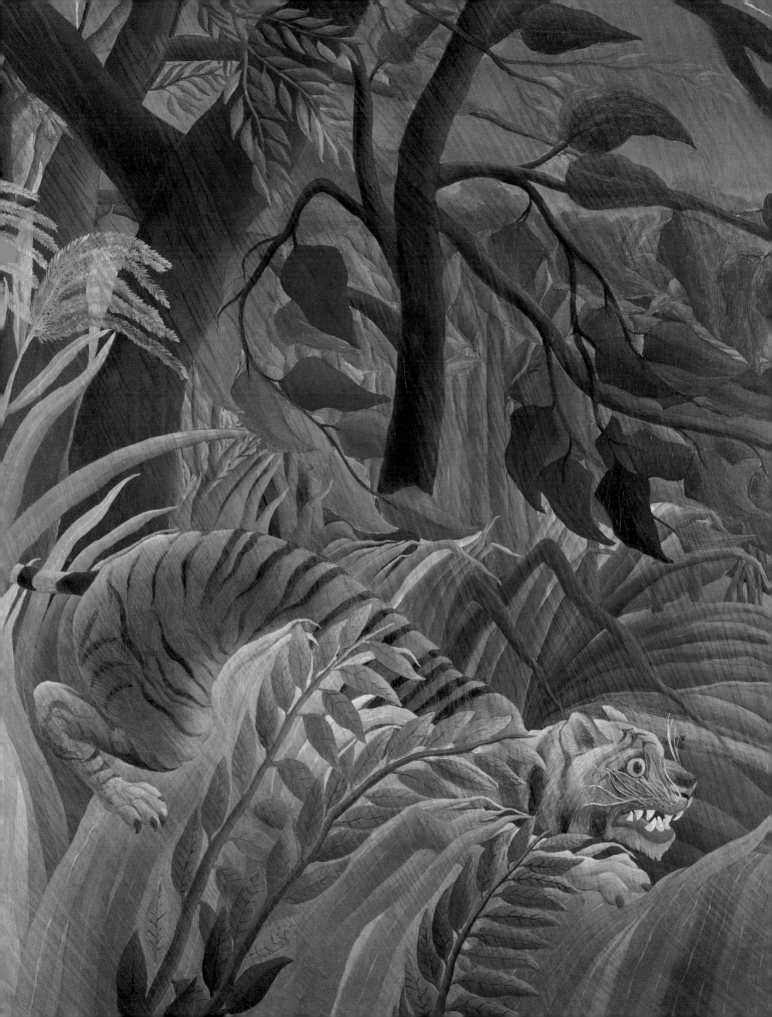

FOR THE FILLING
1kg rhubarb (forced or new season's)
200g caster sugar
250ml crème fraîche
125ml double cream
3 egg yolks

500g shortcrust pastry (page 257)
Beaten egg, for sealing

SERVES EIGHT

RHUBARB TART

Here, the quintessential English pairing of rhubarb and custard is cooked
in a pastry case that looks like a sweet quiche. Instead of cooking the rhubarb
beforehand, which would turn it to a pulp, it's macerated in sugar. This leaves
the rhubarb with its natural colour, a little bit of crunch and an intense flavour.

1 Trim the rhubarb, then cut the stalks across into thin slices (this
helps break down any stringy fibres). Mix the rhubarb with 150g of
the sugar in a bowl. Leave at room temperature for at least 1 hour.
2 Meanwhile, make the tart case. Roll out the pastry on a floured
surface to about 5mm thick. Use to line a 25cm flan ring placed
on a baking sheet covered with greaseproof paper (or use a fluted
loose-bottomed tart tin). Let the surplus pastry hang over the edge
of the ring, and do not stretch it or it will shrink during baking.
Prick the bottom all over with a fork, then leave the case to rest
in the fridge for about half an hour before baking.
3 Set the oven at 170°C. Line the bottom and sides of the pastry
case with a disc of greaseproof paper. Fill with baking beans or
uncooked pulses or rice and bake for 20 minutes. Slide the baking
sheet out of the oven and lift out the paper and beans. Brush the
pastry with beaten egg and return to the oven for 5 minutes.
4 Tip the macerated rhubarb into a sieve and let the liquid drain
through, pressing and squeezing the rhubarb tightly with your
hands to extract as much liquid as possible – the pieces should
be compact and dry.
5 Increase the oven to 180°C. Trim off the surplus pastry from the
edge of the tart case with a sharp knife. Mix the remaining filling
ingredients with the remaining sugar. Pile the rhubarb in the tart
case and slowly pour in the filling. Bake for 20–25 minutes until
the pastry is lightly coloured. The filling should be just set, with
a slight quiver in the centre when you gently shake the tart.

FOR THE CANDIED ORANGE SLICES
100g caster sugar
4 paper-thin slices of blood orange,
 including the skin

300ml pouring double cream
75g caster sugar
Finely grated zest of 1 small lemon
2tbsp lemon juice

FOR THE BLOOD ORANGE SAUCE
1 blood orange
30g caster sugar

SERVES FOUR

LEMON POSSET WITH A BLOOD ORANGE SAUCE

Posset is one of those dishes from our culinary history that has all but disappeared. Sometime in the future it will be popular again, like its foreign relations *pannacotta* and *crème brûlée* are today, and hopefully this recipe will go some way to making this happen. The elegant, dainty presentation makes it perfect for a dinner party dessert, and debating its origins should stimulate some lively conversation around the table.

1 First make the candied orange slices for the decoration. Put the sugar in a small saucepan with 100ml cold water and bring slowly to the boil, stirring until the sugar has dissolved. Remove from the heat. Dip the orange slices in the sugar syrup and place on a rack set over a tray. Leave in a warm place, or in an oven that has been heated and turned off, until crisp, which should take about 8 hours.

2 For the posset, put the cream, sugar and lemon zest in a small saucepan and warm over a low heat, stirring all the time to make sure the sugar dissolves, until bubbles start to form around the edge. Continue cooking gently, without stirring, for about 2 minutes. Do not let the cream get to a rolling boil. Remove from the heat and stir in the lemon juice until evenly distributed. Pour into four small dessert glasses (about 80ml each). Cover and refrigerate for at least 2 hours or until set (you can leave the possets in the fridge overnight if this is more convenient).

3 Make the sauce. Cut the orange into wedges and remove all the pips. Place the wedges (skin on) in a blender with the sugar and blitz until the sugar has dissolved and the purée is smooth. Pass the sauce through a fine sieve set over a bowl.

4 Serve each posset topped with a spoonful of the sauce and a candied orange slice.

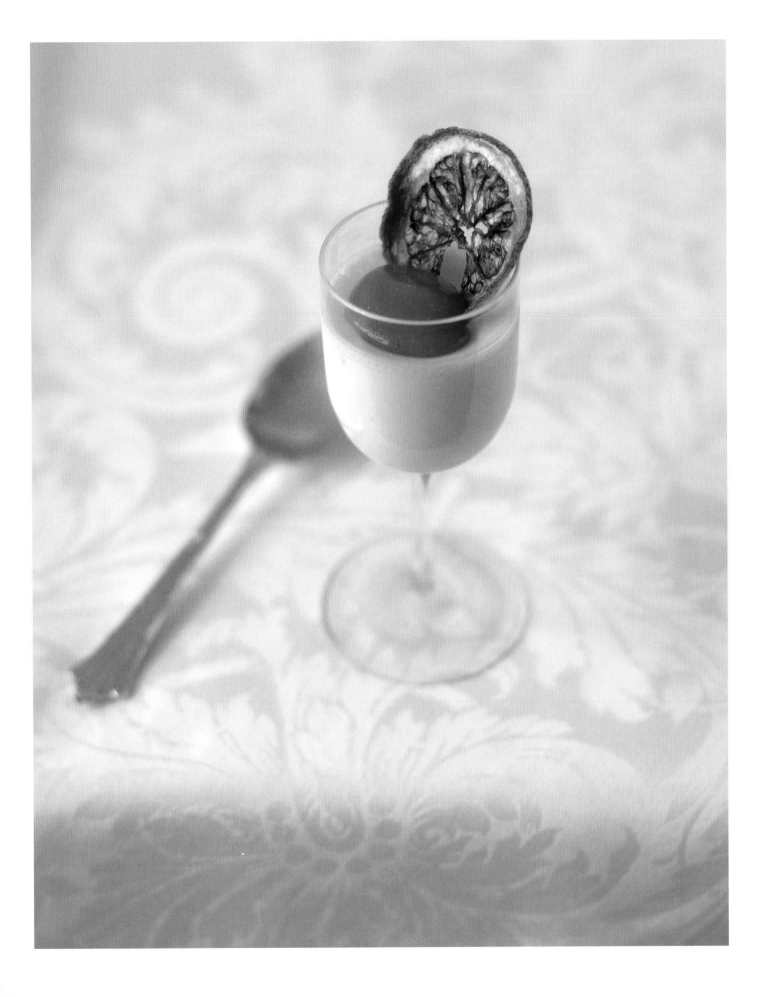

FOR THE PASTRY
125g soft butter, diced
75g caster sugar
1tsp ground cinnamon
Pinch of ground allspice
Pinch of ground cloves
1 egg
325g plain flour
125g ground almonds

350g soft semi-dried figs, coarsely
 chopped
60g caster sugar
2tsp finely grated lemon zest
Juice of 1 lemon

MAKES THIRTY-TWO

FIG ROLLS

If you like figs, you'll love these. Don't be put off by the familiar supermarket fig rolls. These are completely different. One of the tricks is the type of figs you use: they need to be the moist, semi-dried ones, not the blocks of hard, dry fruit. The other secret of success is the contrasting textures of the pastry: it's crisp on the outside when you bite into it, but soft and squidgy on the inside from the figs.

**François-Hubert Drouais,
1727–1775
*Madame de Pompadour
at her Tambour Frame*
(detail), 1763–4**

This lavishly embroidered, lace-edged dress is worn by Madame de Pompadour. Born plain Mademoiselle Poisson (meaning fish) to a bourgeois family, she became mistress to King Louis XV, and remained his influential friend long after that relationship ended.

1 Make the pastry. Beat the butter, sugar, spices and egg in a bowl until light and fluffy. Stir in the flour and ground almonds, and bring the mixture together with your hands to form a dough.
2 Turn the dough on to a floured surface and knead for 1 minute. Wrap in cling film and refrigerate for 15–20 minutes.
3 Meanwhile, combine the figs with 125ml cold water in a medium saucepan. Add the sugar and lemon zest and juice. Heat gently, stirring, until the sugar has dissolved, then simmer, stirring occasionally, for about 10 minutes or until the mixture is thick and pulpy. Cool, then blitz until smooth in a small blender.
4 Set the oven at 180°C, and grease two baking trays. Cut the pastry into quarters. Roll out each piece between two sheets of non-stick baking parchment into a 25 × 10cm rectangle. Spread the filling over the pastry, leaving a 1cm border along the long sides. Fold the long sides over the filling to overlap slightly in the centre, using the parchment to help you lift the pastry (it is soft and likely to crack). Gently press the seams together to seal.
5 Place the rolls, seam-side down, on the baking trays. Bake for about 25 minutes or until lightly browned. Cool on the trays for 10 minutes, then cut each roll across into eight slices, each about 3cm wide. Leave to cool completely before serving.

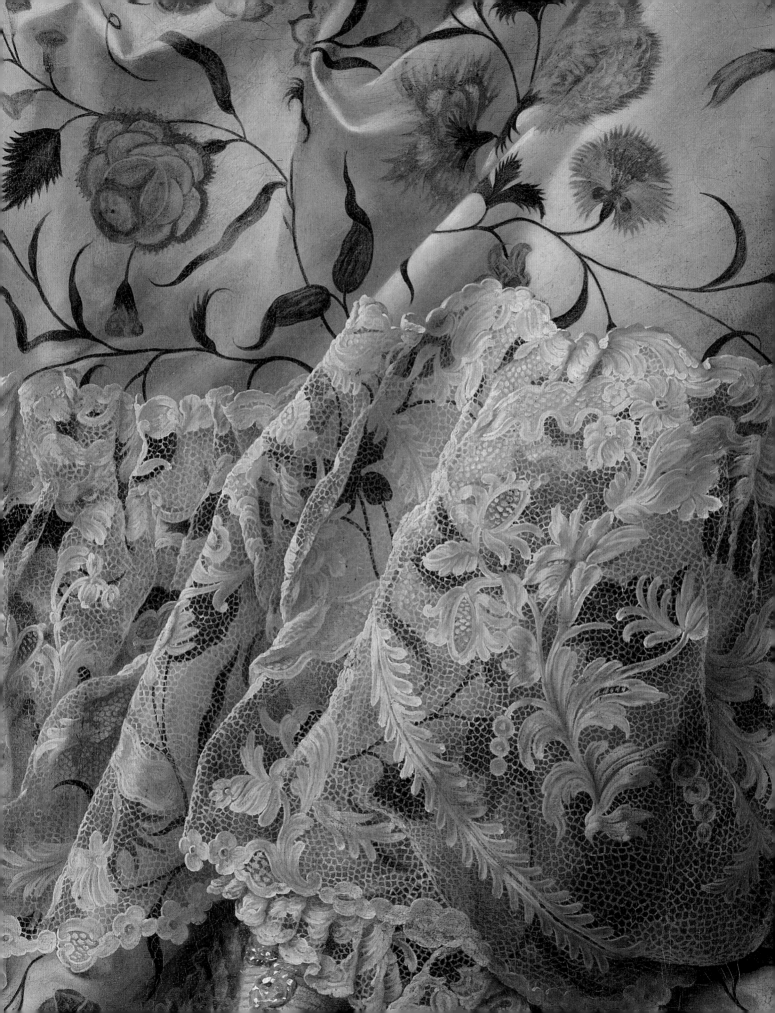

2 eggs
175g caster sugar
75ml double cream
175g plain flour
1tsp baking powder
Finely grated zest of 2 lemons
175g really soft butter

FOR THE GLAZE
100g caster sugar
Juice of 1 lemon

SERVES EIGHT

LEMON DRIZZLE CAKE

Whatever it is that gives a cake a home-made look and flavour, this cake has it.
It's a moist cake that keeps well and would last a while – were it not so moreish.
To inject a bit of your own personality, treat the recipe as a blank canvas and
don't do exactly what it says every time. Grate the lemon zest thick or thin, use
a little or a lot, or even change from lemon to orange. This is what home-made
cakes are all about – being different every time.

1 Set the oven at 160°C. Grease a 1kg loaf tin (measuring about
23 × 12cm and 7.5cm deep) and line the bottom with non-stick
baking parchment.
2 Tip all the cake ingredients into a large bowl and add a pinch
of salt. Beat with an electric hand whisk for 2–3 minutes until the
mixture is thick and creamy. Turn into the prepared tin. Bake for
45–50 minutes until a skewer inserted in the centre of the cake
comes out clean.
3 Remove from the oven and leave to settle for a few minutes,
then turn out on to a wire rack and remove the lining paper.
4 Make the glaze. Gently heat the sugar and lemon juice in a small
saucepan, stirring until a clear syrup is formed, about 3 minutes.
Do not boil.
5 Prick the warm cake all over with a skewer, then slowly pour
the syrup over it so the syrup is completely absorbed. Leave to
cool before serving.

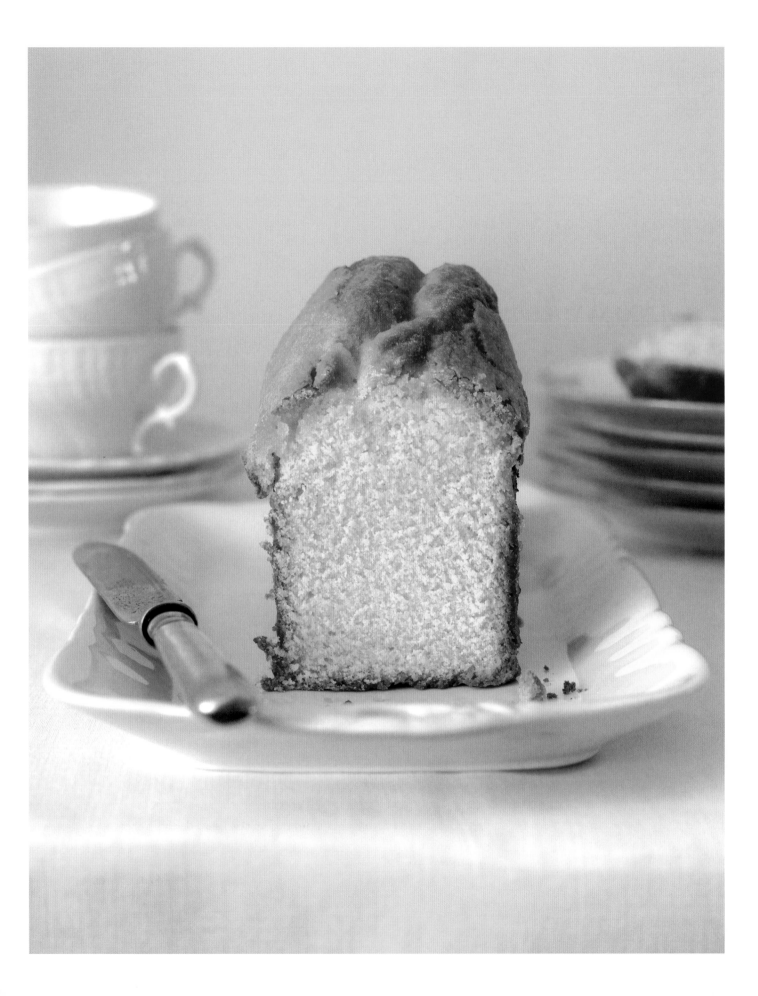

125g soft butter
60g caster sugar, plus extra for sprinkling
125g plain flour
60g semolina
4tsp raspberry jam

MAKES FOUR

JAMMY DODGERS

These are shortbread biscuits sandwiched with jam. Don't be tempted to spread the jam too thickly because the biscuits won't hold together. Then again, don't skimp on it. High-sugar jams are too slippery, so use jam with a high fruit content and crush the pieces of fruit with a fork before spreading. For some reason Dodgers are always round, but there's nothing to stop you making them into fingers, or any other shape you fancy.

Johannes Vermeer,
1632–1675
A Young Woman seated
at a Virginal
(detail), about 1670–2

Until the mid-nineteenth century few people knew of Vermeer; now, his work is among the most sought-after in the world. There are about 35 known paintings by the artist; this is one of two in the National Gallery.

1 Cover a large baking sheet with non-stick baking parchment.
2 Beat the butter with the sugar in a bowl until fluffy and pale in colour. Stir in the flour and semolina until a smooth dough is formed. Turn out on to a floured surface and roll out the dough until it is about 5mm thick. Cut out eight discs with a 10cm fluted pastry cutter. Place four of the discs on the parchment paper.
3 Cut a hole in the middle of each of the remaining four discs using a 2cm fluted or plain cutter. Sprinkle them with caster sugar and add to the paper. Chill in the fridge for 20 minutes. Meanwhile, heat the oven to 180°C.
4 Bake the biscuits for 15 minutes or until pale golden. Remove from the oven and leave to firm up for a few minutes, then lift on to a wire rack to cool.
5 Put 1tsp jam in the middle of each plain biscuit and spread to within 1cm of the edge. Cover with the biscuits that have a hole in the centre, placing them sugared-side up.

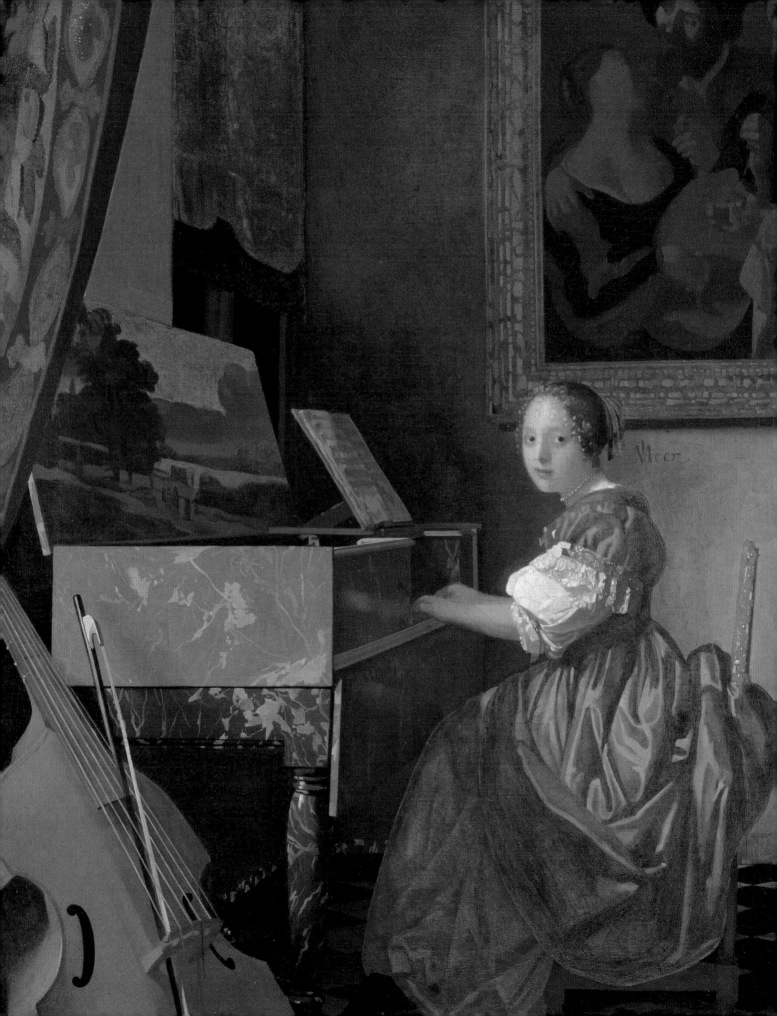

RHUBARB MARTINI

5 small pieces of young
 rhubarb
5 blueberries
40ml vodka
Dash of dry vermouth
Ice cubes

Crush the fruits with a pestle or the end of a rolling pin and put into a shaker with the vodka and vermouth. Add ice and shake well, then strain into a Martini glass.

MAKES ONE

MERRY

20ml crème de cassis
 de Bourgogne
50ml dry gin
Ice cubes
Dash of soda water

Put the cassis and gin in a shaker. Add ice and shake well, then strain over ice in a rocks glass (squat whisky tumbler) and top up with soda water.

MAKES ONE

EARLY RED ROSE

5 fresh rose petals
5 fresh mint leaves
Ice cubes
Sparkling water

Using a spoon, gently mix the rose petals with the mint in the bottom of a highball glass. Add ice and top up with sparkling water.

MAKES ONE

PINK LADY

Dash of grenadine syrup
1tsp caster sugar
30ml Havana Club rum
20ml Cointreau
Ice cubes
Dash of soda water

Put the grenadine, sugar, rum and Cointreau into a shaker. Add ice and shake well, then strain over ice, serve in a Martini or rocks glass (squat whisky tumbler) and top up with soda water. Garnish with raspberries.

Clockwise from the top:
Rhubarb martini, Merry,
Early red rose, Pink lady.

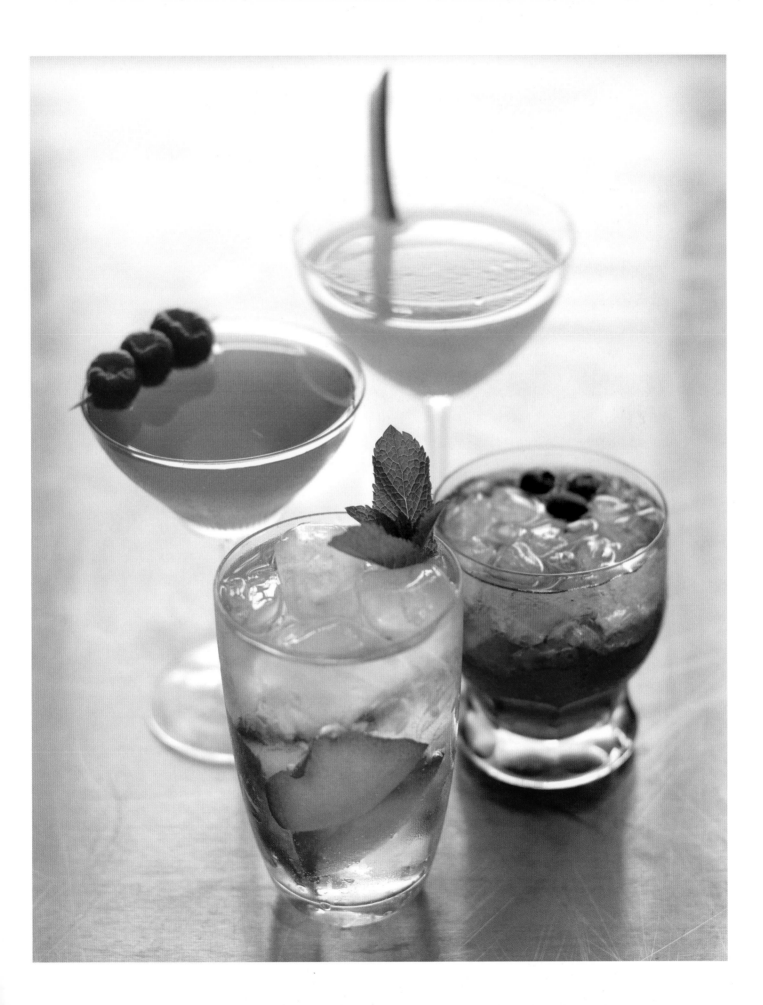

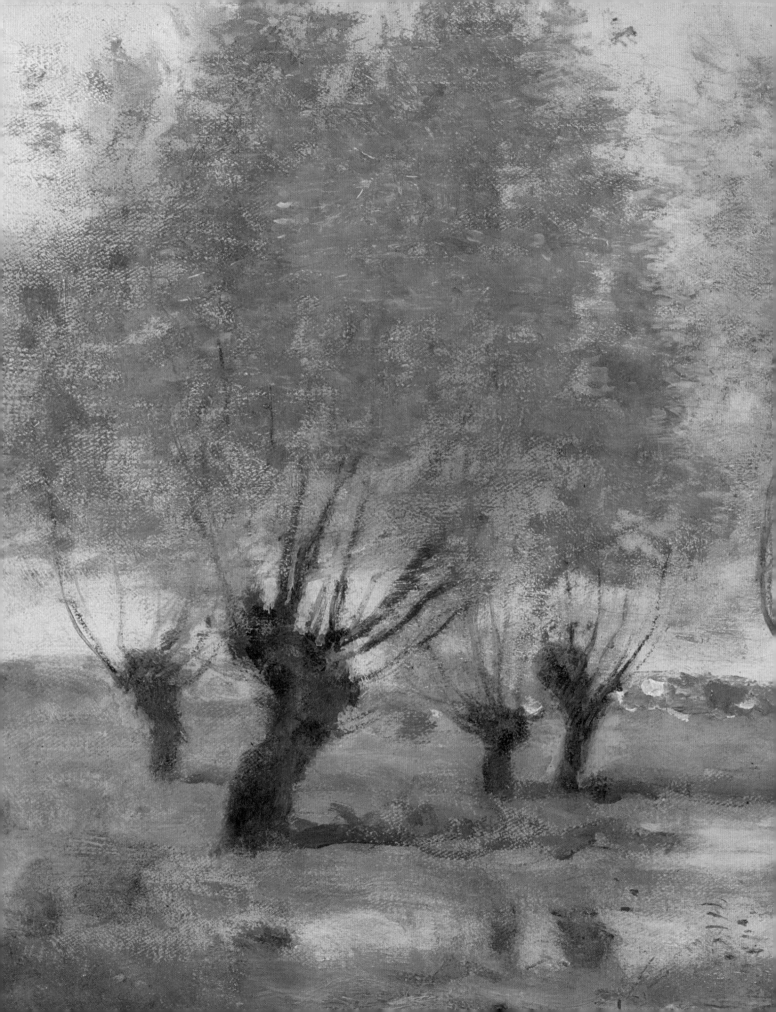

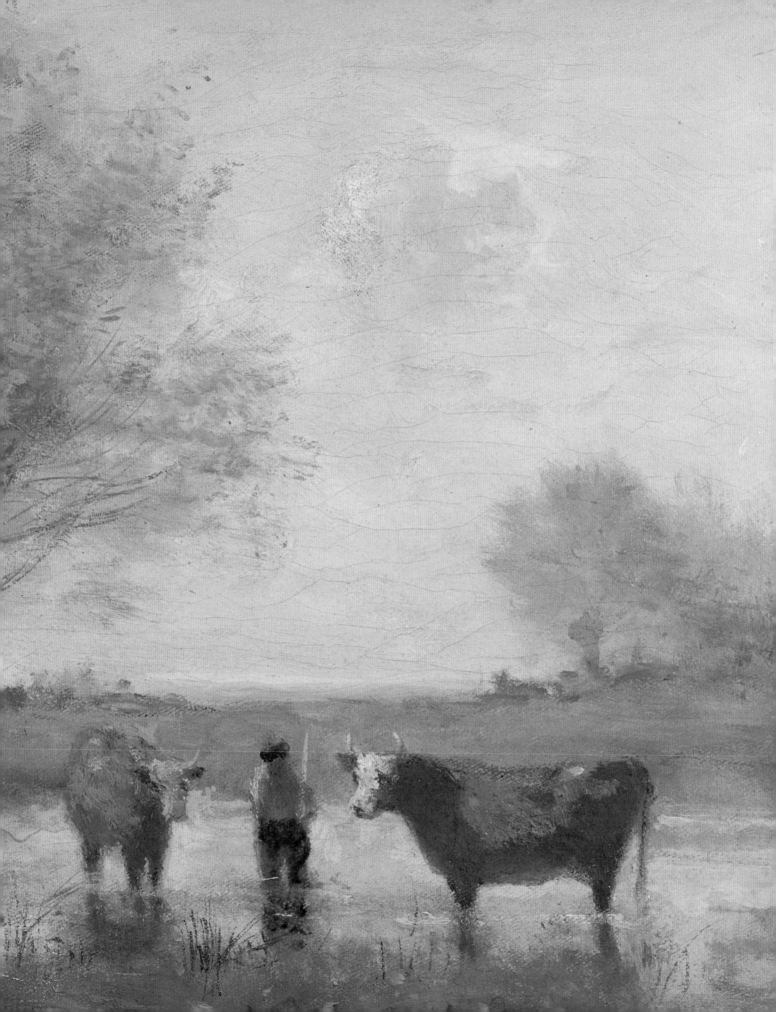

SPRING
SUMMER
AUTUMN
WINTER

Jean-Baptiste-Camille Corot, 1796–1875
Cows in a Marshy Landscape (detail),
probably 1860–70

The location of this scene has not been
identified, and it was probably painted in
the studio. The pastoral subject was a favourite
of Corot's, and he returned to it time and again
in his later years. The silvery tones of the trees
on the left are typical of his late style.

One of the joys of holidaying in Britain over the summer is that we can, if only briefly, recall the summers of our childhood. The absence of school helped, but – through a child's eyes – summers always seemed full of sunshine and endless enjoyment.

From the colours of our fairs and fêtes, through the traditions of Ascot and Henley, to the impressive roster of music festivals, it is during summer that Britain, and the British, are at their best. So why go away?

Heading for the British coast and countryside is the perfect opportunity to enjoy the bounty of summer food. By June, cherries and strawberries are there for the picking, lamb is still excellent, and crab, bream and sea bass are freshly caught and sold at the water's edge.

During the summer, no one should be rushed, least of all the cook. Salads of all kinds take little time, but offer huge rewards in both taste and texture, while a savoury flan is perfect for a relaxing picnic.

And then there are the season's puddings, cakes and bakes – for many of us the crowning glory of British food. An Eton Mess enjoyed on a warm July evening, Summer Pudding eaten in an English country garden, and Devon scones with jam and clotted cream for a proper cricket tea – none of these can be surpassed.

75g blanched hazelnuts
4tbsp hazelnut oil
350g young asparagus
1 curly endive (pale inner leaves only)
10g fresh dill leaves
10g fresh tarragon leaves
2tbsp rapeseed oil
1tbsp lemon juice
1tbsp cider vinegar
125g fresh goat's curd or soft goat's cheese

SERVES FOUR

FRESH GOAT'S CURD SALAD WITH ASPARAGUS AND HAZELNUTS

Goat's curd is healthy and low in fat, but this doesn't mean it won't taste good. For this salad buy British goat's curd, which is mild and creamy, as some imported curds could be too strong for the asparagus. British goat's curd accepts other flavours really well, and the piquant dressing marries everything together beautifully in this recipe. For a change from curly endive you could use lamb's lettuce instead, and toss some fresh peas in with the leaves.

Titian, active about 1506–1576
Bacchus and Ariadne (detail), 1520–3

In this mythological story Bacchus, the god of wine, fell in love with Ariadne, who had been abandoned on the Greek island of Naxos by Theseus. Bacchus raised Ariadne to heaven and turned her into a constellation, represented by the stars.

1 Combine the hazelnuts and hazelnut oil in a small pan and cook over a medium heat for about 4 minutes or until the nuts start to turn golden. Immediately transfer to a bowl to stop the cooking. Put the nuts in a food processor with ½tsp salt and pulse until they are chunky.

2 Cut off any woody ends from the asparagus, then shave the spears into very thin, long ribbons using a mandolin, potato peeler or very sharp knife. Plunge the ribbons into a saucepan of salted boiling water. Bring back to the boil and simmer for 1½ minutes. Drain and immediately plunge into a bowl of iced water to stop the cooking, then drain again and pat dry.

3 Wash and dry the endive and mix with the herb leaves.

4 Make the dressing by combining the rapeseed oil with the lemon juice, vinegar and seasoning to taste.

5 To serve, mix the asparagus ribbons with the endive and half of the hazelnuts, then toss gently to coat with the dressing. Transfer to a serving bowl. Crumble the goat's curd on top and scatter the remaining hazelnuts over and around.

1 large firm head of chicory
2 bunches of watercress
Finely grated zest and juice of 1 pink grapefruit
2tbsp rapeseed oil
1 small red onion, finely sliced
2 pink grapefruit, peel and white pith removed,
 then segmented
300–350g shelled cooked crayfish tails
1 bunch of fresh chives, finely sliced

SERVES FOUR

CRAYFISH WITH A WATERCRESS, CHICORY AND GRAPEFRUIT SALAD

Crayfish are miniature freshwater lobsters that are fiddly to prepare, so you should buy them ready cooked and shelled. Only the tail meat is eaten, which is flavoursome and succulent. Always buy them from a good fishmonger to be sure they're very fresh. If you can't get them for this recipe you can use large prawns instead – they're about the same size.

1 Slice the chicory lengthways, as finely as possible. Pick over the watercress and trim off any thick stalks, then rinse and pat dry.
2 Make a dressing with the grapefruit zest and juice, the oil and seasoning to taste.
3 Toss the chicory with the watercress, onion and grapefruit segments. Drizzle with the dressing, and transfer to a serving bowl. Arrange the crayfish on top and garnish with the chives.

150ml perry (pear cider)
2tsp Worcestershire sauce
1tsp smooth mild mustard
4 slices of bloomer or other white bread
2tbsp white sauce (page 253) or double cream
3tbsp apple sauce (from a jar), pushed through a fine sieve
100g white crab meat
50g brown crab meat, pushed through a fine sieve
1 egg yolk

SERVES FOUR

CRAB ON TOAST

Buying a whole crab and removing the meat yourself is a time-consuming job, so don't feel guilty about buying it ready-prepared from the fishmonger. As long as you check it's freshly caught and not pasteurised, you can't go wrong. Mixing the white and brown meat is all about balancing flavours and textures, and you can add more or less of each according to personal preference. Brown meat may not be your favourite part, but here you should include some to accentuate the flavour of the crab, because white meat on its own can be rather bland.

1 Simmer the perry in a small pan with the Worcestershire sauce and mustard for about 10 minutes or until reduced and thickened.
2 Meanwhile, preheat the grill to hot and toast the slices of bread on both sides.
3 Remove the perry reduction from the heat, add the white sauce and stir to combine. Add the apple sauce and the white and brown crab meat. Mix well. Season to taste and beat in the egg yolk.
4 Spoon the crab mixture on the toast and flash under the grill for a few minutes until bubbling. Serve hot.

500g fresh young peas in their pods
2 onions, finely chopped
2 leeks (white parts only), sliced into 2.5cm pieces
5 garlic cloves, roughly chopped
2tbsp sunflower oil
60g butter
1 litre vegetable stock
100g Somerset brie, diced small

SERVES FOUR

FRESH GREEN PEA SOUP WITH SOMERSET BRIE

Somerset brie is one of Britain's best cheeses. It has a good, strong flavour that sets it apart from the many puny bries you find in the supermarket, but it is not overpowering. The character of this soup depends on it, so don't compromise by using anything else.

1 Pod the peas, then wash the pods and set aside. Sweat the onions, leeks and garlic in the oil and half the butter in a covered pan over a low heat for 10–15 minutes. At the end of this time the vegetables should be soft and translucent, but not coloured. Add the pea pods and stock and bring to the boil, then reduce the heat and simmer, uncovered, for 35 minutes. Strain and leave to cool.

2 Plunge the peas into a pan of salted boiling water. Bring back to the boil and simmer for a few minutes or until tender. Drain the peas. Set a few spoonfuls aside for the garnish. Tip the rest immediately into a blender and add the remaining butter. Blend the peas while they are still hot, keeping the machine running until you get a really smooth purée. Pour the purée into a bowl and cool by setting over another bowl filled with ice cubes.

3 To serve, decant the purée into a clean pan and gradually whisk in the stock until it is all incorporated and the soup has a silky smooth consistency. Heat through and season to taste. Divide the brie among four warmed soup bowls, pour the hot soup over and dot with the reserved peas. Serve straightaway.

100g raisins

3tbsp sherry, warmed

300g long-grain white rice

100g fresh shelled or frozen peas

1 small red pepper, diced

1 bunch of spring onions, trimmed
and finely sliced

20g fresh flat-leaf parsley, leaves and
stalks finely chopped

20g fresh coriander, leaves and stalks
finely chopped

500g cooked white chicken meat,
shredded

50g toasted flaked almonds

FOR THE DRESSING

2tbsp mild curry powder

1tsp very finely chopped or grated
fresh root ginger

4tbsp mayonnaise

2tbsp natural yogurt

2tsp Worcestershire sauce

2tbsp apricot conserve

SERVES EIGHT

CORONATION CHICKEN SALAD

When this Anglo-Indian dish was created to celebrate the coronation in 1953, it had a thick curry dressing made with mayonnaise and cream. The modern version here uses yogurt in the dressing so it's lighter, and the addition of fresh herbs lends a whole new dimension. The salad is traditionally presented as a table centrepiece for garden parties and buffets, but it deserves to be made more often than this. It's a great way to use up leftover roast chicken and, because it keeps well in the fridge, it's also ideal for preparing ahead when you're entertaining.

Canaletto, 1697–1768
A Regatta on the Grand Canal
(detail), about 1740

This painting shows the annual carnival regatta in Venice. The white highlights on stockings, collars and gondolas are done in fluid, trailing threads of paint, rather like icing on a biscuit.

1 In a large bowl, soak the raisins in the warmed sherry for 1 hour. Meanwhile, cook the rice in plenty of lightly salted boiling water according to packet instructions until tender. Cook the peas in salted boiling water for 3–4 minutes until tender. Drain the rice and peas and leave to cool.

2 Add the rice and peas to the raisins together with the red pepper, spring onions, herbs and seasoning to taste.

3 Make the dressing. Dry-fry the curry powder in a non-stick frying pan over a medium heat for a few minutes, stirring, until fragrant. Stir in the ginger, then tip into a large bowl and combine with the other dressing ingredients.

4 To serve, add the chicken to the dressing and stir to coat. Spoon the rice on to a large platter and make a well in the middle. Fill the well with the dressed chicken and sprinkle the almonds on top.

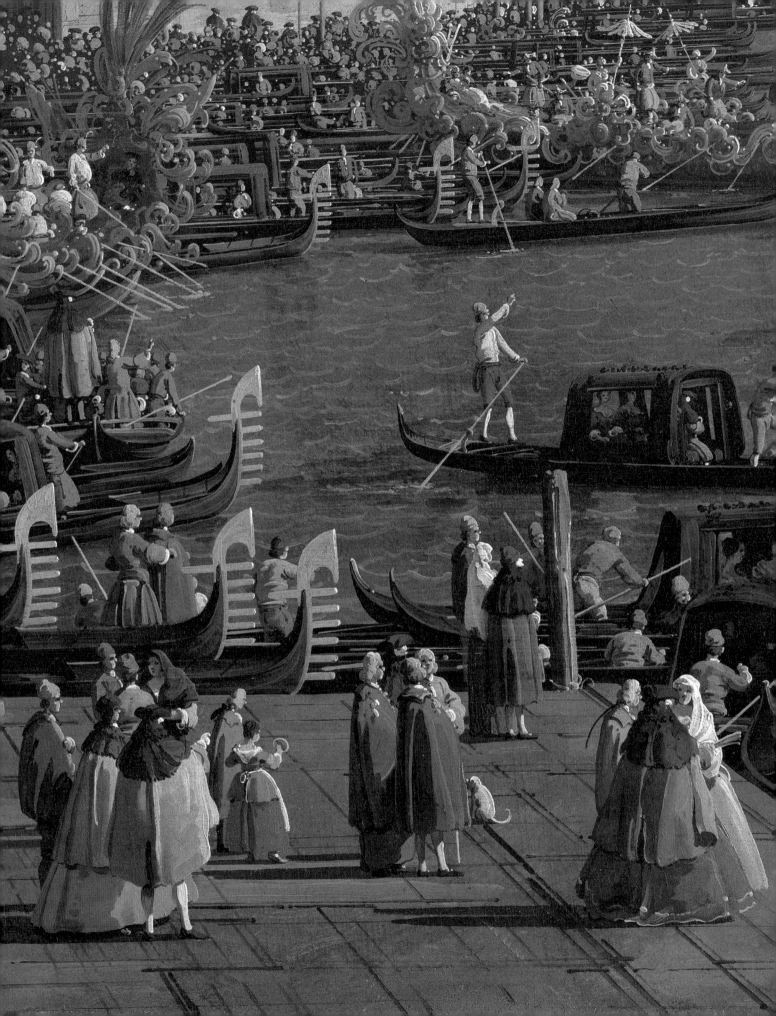

2 kippers
200g soft butter
2tsp clear whisky
1tsp Worcestershire sauce
Lemon juice
Tabasco
Cayenne pepper
Hot toasted bloomer or other white bread, to serve

SERVES FOUR

MANX KIPPER PÂTÉ

This heady pâté, with its oaky aroma and flavour, is named after the kippers that come from the Isle of Man. Manx kippers are smoked naturally without dyes, which makes them well worth looking for – you can get them at good fishmongers and specialist food stores. As a perfect complement to the kippers, try to find clear Manx spirit, a whisky that is re-distilled to extract its colour. Its taste is delicate and refined, and it's useful in cooking because it is clear.

1 Remove the skin and large bones from the kippers. Rub the fish into a bowl with your hands, pulling out the small bones as you come across them. Add the butter to the kipper flesh and beat well to mix, then add the whisky and Worcestershire sauce, plus lemon juice, Tabasco and cayenne to taste. Taste the pâté and only add salt if you think it is needed.

2 Spoon the pâté into a serving bowl, or into four individual pots if you prefer. Chill in the fridge until the butter sets, about 3 hours. Serve chilled, with hot toast.

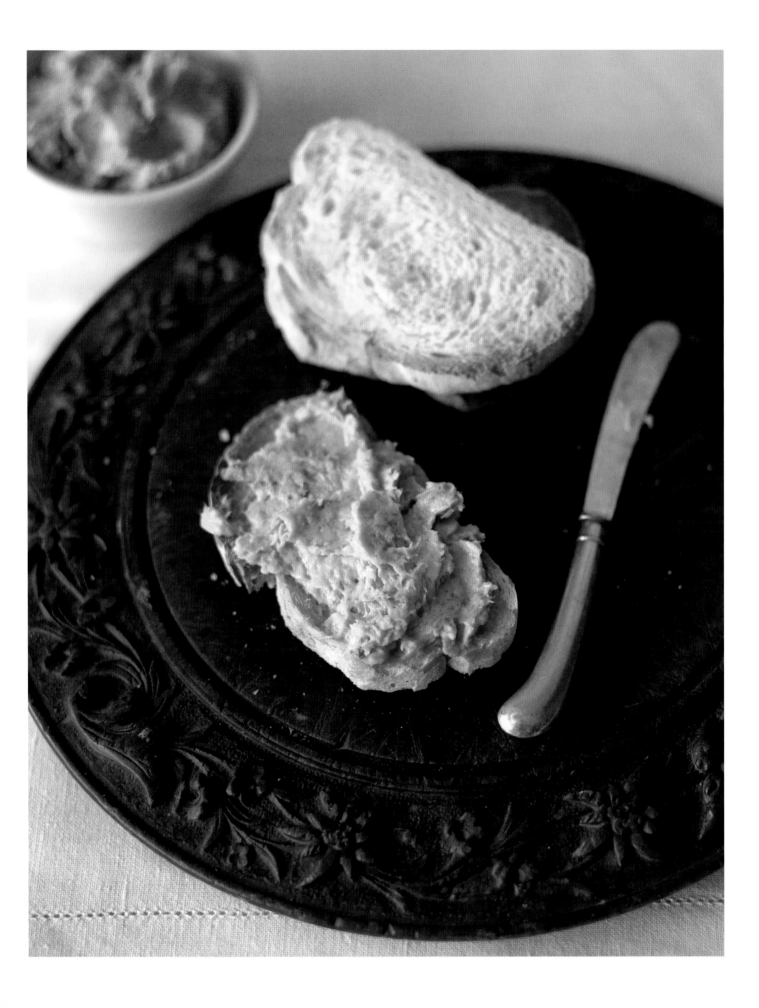

2 Baby Gem lettuces, finely shredded
500g peeled cooked prawns, drained well but not squeezed
Pinch of paprika

FOR THE MARIE ROSE SAUCE
250ml mayonnaise
1tbsp tomato ketchup
1tsp lemon juice
1tsp brandy
Dash each of Tabasco and Worcestershire sauces

SERVES FOUR

PRAWN COCKTAIL

This prawn cocktail is decidedly retro and un-posh – a classic that you should not try to improve on. The sauce is easily put together with affordable storecupboard ingredients and, as long as you use the plumpest and juiciest looking prawns you can find, you simply can't go wrong.

1 Whisk the sauce ingredients together until pink and smooth. Keep in a covered bowl in the fridge for up to 48 hours.
2 To serve, make a bed of shredded lettuce in the bottom of four glass dishes and pile the prawns in the centre. Top with generous spoonfuls of sauce and a light dusting of paprika.

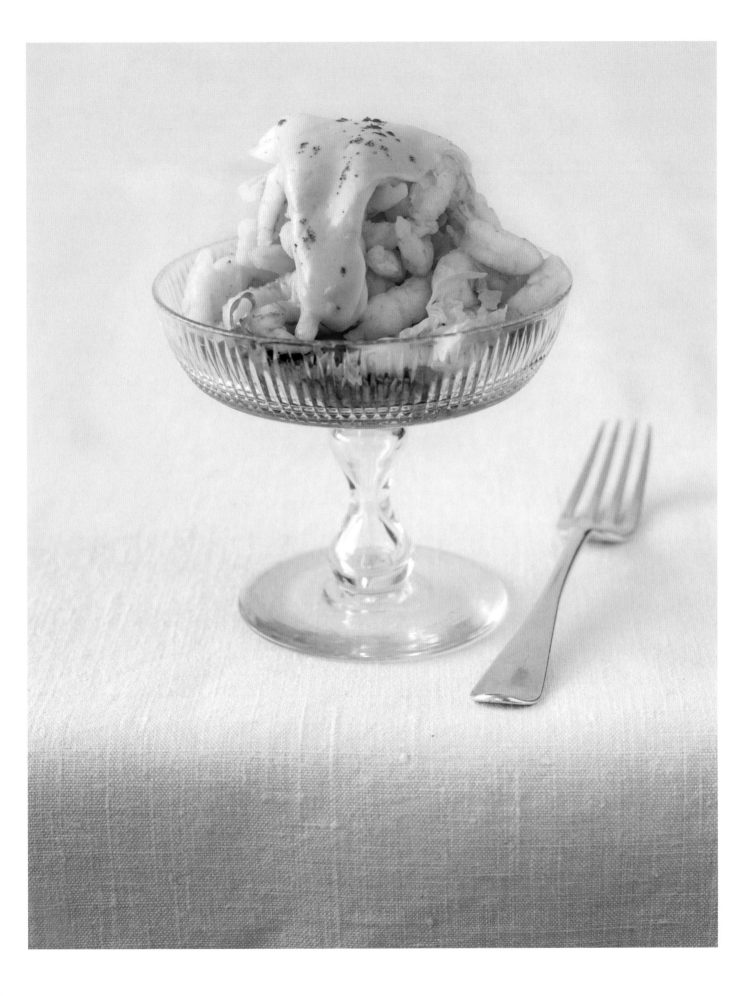

50g blanched hazelnuts

50g soft salted butter

50g grainy mustard

4 double fillets of lemon sole without
skin, taken from 2 whole lemon sole,
each fish weighing about 750g

Mild smooth mustard

Buttered runner beans, to serve

FOR THE DRESSING

100ml rapeseed oil

2tbsp lemon juice

2tsp chopped capers

2tsp finely chopped shallots

2tsp finely chopped fresh flat-leaf parsley

1tsp finely chopped fresh chervil

¼ bunch of fresh chives, cut 2cm long

SERVES FOUR

LEMON SOLE WITH A HAZELNUT AND MUSTARD CRUST

Dover sole, which is wildly expensive, is best when simply prepared, whereas lemon sole is cheaper so you needn't feel guilty about experimenting with it. It's a flexible fish to cook with in terms of flavour, and especially good with tangy ingredients like the mustard and capers used here. Take care not to overcook it, or you will spoil its delicate, melt-in-the-mouth texture.

1 Set the oven at 150°C. Toast the hazelnuts on a roasting tray in the oven for 15 minutes, shaking the tray occasionally to ensure even browning. Cool, then grind to a coarse powder in a food processor. Whisk the soft butter with an electric hand whisk until light in colour and fluffy. Fold in the hazelnuts and grainy mustard.

2 Hold each double fillet of sole flesh-side up, and fold the tail end under by about 3cm. Do the same with the head end so you have four square pieces of fish. Sprinkle with pepper. Brush a thin layer of smooth mustard over the fish, then spread the hazelnut crust on top using a table knife. Chill in the fridge for at least an hour until the crust has set hard.

3 Mix the dressing ingredients together with seasoning to taste.

4 When you are ready to cook, preheat the grill to hot and brush a non-stick baking tray with butter. Place the sole on the tray and put it on the middle shelf under the grill. Grill for 5–7 minutes until the crust is golden brown and the fish is cooked. If your grill is separate from the oven, grill the fish for 5–7 minutes, then finish the cooking in the oven preheated to 150°C; this should take 3–4 minutes, depending on the thickness of the fish.

5 Serve the fish with runner beans in the centre of four warmed plates, with the dressing spooned over and around.

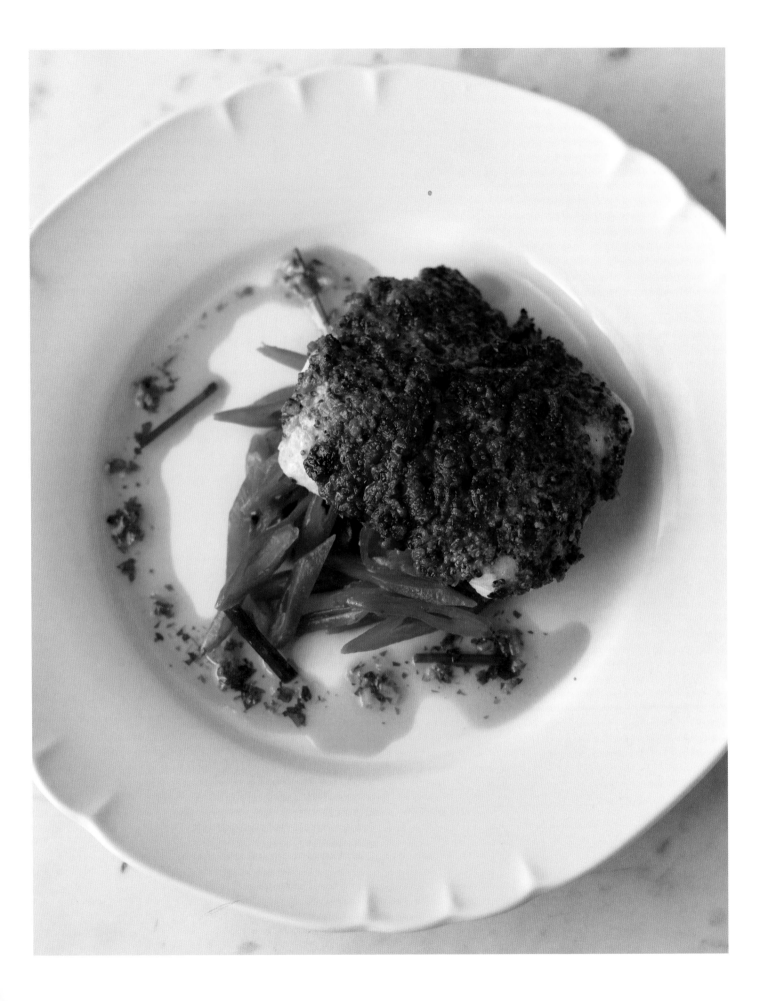

1 whole sea bass, weighing about 2kg,
 scaled and gutted
1 lemon, sliced
Fennel stalks (see below)
About 3.5kg coarse sea salt
4 lemon halves, to serve

FOR THE SALAD
12 baby fennel bulbs, halved lengthways
 (stalks removed and reserved for the fish)
50ml rapeseed oil
2 garlic cloves, finely chopped
6 canned anchovy fillets, drained and chopped

SERVES FOUR

SEA BASS BAKED IN SALT WITH A WARM FENNEL SALAD

There's no better way of cooking a large whole fish than smothering it in sea salt. It's taken a long time for this cooking method to arrive on our shores, but now that it's here, it's high time we adopted it. Future generations will thank us, because it couldn't be more simple and quick – and the fish always tastes like it has come straight from the sea.

1 Set the oven at 180°C. Wash and dry the fish, then put the lemon slices and fennel stalks inside it. Cover the bottom of a large baking dish with half the salt and lay the fish on the salt. Cover the fish completely with the remaining salt in a layer 1–2cm thick. Sprinkle a little water (about 1tbsp) evenly over the salt.

2 Bake the fish for 25–30 minutes until a skewer slides easily into the thickest part of the flesh.

3 Meanwhile, put the halved fennel bulbs in a saucepan of salted boiling water and simmer for about 10 minutes or until tender. Drain. Heat the oil in a frying pan over a low to medium heat, add the garlic and anchovies, and cook gently until the garlic has softened and the anchovies have begun to dissolve. Add the fennel and continue cooking for 2–3 minutes, stirring to coat it with the oil. Transfer to a warmed serving bowl.

4 Rest the fish for about 5 minutes after removing it from the oven, then crack open the salt crust and lift the fish out. Remove the skin and place the whole fish on a warmed serving plate with the lemon halves. Hand the salad separately.

2 red bream, weighing 500–600g each, scaled and gutted
4 lemon quarters, to serve

FOR THE HERBED OIL
15g fresh flat-leaf parsley
15g fresh coriander
10g fresh marjoram
1 sprig of fresh thyme or lemon thyme
1 small garlic clove, roughly chopped
100ml rapeseed oil
Finely grated zest of ½ lemon
¾tsp lemon juice

SERVES FOUR

BARBECUED RED BREAM

This recipe is all about the piquant dressing. With its fresh summery herbs, it goes well with strong-flavoured bream and just about any other small whole fish you care to name. And when the weather's not fit for barbecuing, simply drizzle it over grilled or pan-fried fish fillets – try it once and you'll do it again and again.

1 Make the herbed oil. Roughly chop the herbs (leaves and stalks together), then place in a food processor with the remaining ingredients and seasoning to taste. Blitz until finely chopped and evenly combined.

2 Wash the fish and pat dry with kitchen paper.

3 Prepare and light the barbecue. It is ready for cooking when the flames have died down and the coals are white.

4 Brush each fish generously inside and out with herbed oil. Place on the barbecue grid and cook for 6–8 minutes on each side until the fish feels tender when pierced with a skewer. During cooking, brush with herbed oil from time to time to keep the fish moist. Serve straightaway, with the lemon quarters.

2 John Dory, each weighing 750g–1kg, each cut into
 2 fillets and skinned
100g pea shoots or baby spinach leaves

FOR THE TOPPING
100g butter, diced
2tbsp finely sliced garlic
3tbsp finely shredded fresh root ginger
¼tsp crushed dried red chillies
50g fresh basil leaves, cut lengthways in half if large

SERVES FOUR

SIZZLING JOHN DORY

Delicate John Dory is best served slightly undercooked, and the recipe here gives a clever way of cooking it to perfection. Poaching the fish in the oven first cooks it gently from underneath, then the heat of the sizzling butter completes the cooking of the top.

1 Start by clarifying the butter for the topping. Heat it gently in a small pan until melted, then very slowly pour the clear butter into another small pan. Discard the sediment that is left behind.
2 Set the oven at 140°C.
3 Separate each fish fillet lengthways into three pieces. Place the pieces in a roasting tin, season and pour a little water around. Cover the tin, place in the oven and cook for 5 minutes.
4 Meanwhile, continue with the topping. Put the garlic in the pan with the clarified butter and place over a high heat to cook for a minute or two until the garlic turns golden. Add the ginger and keep the butter sizzling for a minute, then stir in the chillies and ½tsp salt. By now the mixture will smell really fragrant.
5 Put a handful of pea shoots in the centre of four plates, sprinkle lightly with salt and top with the fish. Add the basil to the sizzling butter mixture and wait until it just wilts, then spoon the contents of the pan over the fish. Serve straightaway.

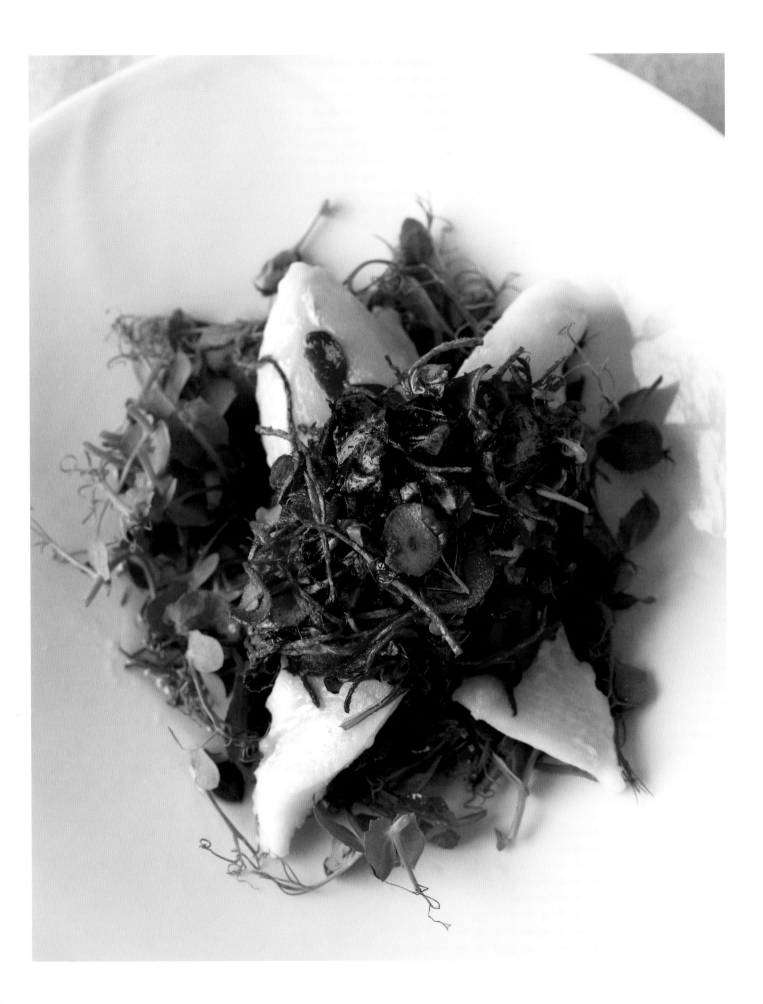

4 thick pieces of salmon fillet with skin,
 weighing about 225g each
1tsp caster sugar
200g marsh samphire
25g butter
Hollandaise sauce (page 254), to serve

FOR THE POACHING LIQUID
250ml dry white wine
1 carrot, diced
1 onion, diced
1 celery stick, diced
10 black peppercorns

SERVES FOUR

POACHED SALMON WITH SAMPHIRE AND HOLLANDAISE

Salmon has become one of the cornerstones of modern British cooking, both at home and in restaurants up and down the country. Only ever cook with the best-quality organic salmon – the one with the lean, pale flesh and delicate flavour. You might think that samphire would be too salty and strong to go with it, but opposites attract, and they're perfect for one another in terms of colour, texture and taste.

1 Make the poaching liquid. Pour the wine into a large, wide sauté pan or deep frying pan and add 750ml cold water, the vegetables and peppercorns. Bring the liquid slowly to the boil. Remove the vegetables and peppercorns with a slotted spoon and discard.
2 Adjust the heat under the pan so that the poaching liquid is barely simmering, then immerse the salmon, skin-side up, in the liquid. Poach gently until the flesh separates easily when tested with a fork. This will take 6–7 minutes, depending on the thickness of the salmon fillets.
3 While the fish is cooking, bring a large saucepan of water to the boil. Add the sugar and drop in the samphire. Stir well and bring back to the boil. Simmer for about 2 minutes or until it is tender to the bite. Drain the samphire thoroughly and tip into a bowl, then toss with the butter and pepper to taste. Keep hot.
4 Lift the fish out of the poaching liquid and remove the skin. Divide the samphire among four warmed plates, place the fish on top and coat with the Hollandaise sauce. For a glazed effect, flash the sauce with a blow torch.

4 brill fillets, weighing 175–200g each
1tsp plain flour
1tbsp vegetable oil
25g butter
1 shallot, finely chopped
150ml dry white wine
100ml fish stock

FOR THE BEANS
500g fresh shelled or frozen broad beans
10g unsalted butter
1 small shallot, chopped
50ml whipping or double cream
1tsp chopped fresh chives
1tsp chopped fresh chervil
1tsp chopped fresh flat-leaf parsley

SERVES FOUR

BRILL WITH BROAD BEAN CRUSH

Double cooking fish fillets – pan frying one side and then oven poaching the other – is an easy chef's technique that suits brill well. Its delicate flavour and soft flesh deserve this kid-glove treatment, and it's a method that can be used for other similar flat fish such as plaice, sole and turbot.

1 First prepare the beans. Plunge them into a saucepan of salted boiling water and simmer for 3–4 minutes until tender. Drain and immediately plunge the beans into a bowl of iced water to stop the cooking. Drain again, then peel off the skins with your fingers. Heat the butter in the saucepan, add the shallot and cook over a low heat for a few minutes until softened but not coloured. Add the beans and stir to mix with the shallot, then remove from the heat and crush with a fork. Set aside.

2 Set the oven at 160°C. Coat the skin side of the fish in the flour and shake off the excess. Heat the oil in a large ovenproof frying pan until hot, then add the butter and melt until foaming. Put the fish, skin-side down, in the pan and cook over a medium to high heat for 2–3 minutes until the skin is golden brown. Remove the fish and set aside.

3 Add the shallot, wine and stock to the frying pan and bring to the boil. Return the fish, skin-side up, to the pan, then transfer the pan to the oven. Poach the fish for 5–6 minutes until the flesh flakes easily when tested with a fork. Remove the fish to a heatproof dish, cover and keep warm in the oven turned down to 100°C.

4 Strain the cooking liquid into a saucepan and boil rapidly until reduced to about 100ml, then add to the beans with the cream. Toss over a high heat for about 2 minutes or until the beans are hot, then add the herbs and seasoning to taste. Serve the beans hot, topped with the fish.

200ml milk
2 garlic cloves, very finely sliced
 (use a mandolin if you have one)
Finely grated zest of 1 lemon
Juice of ½ lemon
50g soft butter

1tbsp finely shredded fresh flat-leaf
 parsley leaves
1 chicken, weighing about 1.5kg
Vegetable oil, for brushing
100ml Madeira or sherry
200ml chicken stock

SERVES FOUR

ROAST CHICKEN WITH GARLIC AND LEMON

This all-time favourite is good in any season, but there's something particularly summery about the aroma of chicken roasting with butter, garlic and lemon, and it's equally delicious served cold or hot. Organic chickens with creamy-white meat have the most flavour because they've been reared on a varied diet, so check the colour when buying and don't settle for anything less than the best.

Vincent van Gogh, 1853–1890
Sunflowers (detail), 1888

There are several versions of *Sunflowers*. Van Gogh painted this one for his friend Gauguin's room in the so-called Yellow House in Arles. The dying flowers are built up with thick, buttery, textured yellow paint. Vincent wrote to his brother Theo in August 1888, 'I am hard at it, painting with the enthusiasm of a Marseillais eating bouillabaisse … '.

1 Put 100ml of the milk in a saucepan with 100ml water and the garlic and bring slowly to the boil. Drain and rinse the garlic in a sieve under cold running water. Repeat with the remaining milk and an equal amount of water.

2 Beat the lemon zest and juice into the butter in a bowl, then gently fold in the garlic and parsley.

3 Remove any ties and string from the chicken, then twist and pull out the wishbone. Lift up the skin where the wishbone came from, then gently separate the skin from the flesh on the breast, taking care not to break the skin. Spread the butter over the breast with your fingers (or pipe in the butter using a small freezer bag with one of the corners cut off), then smooth the skin evenly over the butter. Put the chicken in a heavy roasting tin and chill in the fridge for 1 hour or until the butter is hard.

4 Set the oven at 190°C. Lightly brush the chicken with oil and sprinkle with salt and pepper. Roast for about 50 minutes or until the juices run clear when the thickest part of a thigh is pierced with a fork. Transfer the chicken to a board and cover with foil, then leave to stand for about 15 minutes while making the gravy.

5 Put the roasting tin on top of the stove over a medium heat, pour in the Madeira and boil until reduced by half, scraping to release the residue from the bottom of the tin. Add the stock and boil to reduce by half again, then strain and add seasoning to taste.

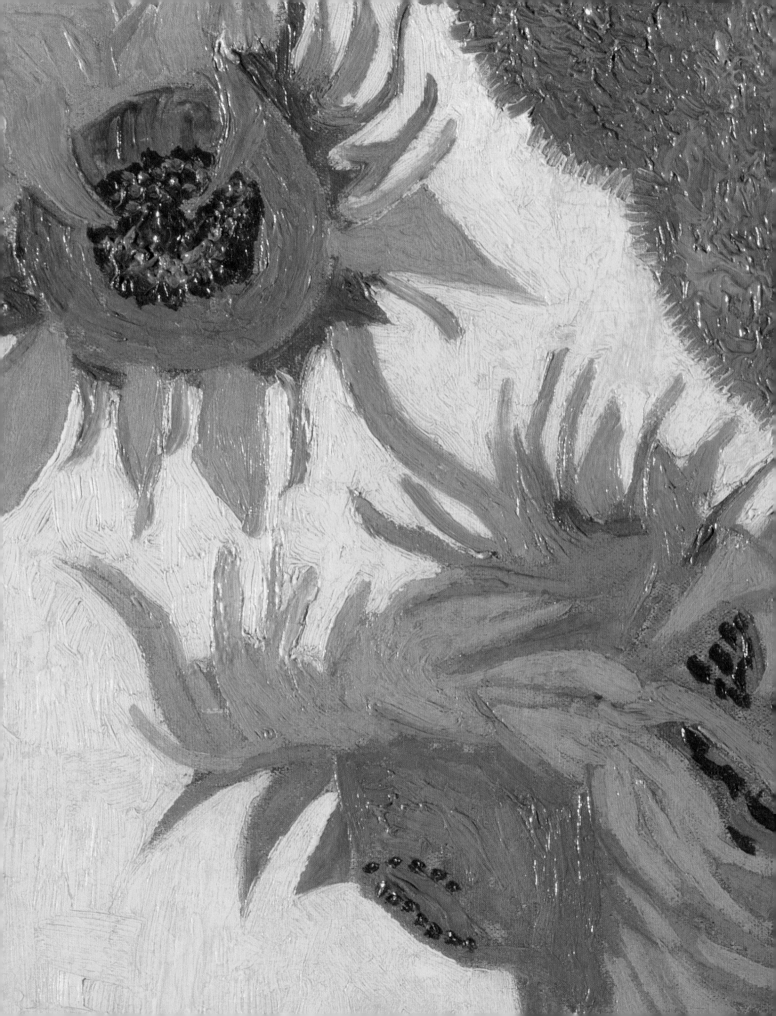

4 pork loin chops, weighing
 about 200g each
Vegetable oil, for brushing

FOR THE CRUSH

800g new potatoes, washed
 or scrubbed clean
6 spring onions, chopped
2tbsp rapeseed oil
Lemon juice, to taste

FOR THE DRESSING

20g fresh flat-leaf parsley, leaves
 finely chopped
10g fresh basil leaves, finely chopped
10g fresh mint leaves, chopped
1 spring onion, chopped
150ml rapeseed oil
Juice of 1 lemon

SERVES FOUR

GRIDDLED PORK CHOPS WITH POTATO AND SPRING ONION CRUSH

Nowadays pork can be a little tricky to cook because it's so lean, but there are things you can do that will help. Firstly, buy pork from a good butcher who can tell you the provenance of the meat. A traditional rare breed such as Gloucester Old Spot is one of the best, because it has a fair amount of fat that makes it succulent and full of flavour. Secondly, don't make the mistake of overcooking, as this will make the meat dry and tough. Brown the fat on the outside first, so it renders into the pan, then cook the pork quickly. This recipe does just that, and produces an excellent result.

1 Make the dressing. Whisk all the ingredients to combine, adding seasoning to taste.

2 Put the potatoes for the crush into a saucepan of salted cold water. Cover and bring to the boil, then simmer for 15–20 minutes until tender. Drain well and leave until cool enough to handle, then peel. Return the potatoes to the pan and crush lightly. Add the spring onions and oil, and season to taste with lemon juice, salt and pepper. Set aside.

3 For the chops, heat a ridged chargrill pan over a medium to high heat until very hot. Brush the chops with oil and season them, then hold them one at a time fat-side down in the hot pan until the fat is brown. Now lay all the chops flat in the pan and griddle them, without moving, for 6 minutes. Turn the chops over and repeat on the other side.

4 To serve, gently reheat the potatoes. Spoon on to four warmed plates, place the chops on top and drizzle over the dressing.

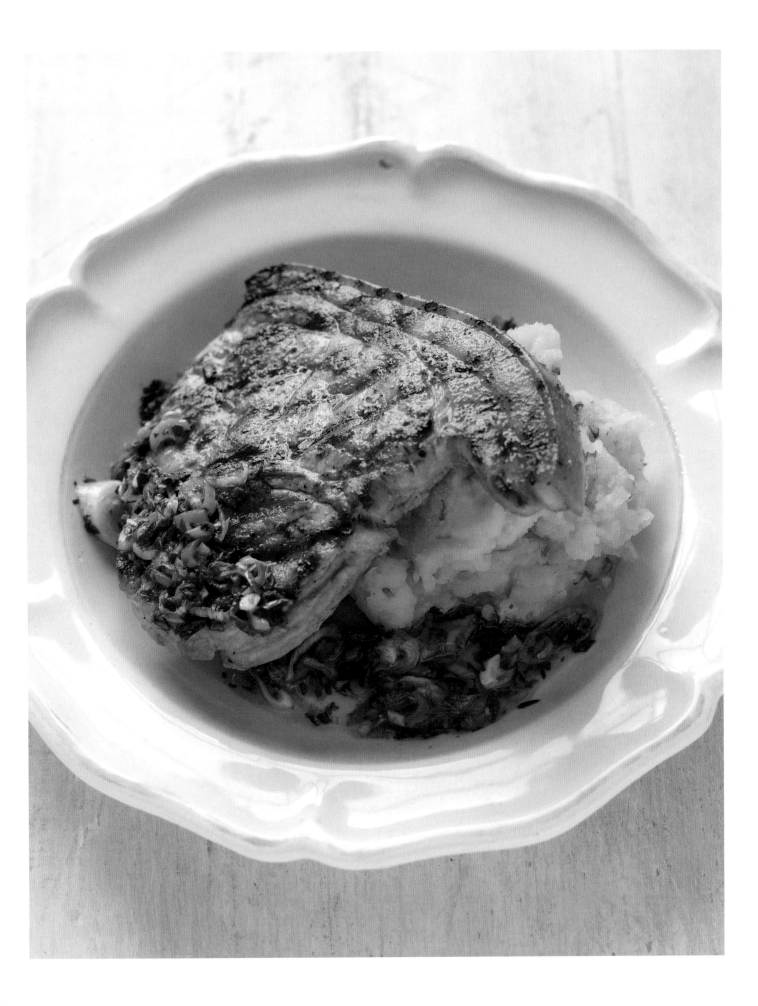

1 shoulder of lamb on the bone, weighing about 2kg,
 trimmed of excess fat
3 onions, sliced
3 shallots, sliced
2 celery sticks, roughly chopped
2 carrots, roughly chopped
3 garlic cloves, sliced
300ml red wine
200ml red wine vinegar
Radicchio and rocket leaves, to serve

FOR THE DRESSING
200ml rapeseed oil
4tbsp cherry or sherry vinegar
350g ripe cherries, pitted and quartered
20g fresh mint, stalks removed and leaves shredded

SERVES FOUR

SHREDDED LAMB SALAD WITH CHERRIES AND MINT

Served all year round as a hot roast joint, shoulder of lamb is rarely thought of as a salad ingredient, but using meat in a salad is a great way to enjoy it in the summer. At this time of year lamb has lots of flavour, which teams very well with fresh cherries and mint.

1 Set the oven at 120°C. Put the lamb in a large flameproof casserole or roasting tin with the vegetables, garlic, wine and vinegar. Pour in 500ml cold water. Cover with the lid or a large sheet of foil and bring to a simmer on top of the stove. Transfer to the oven and braise for about 4 hours or until the meat is so tender that it is falling off the bone.

2 Remove from the oven and leave the lamb in the liquid until cool enough to handle, then lift out and set aside in a warm place.

3 Skim off the fat from the cooking liquid (or use a bulb baster to remove the fat), then measure 500ml of the fat-free liquid into a pan. Boil until reduced to about 4tbsp. Mix with the oil and vinegar for the dressing.

4 Remove the lamb from the bone and shred the meat, removing as much fat as possible. Fold the cherries and mint into the dressing and mix with the meat, then gently toss in some radicchio and rocket leaves. Serve at room temperature.

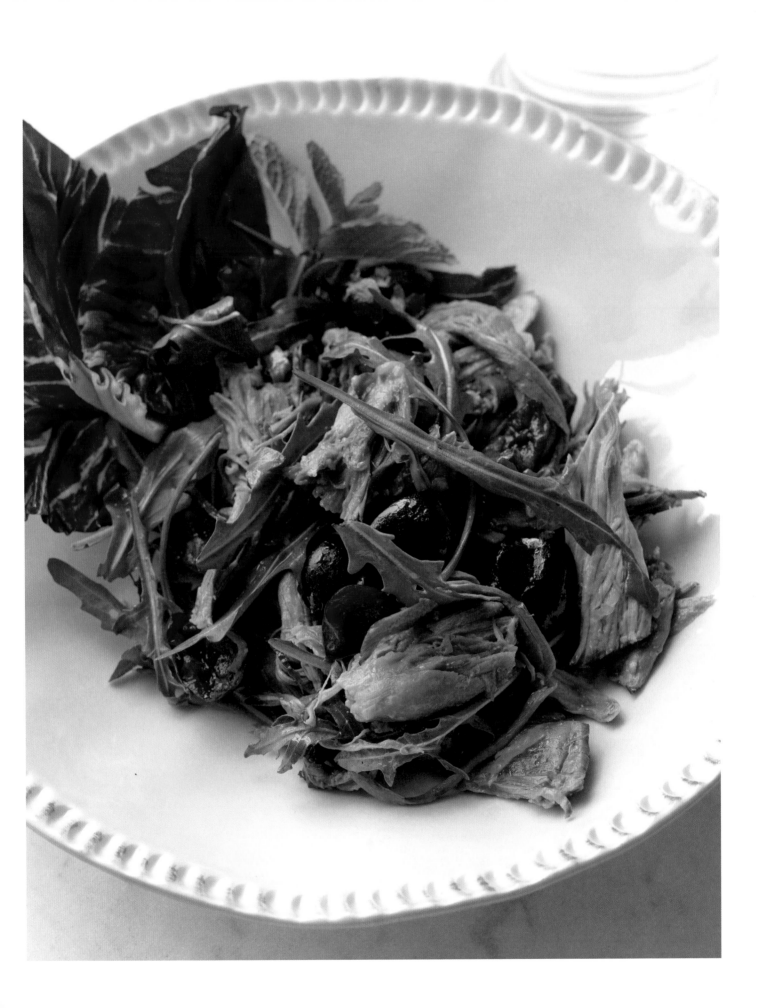

FOR THE POTATOES
600g new potatoes, preferably Jersey
 Royals, scrubbed clean
2tbsp vegetable oil
2tsp black mustard seeds
1tsp turmeric
½tsp crushed dried red chillies
4–5 fresh curry leaves, bruised
Lemon juice

12 lamb loin chops, weighing about
 115g each
Vegetable oil, for brushing
1tsp cumin seeds, toasted and crushed

SERVES FOUR

LAMB T-BONES WITH CUMIN AND CURRY LEAF POTATOES

Nowadays we're spoilt for choice with different breeds of lamb, and Welsh salt marsh lamb is one of the best at this time of year. In this dish its deep-red colour and distinctive flavour stand up well to the Indian spices that have become such an integral part of British cooking – what better way to use them than with home-produced meat and potatoes?

Aelbert Cuyp, 1620–1691
River Landscape with Horseman and Peasants (detail), about 1658–60

One of the greatest seventeenth-century Dutch landscapes, this is the largest surviving landscape by Cuyp, and perhaps the most beautiful. The entire scene is bathed in a gentle sunlight, harmonising all the elements, natural, animal and human. The quality of the light is Italianate, although Cuyp never travelled to Italy, and he must have acquired this interest from Dutch contemporaries who did.

1 Cook the potatoes in a saucepan of salted boiling water for about 10 minutes or until just tender. Drain and cool, then peel the potatoes and slice thickly.

2 Set the oven at 220°C, and brush a roasting tray with oil.

3 Heat the oil in a large frying pan with the mustard seeds and turmeric until hot. Add the potatoes, chillies and curry leaves and season with salt, then fry over a medium heat for 15–20 minutes until the potatoes are tinged golden brown, turning them over once or twice.

4 Meanwhile, brush the chops with oil, and sprinkle each side with salt and pepper and the crushed cumin seeds. Place on the hot roasting tray and roast for 10 minutes (or 15 minutes if you prefer well-done lamb), turning the chops over halfway.

5 Let the meat rest out of the oven for 5 minutes. Before serving, add a good sprinkling of lemon juice to the potatoes.

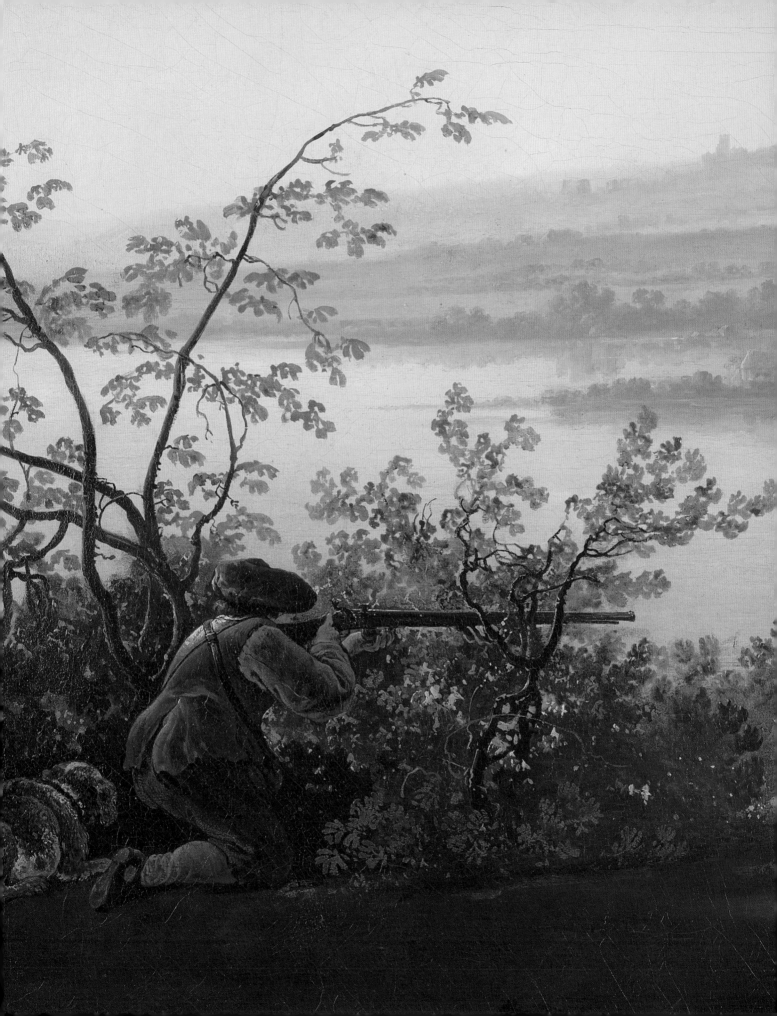

2kg joint of boned and rolled smoked
 gammon, with skin
25g fresh lavender
1 litre dry cider

FOR THE GLAZE
3tbsp lavender or wildflower honey
3tbsp smooth mild mustard
100ml dry cider
Handful of cloves

SERVES EIGHT

LAVENDER HAM

Cooking ham with lavender and cider gives it a quaint English flavour, and the tanginess offsets the richness of the meat. A whole ham is comfort food that wouldn't be right without the studding of cloves – it's what we've come to expect when we see a large joint of ham, whatever the time of year or occasion. The criss-cross pattern is the way it should look, but don't overdo it. Too many cloves would be gilding the lily.

1 Place the gammon and lavender in a large saucepan. Pour in the cider and enough cold water to cover the gammon (about 1 litre water). Put the lid on the pan and bring to the boil, then simmer for about 2½ hours or until the meat is tender when pierced with a skewer in the centre. Leave to cool in the liquid overnight.

2 The next day, set the oven at 220°C. Remove the ham from the liquid and strip off the skin, leaving the fat intact. Place the ham in a roasting tin and criss-cross the fat using a sharp knife.

3 Combine the honey, mustard and cider in a small pan and boil for about 10 minutes or until the glaze is thick enough to coat the back of a spoon. Spoon the glaze over the ham fat, then stud the fat lightly with cloves. Bake for about 20 minutes or until the glaze has caramelised all over. Serve hot or cold.

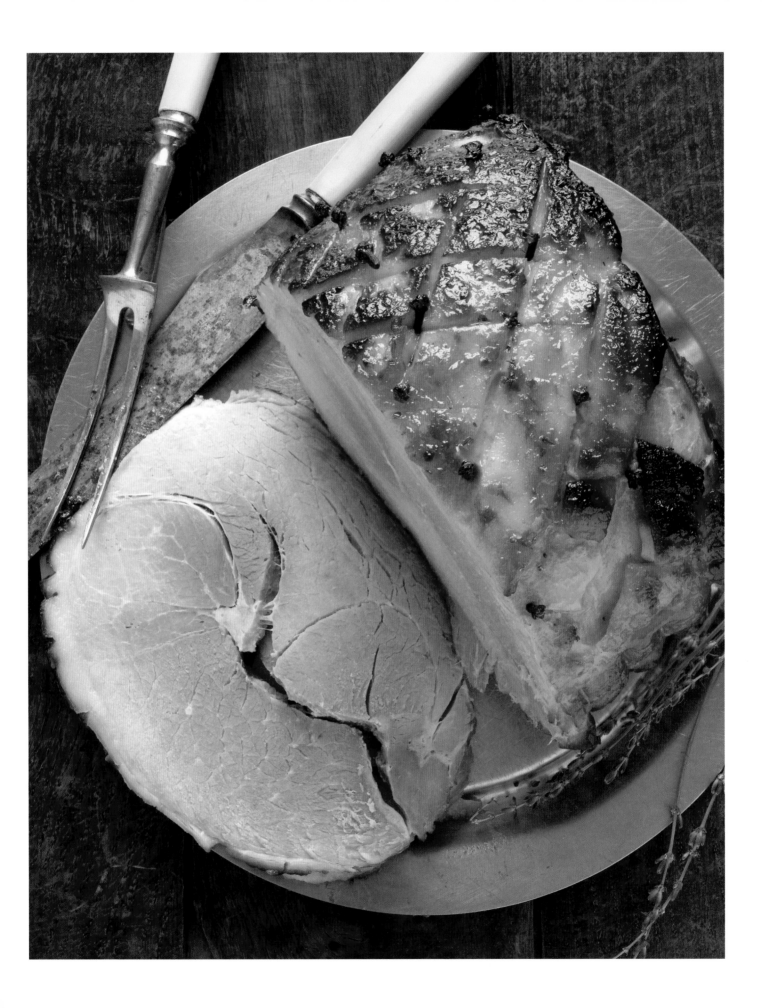

8 asparagus tips, including about one-third of the stalks
8 spring onions, trimmed
1 yellow or green courgette, cut into 8 wedges
1 red pepper, cut into 8 wedges
1 red onion, cut into 8 wedges
8 cherry tomatoes
Pinch of cayenne pepper
Knob of butter

FOR THE CHIVE OIL
1 bunch of fresh chives, roughly chopped
50ml rapeseed oil

SERVES FOUR

BARBECUED VEGETABLE SKEWERS

Everyone loves roasted vegetables, with their sweet and smoky flavour that comes from the natural sugars caramelising in the heat of the oven. You can get the same effect by cooking them on the barbecue in summer. It's the simplest of ideas, and vegetables are at their absolute freshest and best at this time of year.

1 Make the chive oil. In a small blender, blitz the chives with the oil and a pinch of salt. Pass through a fine-meshed sieve. Set aside.
2 Soak eight 20cm wooden skewers in a bowl of warm water for a couple of hours.
3 Plunge the asparagus into a saucepan of salted boiling water, bring back to the boil and boil for 30 seconds. Lift the asparagus out with a slotted spoon and plunge into a bowl of iced water. Drop the spring onions into the boiling water; lift them out as soon as it comes back to the boil. Do the same with the courgette, allowing 45 seconds, followed by the red pepper and red onion, allowing only 30 seconds each and immersing in iced water after blanching.
4 Drain the skewers and vegetables. Thread the blanched vegetables and tomatoes on to the skewers, folding the spring onions in half as you thread them on. Place the skewers on a tray.
5 Prepare and light the barbecue. It is ready for cooking when the flames have died down and the coals are white.
6 Bring 1tbsp water to the boil in a small saucepan with the cayenne and a pinch of salt. Remove from the heat and whisk in the butter. Brush over the vegetables. Place the skewers on the barbecue grid and cook for 7–8 minutes on each side, just until the vegetables are lightly charred. Serve hot or cold, with the chive oil.

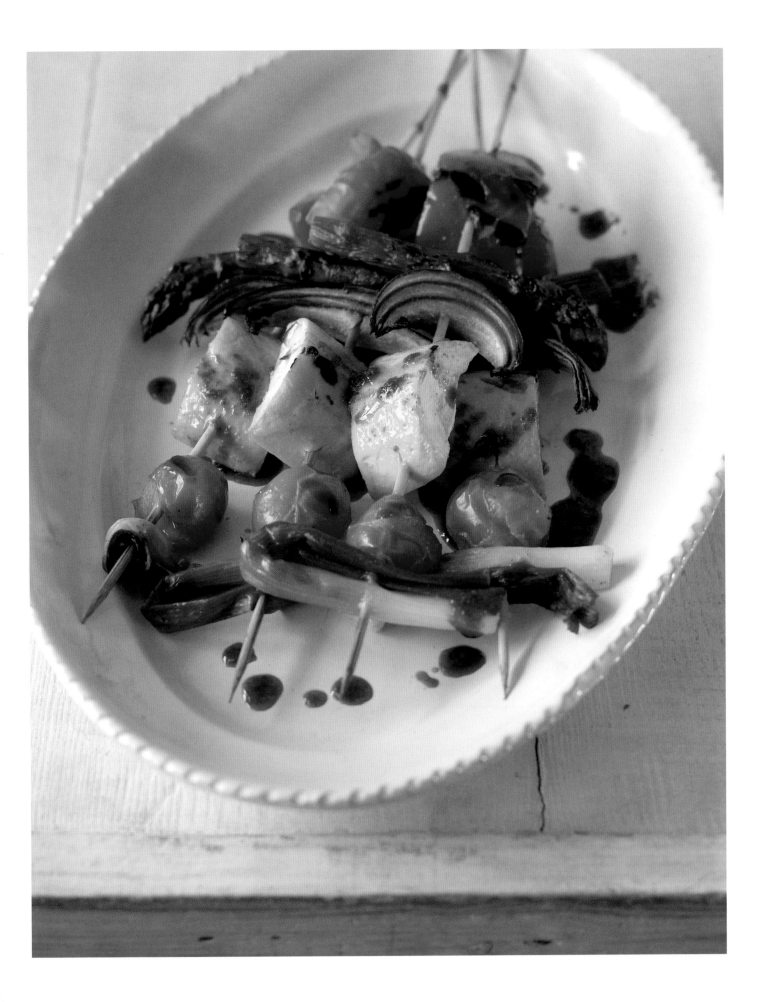

150g Swiss chard
Pinch of saffron threads
75g golden raisins
1 cauliflower, weighing about 1kg
3tbsp vegetable oil, plus extra for brushing
1 large onion, thinly sliced
4 heaped tbsp pine nuts, lightly toasted

SERVES TWO

CAULIFLOWER WITH SAFFRON AND SWISS CHARD

Saffron's exotic reputation as the most expensive spice in the world always seems to belie the fact that it gave its name to the town of Saffron Waldon in Essex, where it was grown for over 400 years. It is also associated with Cornwall, where it is used in saffron cake, an Easter speciality made with yeast and currants that is traditionally served with Cornish clotted cream.

Jan van Os, 1744–1808
Fruit and Flowers in a Terracotta Vase (detail), 1777–8

It wasn't unusual for a still-life artist to date a picture in two successive years. The artist waited for particular flowers to bloom and fruits to ripen in their different seasons before painting them all together.

1 Cut the green leaves off the chard and finely shred them. Set aside with the white stems. Soak the saffron in 4tbsp boiling water, and soak the raisins in 4tbsp warm water.

2 Separate the cauliflower into florets; trim off the long stalks and reserve the small leaves. Drop the florets into a pan of salted boiling water and bring back to the boil, then drain and refresh under cold running water. Drain well again.

3 Place a ridged chargrill pan over a medium to high heat until very hot. At the same time, heat 3tbsp oil in a saucepan over a low heat and cook the onion with a pinch of salt until soft. Take the saucepan off the heat and remove the onion with a slotted spoon.

4 Reheat the oil left in the saucepan and add the cauliflower florets together with the leaves from the cauliflower and chard. Fry until the florets begin to colour. Return the onion to the pan with the pine nuts. Strain in the saffron water. Drain the raisins and add them to the pan. Cook for about 5 minutes or until the water has evaporated, stirring frequently.

5 Meanwhile, brush the white chard stems with oil, place in the hot chargrill pan and griddle on all sides until tender.

6 To serve, cut the chard stems into triangles and divide between two warmed plates. Taste the cauliflower for seasoning, then pile on top of the chard. Serve straightaway.

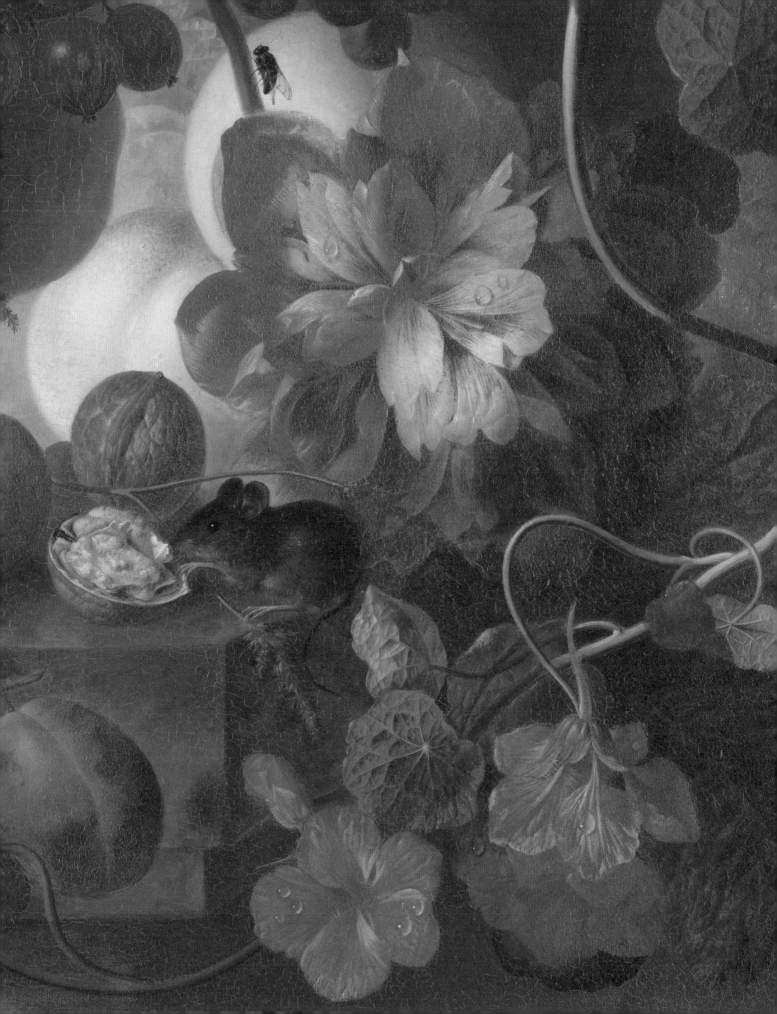

200g shelled fresh or frozen broad beans
¼ red onion, chopped
1tbsp chopped fresh chives
1tbsp rapeseed oil
Juice of ½ lemon
100g pea shoots or baby spinach leaves
Vegetable oil, for frying
4 duck eggs

SERVES FOUR

BROAD BEAN AND PEA SHOOT SALAD WITH FRIED DUCK EGGS

Big on colour and big on flavour, here's a salad that brings together two of Britain's best summer vegetables in one dish. Young broad beans fresh from the pod are sweet and tender. Combining them with pea shoots rather than the peas themselves provides a surprising contrast in texture. Duck eggs are a must because they taste like hen's eggs should, and the salad takes on a whole new dimension when drenched in their warm, runny yolks.

1 Plunge the beans into a saucepan of salted boiling water and simmer for 3–4 minutes until tender. Drain and immediately plunge the beans into a bowl of iced water to stop the cooking. Drain again, then peel off the skins with your fingers.

2 Mix the beans, onion and chives in a bowl. Drizzle over the oil and lemon juice, and add seasoning to taste. Toss with the pea shoots and divide among four plates.

3 Heat a large frying pan until hot. Pour in enough oil to lightly cover the bottom of the pan, and heat until warm. Crack the eggs into the oil and fry gently for 3–4 minutes until the whites are fully cooked, spooning the hot oil over the yolks from time to time.

4 Top each salad with a duck egg and sprinkle with sea salt and freshly milled pepper.

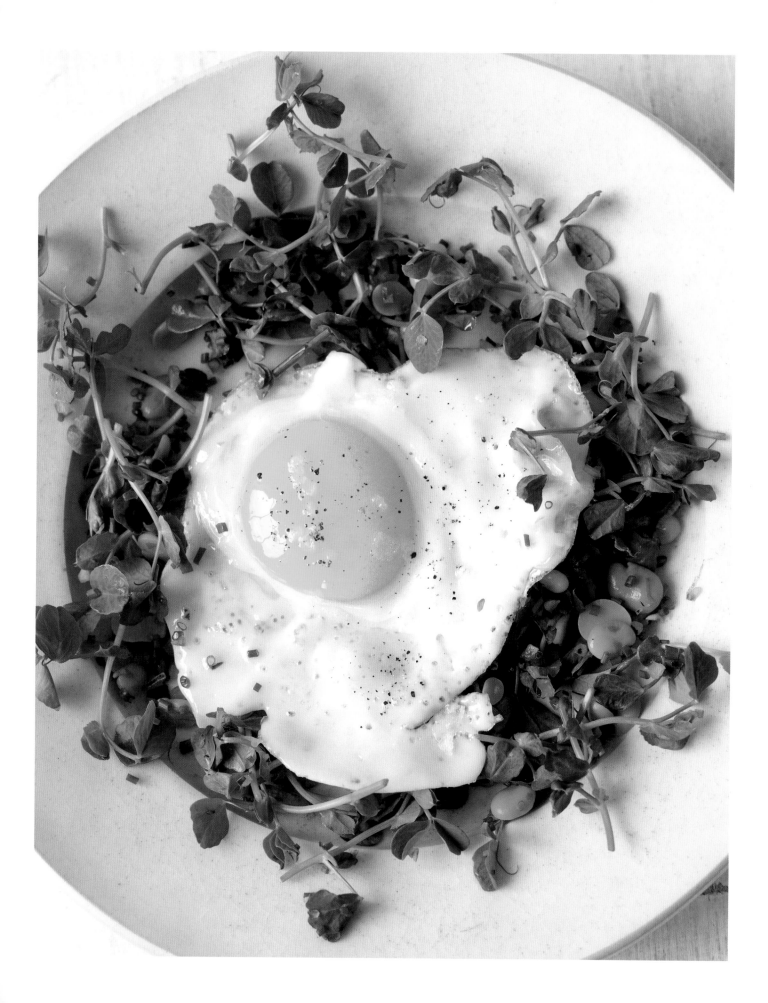

2tbsp vegetable oil
2 onions, chopped
2 carrots, diced
2 celery sticks, sliced
1 courgette, diced
2 garlic cloves, crushed
175g red lentils, rinsed and checked
 for small stones
600ml vegetable stock
1tbsp yeast extract
1tbsp chopped fresh flat-leaf parsley
 or 1½tsp dried parsley

FOR THE CRUMBLE
75g butter, diced
75g fresh breadcrumbs
50g plain flour
2tbsp chopped walnuts
2tbsp sunflower seeds

SERVES FOUR

VEGETABLE AND LENTIL CRUMBLE

This is a thoroughly modern recipe that puts to rest the old-fashioned image of savoury crumbles. These days there are so many nuts and seeds to choose from that you can change the crunchy topping each time you make it. Try nutritious Brazil nuts instead of walnuts, or opt for pumpkin seeds or linseeds instead of sunflower seeds – keep a lookout for all the new seeds that are coming into the shops now.

1 Heat the oil in a large heavy saucepan and fry the vegetables and garlic over a gentle heat for a few minutes to soften. Stir in the lentils, stock and yeast extract, and bring to the boil. (If using dried parsley, add it now.) Reduce the heat and simmer gently, stirring occasionally, for 40–45 minutes until most of the liquid has been absorbed and the lentils are cooked. Remove from the heat.

2 Set the oven at 170°C. Grease a large baking dish that is about 25 × 18cm and 5cm deep. Season the lentil mixture well. If using fresh parsley, add it now, then transfer the mixture to the dish and level the surface with the back of a spoon.

3 Make the crumble. Melt the butter in a saucepan or in a bowl in the microwave. Stir in the remaining crumble ingredients, mixing well. Sprinkle the crumble evenly over the lentil mixture. Bake for 20–25 minutes until golden and bubbling. Serve hot.

500g shortcrust pastry (page 257)
8 baby corn
A small knob of soft butter
2 large corn-on-the-cob, husks
 and silks removed
115g drained canned sweetcorn
 kernels or niblets

150g marsh samphire
1 egg yolk
4 eggs
About 150ml milk
About 150ml double cream
Fennel and red onion salad
 (page 260), to serve

SERVES SIX

SWEETCORN AND SAMPHIRE FLAN

There are three forms of sweetcorn in this flan, all with very different and distinct flavours. The custard is rich and luxurious, which is how it should be, and puréed corn is just perfect for deepening the colour.

1 Butter a 25cm loose-bottomed, fluted tart tin that is 2cm deep. Set it on a baking sheet. Roll out the pastry to about 5mm thick and line the tin, letting the surplus pastry hang over the edge. Prick the bottom all over with a fork. Allow to rest in the fridge for about half an hour.

2 Meanwhile, preheat the grill to hot. Plunge the baby corn into a saucepan of salted boiling water and boil for 2 minutes. Drain and toss in the butter, then grill for 6–8 minutes until golden brown. Cut into quarters lengthways. Now grill the corn-on-the-cob for 15 minutes, turning frequently, until golden brown all over. When cool enough to handle, cut the kernels from the cobs. Blitz the canned sweetcorn to a purée in a blender. Plunge the samphire into a saucepan of lightly salted boiling water and leave for 30 seconds, then drain and set aside to dry.

3 Set the oven at 190°C. Line the bottom and sides of the pastry case with a disc of non-stick baking parchment. Fill with baking beans or uncooked pulses or rice, and bake for about 35 minutes. Lift out the paper and beans. Return the pastry case to the oven and bake for a further 10 minutes or until crisp and nicely coloured. Brush with a little egg yolk and put back in the oven for 1–2 minutes. Remove the pastry case from the oven and turn the temperature down to 150°C.

4 Arrange the corn kernels, baby corn and samphire neatly in the pastry case. Beat the eggs and remaining yolk in a measuring jug. Mix in the puréed sweetcorn, then top up to 600ml with milk and cream. Season.

5 Pour the egg mixture into the pastry case and season the top with freshly ground white pepper. Bake for about 40 minutes or until the filling is softly set in the centre. Remove from the oven and leave to settle for 15 minutes. Serve cut into wedges, with the salad.

500g Pink Fir Apple potatoes, scrubbed clean but not peeled
2 bunches of watercress, stalks removed
Large handful of fresh young dandelion leaves, chopped
100g butter, diced
2–4 shelled hard-boiled eggs, each cut lengthways into eighths

FOR THE DRESSING
3tbsp rapeseed oil
1tbsp cider vinegar
1tbsp lemon juice
1tbsp orange juice
1 shallot, finely chopped
1tbsp chopped fresh chives

SERVES FOUR

WATERCRESS, DANDELION AND POTATO SALAD

The key to making a good potato salad is to drench the potatoes in lots of butter and seasoning as soon as they've been cooked and drained. They absorb the butter while they're warm, which makes them really juicy and tasty. Do this whenever you're making a potato salad, no matter what the recipe says, then drain off excess butter before adding the dressing. The flavour will amaze you.

1 Put the potatoes into a saucepan of salted boiling water, cover and simmer for 20–25 minutes until just tender.

2 Meanwhile, wash and dry the watercress and dandelion leaves, and place in a large serving bowl.

3 Drain the potatoes and halve or slice when they are cool enough to handle, then place in a bowl with seasoning to taste. Melt the butter, pour evenly over the potatoes and leave to cool to room temperature, stirring occasionally to make sure the potatoes are evenly coated. Whisk the dressing ingredients together in a jug with seasoning to taste.

4 When the potatoes have cooled, pour off any excess butter and coat them gently in the dressing. Add the potatoes to the watercress and dandelion leaves, and mix gently together. Top the salad with the hard-boiled eggs and serve straightaway.

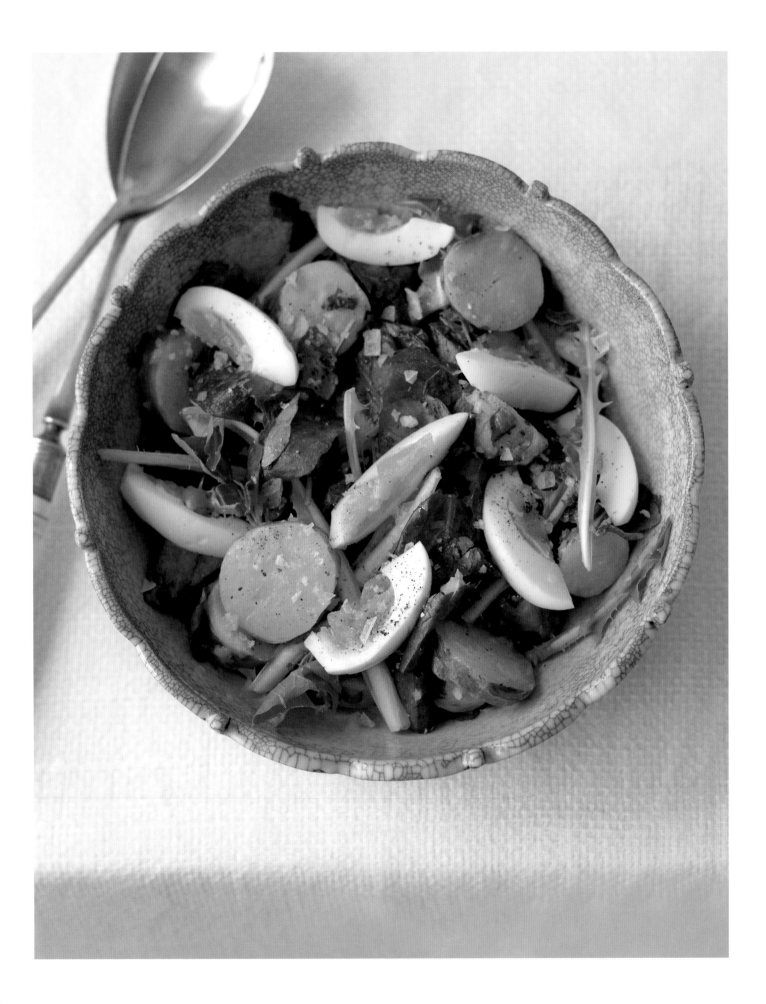

600g frozen raspberries
250g fresh raspberries
12 fresh mint leaves, finely shredded
6 fresh mint sprigs, to decorate

FOR THE MOUSSE
2 leaves of gelatine (5g total weight)
100ml Grand Marnier
1 vanilla pod, split lengthways
500g carton sweetened natural yogurt, or natural
 yogurt whisked with 2tbsp icing sugar

SERVES SIX

BERRY CONSOMMÉ

We don't see enough fruit soups in this country, and yet they make excellent summer desserts. They're simple to prepare, refreshing to eat, and light and healthy too. The trick in this recipe is to use frozen raspberries for their juice, so try to freeze some when they're ripe and keep them just for this dish – they'll be full of natural fructose so you won't have to add sugar to make them sweet. Strawberries and loganberries can be used instead of raspberries, and you can replace the mousse in the centre with a clear fruit jelly. If you ring the changes like this, you can be eating fruit soups all summer long.

Paul Gauguin, 1848–1903
Bowl of Fruit and Tankard before a Window (detail), probably 1890

There are reminders in this still life of Brittany, where Gauguin lived at the time. The tankard is probably of local production, and the strip of townscape at the top may be based on a photograph of Pont-Aven.

1 Make the mousse. In a small saucepan, soak the gelatine leaves in the Grand Marnier for about 5 minutes or until soft. Scrape the vanilla seeds into the pan and heat gently, stirring until the gelatine has dissolved. Pass through a fine sieve, then fold into the yogurt and divide equally among six 100ml moulds. Cover and put in the fridge to set, which will take about 3 hours.

2 Meanwhile, put the frozen raspberries into a sieve set over a bowl and leave to thaw and drain in a warm place for 3–4 hours. Tip the thawed raspberries into a blender and blitz to a purée, then push the purée through a fine sieve into the bowl of juice and stir well to mix. Cover and set aside in the fridge. In another bowl, gently toss the fresh raspberries with the shredded mint leaves. Cover and set aside in the fridge.

3 To serve, dip each moulded mousse in a bowl of hot water for 5–10 seconds, taking care not to let the water touch the top of the mousse, then turn out each mousse into the centre of a serving bowl. Spoon the raspberry soup around each mousse, dot with the fresh raspberries, and decorate with the mint sprigs.

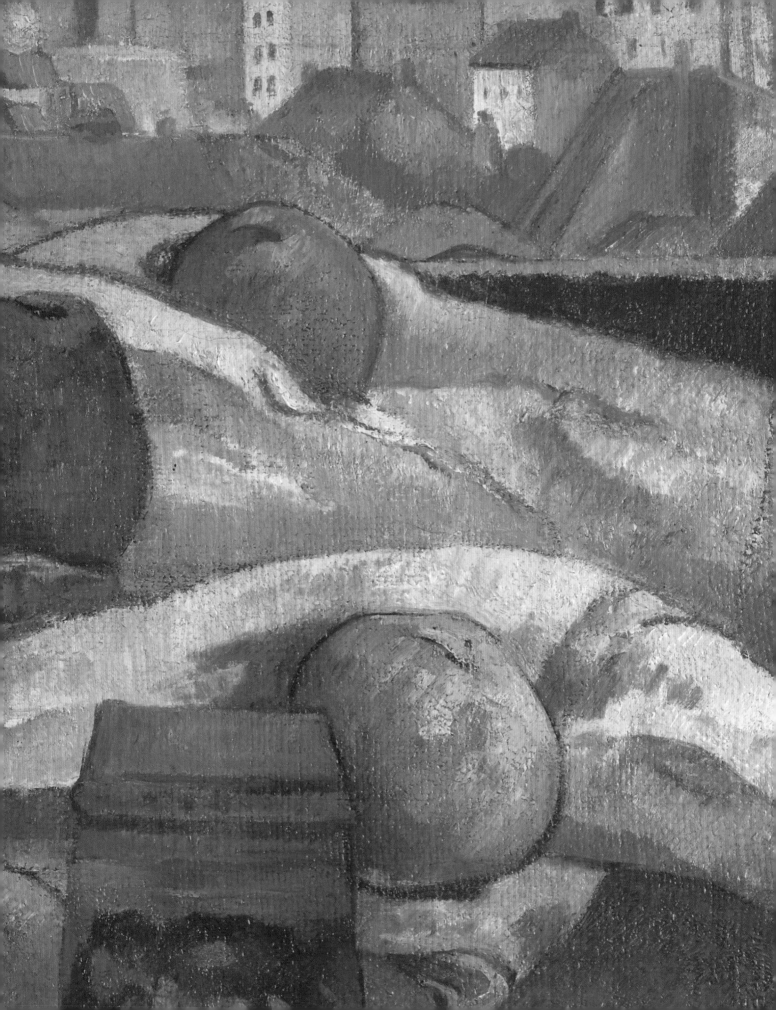

200g ripe strawberries
150g good-quality bought meringues
150ml whipping or double cream

FOR THE SAUCE
100g overripe strawberries, hulled and halved
Caster sugar (optional)

SERVES FOUR

ETON MESS

Old Etonians claim this pudding was originally made with bananas, but as for the rest of us it couldn't be made with anything other than strawberries and cream – two ingredients that epitomise the English summer. Like most great dishes it's unbelievably easy to make and, without a doubt, it is one of the greatest puddings of all time.

1 Make the sauce. Purée the strawberries in a blender, then pass through a sieve into a bowl to remove all the seeds. Taste for sweetness, and only add sugar if you think the sauce is too tart.
2 Wash and dry the whole strawberries, then remove the hulls and cut each fruit lengthways into quarters. Break the meringues into pieces the same size as the strawberries.
3 Whip the cream in a large bowl until it will just hold its shape.
4 Gently fold the strawberries and meringue pieces into the cream. Serve straightaway, drizzled with the sauce. Or chill the Eton mess and sauce separately in the fridge for up to 2 hours until you are ready to serve.

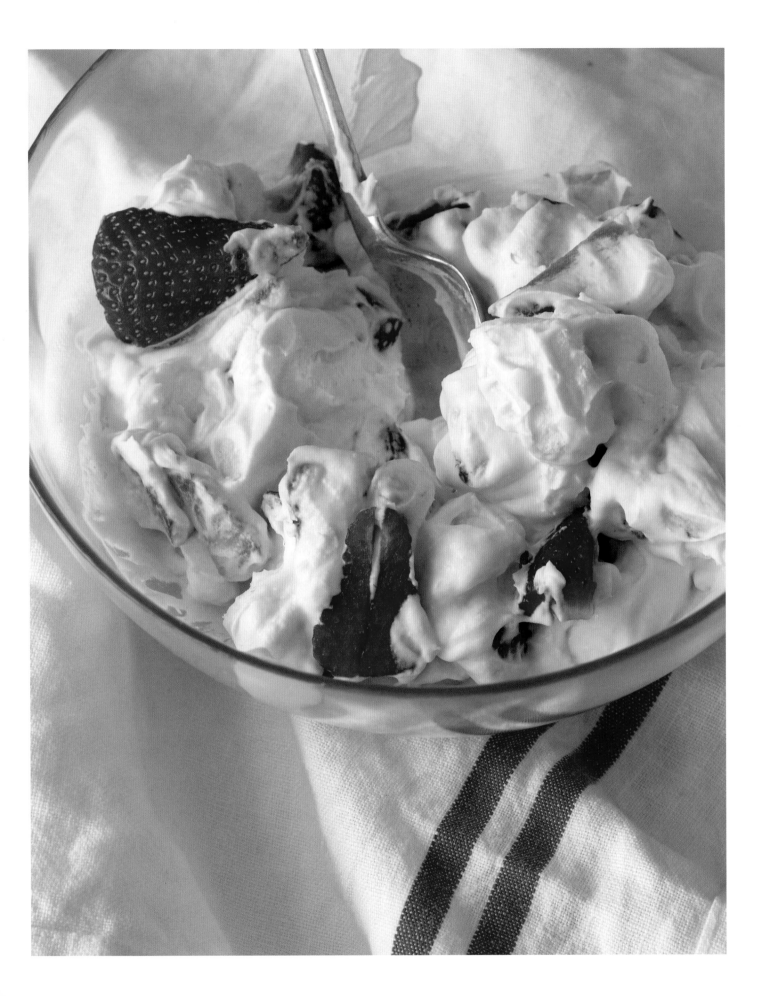

350g ripe raspberries
350g ripe strawberries, hulled and halved or quartered if large
175g ripe blueberries
125g ripe redcurrants, stalks removed
175g caster sugar
Juice of 1 lemon
10 thin slices of bloomer or other white bread, crusts removed

SERVES SIX

SUMMER PUDDING

Don't be too heavy on the bread or this will feel like a winter dish – it should
be as light, fruity and summery as possible. The choice of firm yet ripe fruit
is important too, because you don't want the pudding to be too tart. Fresh
redcurrants are traditional and an authentic summer pudding shouldn't
be made without them, but don't use too many.

Pieter Claesz, 1597/8–1660
Still Life with Drinking Vessels
(detail), 1649

The porcelain bowl is an example
of Chinese export ware of the Wanli
period (1573–1619). A contemporary
viewer would have immediately
recognised the costliness of the
different objects.

1 Place the fruit, sugar and lemon juice in a saucepan over a low
heat and simmer gently, stirring occasionally, for 3–4 minutes until
the sugar has dissolved. Cool, then tip the contents of the pan into
a sieve set over a bowl and let the juice strain through. Reserve
the fruit and juice in separate bowls.

2 Cut one slice of bread into a disc to fit the bottom of a 1.5-litre
pudding basin. Cut another disc to fit the top of the basin. Cut the
remaining bread into slices, 2cm at one end and 4cm at the other.

3 Dip one side of the small disc of bread quickly into the juice and
place juice-side down in the bottom of the basin. Now dip one
side of each slice of bread into the juice and use to line the basin,
placing them juice-side against the basin and overlapping by 5mm
so there are no gaps.

4 Fill the basin with the fruit and pour in any leftover juice, saving
2tbsp for the top. Place the final disc of bread over the fruit and
sprinkle with the reserved juice.

5 Stand the basin in a dish to catch any juice that might come out,
then cover the pudding with cling film and fit a saucer or plate
just inside the rim. Put a couple of heavy cans on top to press the
pudding down. Chill in the fridge for at least 12 hours, or up to
48 hours. Turn the pudding out to serve.

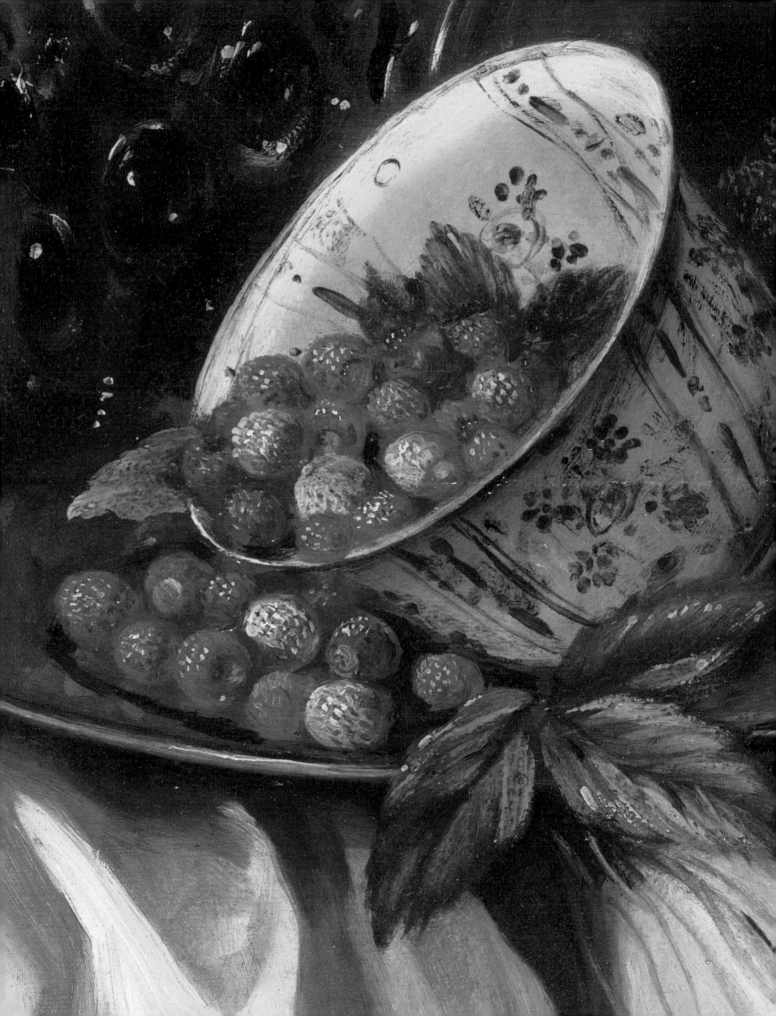

25g butter
450g gooseberries
About 2tbsp caster sugar
250ml whipping or double cream
Butter biscuits (page 125), to serve

FOR THE CUSTARD
150ml milk
¼ vanilla pod, split open
3 egg yolks
40g caster sugar
20g plain flour

SERVES FOUR

GOOSEBERRY FOOL

Fools should have a better reputation, but their name does nothing to make them sound appealing, which could be one of the reasons why they're not as popular as they deserve to be. The same can be said of gooseberries, which should only be eaten when they're fully ripe, so check before you pick or buy them. You'll really appreciate the bittersweet gooseberry flavour in this delicate, creamy dessert.

1 Make the custard. Bring the milk slowly to the boil in a saucepan with the vanilla pod. When bubbles start appearing at the edge, remove the pod and scrape the seeds into the milk.

2 In a bowl, whisk the egg yolks with the sugar until pale and slightly thick. Sift the flour over the egg mixture and whisk until thoroughly combined.

3 Slowly pour the milk on to the egg mix, whisking constantly. Pour into a clean pan and heat gently until the custard comes to the boil and starts to thicken, whisking to ensure it is smooth. Strain into a bowl and cover the surface closely with cling film to prevent a skin from forming. Chill in the fridge until required.

4 Melt the butter in a heavy saucepan and add the gooseberries and 2tbsp sugar. Cover and cook over a low heat for about 30 minutes or until the gooseberries are soft and mushy. Tip the gooseberries into a bowl and mash to a pulp with a potato masher. Push the pulp through a sieve; discard the skin and pips in the sieve. Taste the gooseberry purée and add more sugar if it is too tart. Leave to cool.

5 Remove the custard from the fridge and whisk lightly. Whip the cream until it will just hold its shape. Gently fold the custard into the gooseberry purée followed by the whipped cream. Divide the fool equally among four glasses and chill for at least an hour. Serve chilled, with the biscuits.

FOR THE VANILLA CREAM
180ml double cream
30g caster sugar
½ vanilla pod, split lengthways
 and seeds scraped out

3½ leaves of gelatine (scant
 10g total weight)
375ml red wine
150g caster sugar
16 fresh basil leaves
200g wild or small strawberries,
 hulled and quartered

TO FINISH
8 wild or small strawberries, each
 sliced lengthways into thirds
4 sprigs of fresh basil

SERVES FOUR

RED WINE JELLY WITH VANILLA CREAM

For a rich colour and flavour, a full-bodied English wine made from pinot noir grapes would be a good choice for this jelly. When making the vanilla cream, don't be tempted to use more gelatine than the amount in the recipe. You are after a finished result that is not too set – it should be quite soft, very creamy and almost on the verge of collapse. With a pudding as delicate as this, texture makes a big difference to the taste.

Jan van Os, 1744–1808
Fruit, Flowers and a Fish
(detail), 1772

Among the fruit are grapes, melons, peaches, plums, a pineapple – very expensive – and a pomegranate; the principal flowers are roses and hollyhocks.

1 Make the jelly. Soak the gelatine leaves in a small bowl of cold water for about 5 minutes or until soft. Bring the wine and sugar slowly to the boil in a heavy pan, stirring until the sugar has dissolved. Remove from the heat. Lift the gelatine out of the water and squeeze, then add to the wine and stir until dissolved. Strain through a fine sieve on to 12 of the basil leaves in a bowl, cover with cling film and leave to infuse for 20 minutes. Strain through a sieve again, to remove the basil, then leave to cool.

2 Put 4tsp of the jelly into each of four Martini or other cocktail glasses and chill in the fridge for about 1 hour or until nearly set. Finely shred the remaining 4 basil leaves and mix with the quartered strawberries, then divide equally among the glasses. Pour in more jelly, not quite covering the fruit, and chill for about 30 minutes or until nearly set again. This will hold the strawberries suspended in the jelly and prevent them from floating. Pour over the remaining jelly and chill for about 1 hour to set completely.

3 Whip the cream with the sugar and vanilla seeds to the soft peak stage. Spoon on top of the jelly and smooth with a palette knife. Keep in the fridge until you are ready to serve. Decorate with the strawberries and basil sprigs just before serving.

200g caster sugar
200g soft margarine
4 eggs, beaten
200g self-raising flour

TO SERVE
250g good-quality strawberry jam
2tbsp icing sugar
200ml whipping or double cream

SERVES SIX

VICTORIA SANDWICH

For this modern version of a traditional English favourite, the shape is square rather than round, and there are four layers of sponge instead of two. The finishing touch is the voluptuous filling of whipped cream and smooth jam, which sets off the cake to perfection.

1 Set the oven at 160°C. Grease a 30–33 × 20–23cm Swiss roll tin and line the bottom with non-stick baking parchment.
2 Cream the sugar and margarine together until light and fluffy, then slowly beat in the eggs until evenly incorporated. Fold in the flour. Spread the mixture evenly in the tin.
3 Bake for 20–25 minutes until springy to the touch in the centre. Turn out on to a wire rack to cool, then peel off the lining paper.
4 Blitz the jam and 1tbsp of the icing sugar in a blender until aerated and smooth. Whip the cream until it stands in soft peaks.
5 Cut the sponge in half widthways, then cut each piece in half through its thickness to make four thin rectangles. Layer the rectangles with jam and cream in between, finishing off with a plain rectangle. Cut into six squares and serve dusted with the remaining icing sugar.

225g self-raising flour
2tsp baking powder
45g chilled butter, diced
1 egg, straight from the fridge
60g caster sugar
4tbsp buttermilk, straight from the fridge
100g raisins (optional)
Beaten egg, to glaze
Jam and clotted cream, to serve

MAKES EIGHT

DEVON SCONES

Scones are an absolute must for the quintessential English cream tea, which should always be a civilised affair, an opportunity to enjoy a break in the middle of the afternoon. The quiet ritual of splitting a scone in half, spreading it with jam, and spooning on a dollop of cream is an absolute joy.

1 Set the oven at 160°C. Sift the flour and baking powder into a bowl and rub in the butter very gently with your fingertips. Beat the egg with the sugar in another bowl until the sugar has dissolved, then add to the flour mixture with the buttermilk and the raisins (if using). Bring everything together quickly and lightly with a round-bladed palette knife and then your fingers, taking care not to be too heavy-handed.

2 Turn the dough on to a floured surface and pat into a round shape that is about 2cm thick. Cut out eight scones with a 5cm round pastry cutter, reshaping the dough as necessary.

3 Place the scones on a baking sheet and brush with beaten egg. Bake for about 20 minutes or until risen and golden. Cool on a wire rack before serving with jam and cream.

100g soft butter
45g caster sugar, plus extra for sprinkling
150g plain flour

MAKES FOURTEEN

BUTTER BISCUITS

These crisp, light biscuits rely on the quality of the butter you use. It should be a rich, salted Jersey butter to give them the very best flavour. If you use a cheap butter, you will struggle to get any flavour at all.

1 Cover a baking sheet with non-stick baking parchment. Beat the butter and sugar together in a bowl until fluffy and pale in colour. Stir in the flour until evenly mixed, then turn out on to a lightly floured surface. Quickly and lightly bring the mixture together with your hands to form a smooth dough.

2 Re-flour the surface and roll out the dough gently until it is about 1cm thick. Cut out 14 biscuits using a 5cm round pastry cutter, gathering the dough together and re-rolling as necessary. Place the biscuits on the baking sheet and sprinkle each one with a little caster sugar. Chill in the fridge for about 20 minutes. Meanwhile, set the oven at 190°C.

3 Bake the biscuits for 10–15 minutes until pale golden. Leave to settle on the baking sheet for a few minutes, then transfer to a rack and leave to cool completely before serving.

PIMMS

2 ripe strawberries
2 ripe raspberries
2 fresh mint leaves
2 slices of cucumber
Ice cubes
50ml Pimms No1
Fizzy lemonade

Put the fruit, mint and cucumber over ice in a highball glass. Add the Pimms and top up with lemonade.

PEACHY

1 ripe peach, pitted
 and chopped
1tsp caster sugar
50ml vodka
Ice cubes

Crush the peach and sugar with a pestle or the end of a rolling pin and put into a shaker with the vodka and ice. Shake well, then strain into a Martini glass.

SWEETIE

4 fresh edible flower petals
1tsp vanilla sugar
Ice cubes
Ginger beer

Using a spoon, stir the flower petals with the sugar in a highball glass or similar. Add ice, and top up with ginger beer.

RASPBERRY-TINI

5 ripe raspberries
1tsp caster sugar
Juice of ½ lime
50ml gin or vodka
Ice cubes

Crush the raspberries and sugar with a pestle or the end of a rolling pin and put into a shaker with the lime juice and gin or vodka. Add ice and shake well, then strain into a Martini glass.

Clockwise from the top:
Pimms, Peachy, Sweetie
and Raspberry-tini.

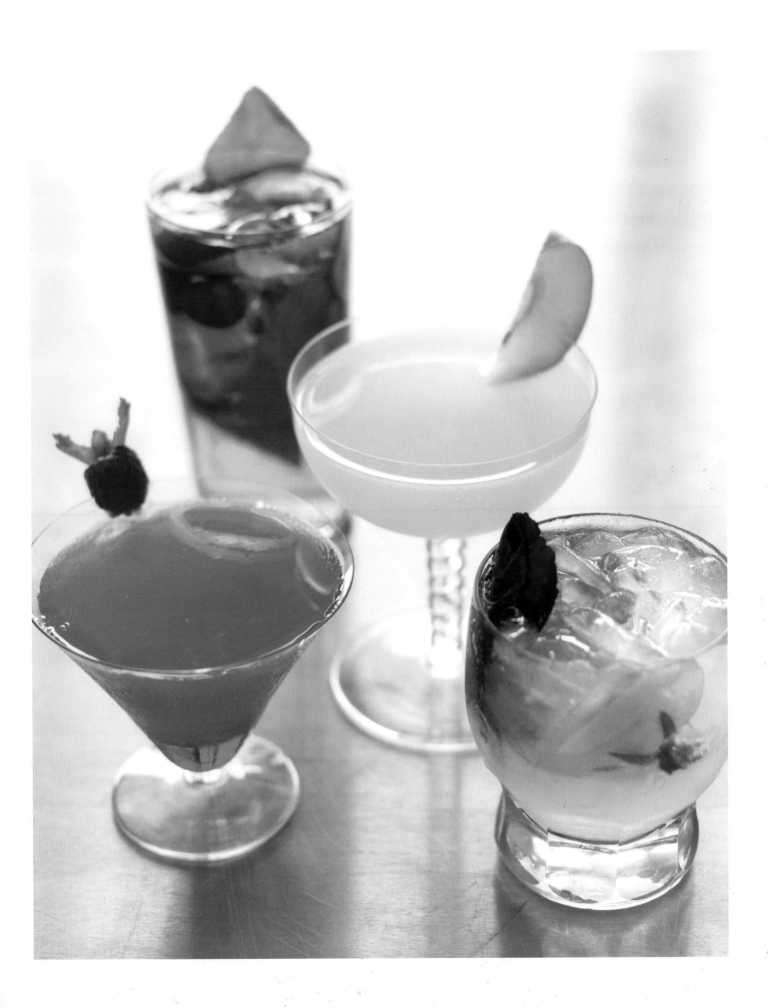

SPRING
SUMMER
AUTUMN
WINTER

If the summer, with its playful informality, is for the child in us all, autumn is the season of maturity – of ingredients, and of tastes.

For many cooks, this is the season they most look forward to. Animals will have grown and matured over the year, and the shooting season is in full swing – first grouse and partridge, soon followed by pheasant and wild duck. Oysters make their comeback in September, while scallops are at their sweetest and best a little later.

Autumn also offers a wealth of treats outside of beasts, birds or fish. Mushrooms spring up; beetroot and parsnips are full of flavour from being so long underground. The earth also becomes the hunting ground for chestnuts and cobnuts, and freshly fallen apples and pears. Contrasting notes arrive in the sweet sharpness of currants and plums.

Cooking methods adapt. Slow roasting and braising are necessary for many meats, and skills in preserving and smoking come into their own.

Soon enough, the autumn festivals are upon us – Hallowe'en and Bonfire Night. We celebrate these shared social evenings with sustaining and warming food, especially bonfire potatoes cooked in the ashes of the fire.

As our bodies naturally stock up in readiness for the winter, it is the perfect time to enjoy the greats of British puddings: sticky toffee, bread and butter, creamy rice and Bakewell. And, of course, apple pie.

1 large raw red beetroot
1 large raw golden beetroot
1 large raw candy-cane beetroot
3 garlic cloves, peeled
3tbsp vegetable oil
Juice of 1 lemon
50g blanched hazelnuts
1tbsp sherry vinegar
175g watercress, stalks removed
150g log soft goat's cheese or fresh goat's curd

SERVES FOUR

TRIO OF BEETROOT WITH GOAT'S CHEESE AND WATERCRESS SALAD

Beetroot and goat's cheese are a classic combination, and using three different colours of beetroot makes this salad so much easier on the eye and the palate than just one deep red variety. Any goat's cheese can be used, but a strong, earthy organic cheese would be the best choice, preferably a local one. The cheese sets off the beetroot so well, and the crunch of the nuts is the salad's crowning glory.

Pieter de Hooch, 1629–1684
A Musical Party in a Courtyard
(detail), 1677

The houses across the canal are similar to those that can still be seen today on the Keizersgracht, Amsterdam. The left-hand one bears a tablet above the open window where a woman looks out, with the date 1620.

1 Make the beetroot purées. Set the oven at 160°C. Wrap each beetroot in foil and roast for about 1 hour or until they feel soft when gently squeezed.

2 Meanwhile, place the garlic cloves and oil in a small saucepan over a low heat and bring to a gentle simmer. Remove from the heat, cover and leave to infuse for 20–30 minutes.

3 Tip the garlic and oil into a sieve set over a large bowl and let the oil strain through. Keep the garlic in the sieve.

4 Cool the beetroot slightly in the foil, then peel and chop each one, keeping them separate. Place one beetroot at a time in a blender with one-third of the lemon juice and 1 chopped garlic clove, and blitz to a smooth purée. Season to taste.

5 Dry-fry the hazelnuts in a frying pan over a medium heat for a few minutes until toasted, then tip on to a board and crush lightly using the flat of the blade of a large cook's knife.

6 Whisk the vinegar and seasoning to taste with the garlic oil to make a dressing. Add the watercress leaves and toss to coat. Pile in the centre of four plates and crumble the goat's cheese or curd in small pieces on top. Spoon one-quarter of each beetroot purée on to each plate, placing them around the salad at 12, 4 and 8 as if the plate were a clock. Sprinkle with the nuts and serve.

FOR THE STOCK
1 carrot, diced
1 leek (white part only), diced
2 celery sticks, diced
1 large onion, diced
1 garlic clove
1 bay leaf
4 black peppercorns

2 butternut squash, weighing
 about 750g each
125g butter, diced
2tbsp vegetable oil

FOR THE GINGER SYRUP
75ml lemon juice
75g caster sugar
75g fresh root ginger, peeled and grated

SERVES FOUR

SILKY SQUASH SOUP WITH GINGER

Squash and ginger is a combination made in heaven – so strikingly obvious in this silky smooth soup. Some recipes call for squash to be boiled, but this can easily ruin it. Roasting in foil is much better: it protects the squash and prevents overcooking, and the generous amount of butter enhances the flavour.

1 Put all the ingredients for the stock in a large saucepan and pour in cold water to cover (about 750ml). Bring to the boil, then cover and simmer gently for 1 hour. Strain the stock; discard the vegetables.

2 Set the oven at 180°C. Cut the squash in half lengthways and remove the seeds and fibres. Wash and dry half the seeds and reserve. Place the squash halves cut-side up on a large piece of foil, season liberally with salt and white pepper, and dot with the butter. Wrap in the foil and place on a roasting tray. Roast for about 1 hour or until tender.

3 Meanwhile, mix the washed and dried squash seeds with the oil and ½tsp salt. Spread over a baking tray covered with non-stick baking parchment and roast for 10–12 minutes until golden brown.

4 Scoop the flesh from the squash while it is hot and purée in a blender with the juices from the foil and the roasting tray, plus enough vegetable stock to get the soup consistency you like.

5 Make the syrup. Combine the lemon juice and sugar in a saucepan and bring to the boil, stirring to dissolve the sugar. Remove from the heat. Put the ginger in a sieve held over the syrup and press with the back of a spoon to extract the ginger juice. Tip the ginger pulp into the syrup and mix well. Cool, then strain through a fine-meshed sieve.

6 To serve, reheat the soup and add ginger syrup to taste. Pour into four warmed bowls and garnish with the roasted squash seeds.

4 large raw red or golden beetroot
650g good-quality puff pastry (preferably
 made with butter)
50g butter, diced
1tbsp vegetable oil
500g red onions, thinly sliced
125ml port
2tbsp caster sugar
3tbsp red wine vinegar
150g Wensleydale cheese, cut into 1cm dice

TO SERVE
125g baby red chard
3tbsp rapeseed oil
1tbsp lemon juice

SERVES FOUR

BEETROOT AND ONION TARTS WITH WENSLEYDALE CHEESE

Juicy slices of roasted red beetroot hide meltingly soft caramelised onions and cheese, spread over a well-browned pastry base that is light and crisp. This dish is all about balance, and the proportions are exactly right.

1 Set the oven at 160°C. Wrap each beetroot in foil and roast for about 1 hour or until the beetroot feels soft when gently squeezed.
2 Meanwhile, cover a large baking sheet with non-stick baking parchment. Roll out the pastry until about 5mm thick. Cut out four 15cm discs and prick all over with a fork. Place the discs on the baking sheet, cover with another sheet of parchment and set another baking sheet on top. Press the sheet down to keep the pastry flat. Bake for 15–20 minutes until the discs are golden, checking after 12 minutes to make sure the pastry isn't getting too brown. Transfer the discs to a rack and cool.
3 Melt the butter with the oil in a saucepan. Add the onions, cover and cook over a low heat, stirring occasionally, for 8–10 minutes until softened. Add the port and sugar, and cook uncovered for about 30 minutes or until the liquid has evaporated, stirring occasionally. Add the vinegar and cook for 10 minutes or until it has evaporated, stirring occasionally. Season to taste and cool.
4 When the beetroot are cooked, cool in the foil, then peel, keeping the shape as round as possible. Slice into a total of 12 discs.
5 To finish, set the oven at 180°C. Spread the onions over the pastry discs, sprinkle on the cheese and cover with the beetroot slices. Bake for 25–30 minutes until hot and the cheese has melted.
6 Dress the chard with the oil, lemon juice and seasoning. Divide among four plates, top with the tarts and sprinkle with sea salt.

8–12 central sections of beef marrowbone,
 each about 4cm long
4 thick slices of crusty bread, to serve

FOR THE SALAD
125g fresh flat-leaf parsley, large stalks removed
150g shallots, finely diced
75g capers
Juice of ½ lemon
3tbsp rapeseed oil

SERVES FOUR

ROASTED BONE MARROW

Over the years we've been scared off eating offal and other 'bits and pieces' like bone marrow. They've simply dropped off our radar. Now it's time for a revival, and if you serve this for a dinner party starter you'll be surprised how well it is received. Marrow makes a big impact on the plate, and serving it with a piquant parsley and shallot salad is the perfect counterbalance to its richness.

1 Set the oven at 230°C. Place the bones on a roasting tray and roast for about 10 minutes or until a skewer will go all the way through the marrow without hitting any resistance. The marrow should be browned and loose, but not melting away. (The timing will depend on the thickness of the bones.)

2 Meanwhile, start to prepare the salad by lightly tearing the parsley leaves and mixing them with the shallots and capers.

3 Just before serving, toast the bread, and dress the salad with the lemon juice and oil.

4 To eat, scrape the marrow from the bones on to the toast. Season with sea salt and black pepper and top with the salad.

100g chicken livers
1 shallot, chopped
100g butter
5tbsp red wine
4tbsp port or Madeira, or
 a mixture of the two
1 egg TO SERVE
1 egg yolk Melba toast made from soda bread,
1 garlic clove, chopped or toasted thin slices of soda bread
5tsp chopped fresh marjoram Piccalilli (page 258)

SERVES FOUR

CHICKEN LIVER MOUSSE

This mousse is all about the colour, which shouldn't be too dark. The flavour of the alcohol should be subtle too, so don't overindulge and overpower the delicacy of the livers with too much red wine and port. Piccalilli may seem an unlikely accompaniment, but its vivid colouring and chunky texture make a great contrast to the creamy smoothness of the mousse.

1 Set the oven at 120°C, and stand four 100ml ramekins in a roasting tin.

2 Purée the chicken livers in a blender and pass through a sieve into a bowl. Set aside.

3 Cook the shallot in a little of the butter in a saucepan over a medium heat until softened and translucent. Add the wine and boil to reduce completely, then add the port and reduce by two-thirds. Now blitz this reduction in the blender with the puréed livers, the egg, egg yolk, garlic, marjoram and a pinch each of salt and pepper.

4 Heat the remaining butter until bubbling, add to the liver mix while still hot and blitz briefly to combine.

5 Fill the ramekins with the mousse and pour warm water around them to come about halfway up their sides. Place the tin in the oven and cook for about 30 minutes or until the mousses are set (the centres should reach 65°C on a thermometer). Cool, then cover and chill in the fridge for at least 3 hours before serving. Serve chilled on toast, with little pots of piccalilli on the side.

500g smoked haddock fillets
300ml milk
750g floury potatoes (King Edward,
 Maris Piper or Desirée), peeled,
 boiled and mashed
Vegetable oil, for deep-frying
4 eggs
1tsp white wine vinegar
Hollandaise sauce (page 254), to serve

FOR THE COATING
50g plain flour
1 egg, beaten
75g panko breadcrumbs

FOR THE SALAD
125g baby spinach leaves
2tbsp rapeseed oil
2tsp lemon juice

SERVES FOUR

SMOKED HADDOCK FISH CAKES

Fish cakes need flavour, and smoked haddock delivers where salmon and white fish do not – they're just too bland. Other ingredients are not so crucial, so you don't have to be purist about them. Frozen peas and sweetcorn can be included for colour, and tartare sauce or mayonnaise can be used instead of hollandaise.

1 Put the fish in a large, deep frying pan. Pour in the milk and enough cold water just to cover the fish. Cover the pan and bring slowly to the boil, then lower the heat and poach the fish gently for 5 minutes or until the flesh flakes easily when tested with a fork.

2 Remove the fish from the liquid and leave until cool enough to handle, then flake into a bowl with your hands, removing the skin and any small bones. Discard the poaching liquid.

3 Add the mash to the fish and beat well to mix, then add seasoning to taste (go easy on the salt because the smoked fish may be salty). Shape into four thick, round cakes and coat each one with the flour, then the beaten egg and, finally, the breadcrumbs.

4 Get the salad ready. Dress the spinach in a bowl with the oil, lemon juice and seasoning to taste, then divide among four plates.

5 Set the oven at 100°C. Heat the oil in a deep-fat fryer to 170°C. Deep-fry the fish cakes for about 4 minutes or until crisp and golden brown all over. Do this in batches according to the size of your fryer, keeping the cooked cakes hot in the oven until they are all done.

6 Meanwhile, poach the eggs in simmering water with the vinegar for 2–4 minutes, depending on whether you like runny yolks or not.

7 Lift the fish cakes out of the oil with a slotted spoon and drain on kitchen paper. Lift the eggs out of the water with a slotted spoon and drain. Put a fish cake on each plate of salad and top with a poached egg. Coat with hollandaise sauce and serve straightaway.

600g cod cheeks
2tbsp plain flour
2tbsp vegetable oil
30g butter, diced
75g button mushrooms, sliced
1 small shallot, finely chopped
2tbsp rapeseed oil
1tbsp lemon juice
10g fresh flat-leaf parsley
 leaves, finely chopped

FOR THE CHAMP
750g floury potatoes (King Edward,
 Maris Piper or Desirée), peeled
 and cut into chunks
75g butter
125g spring onions, trimmed
 and chopped
150ml milk

SERVES FOUR

COD CHEEKS WITH CHAMP

Just as you would expect, cod cheeks come from the face of the fish. They're meaty, tender and satisfying, and well worth trying, although you may have to order them from your fishmonger because they're not widely sold. Alternatively, you could use monkfish cheeks or tails, or knobs of skate, all of which are equally fleshy and firm. Champ is the ultimate accompaniment – a soft, pillowy bed for the cheeks to lie on.

**Joachim Beuckelaer,
active 1560–1574
The Four Elements: Water
(detail), 1569**

Twelve different varieties of fish have been identified in this painting. Elsewhere in the picture is the scene of Christ appearing to the disciples after his Resurrection to perform the miracle by which fish appear in previously empty nets.

1 Make the champ. Put the potatoes into a saucepan of salted cold water. Cover and bring to the boil, then simmer for 15–20 minutes until tender. Drain the potatoes well and return to the pan, then mash. Set aside.

2 Heat the butter in a saucepan until melted, add the spring onions and cook over a very low heat until soft. Pour in the milk and bring to the boil. Beat this mix into the mash until evenly combined. Season to taste. Keep hot.

3 Dust the cod in the flour seasoned with ½tsp salt and ¼tsp pepper. Heat the vegetable oil in a large frying pan over a high heat and sear the cod until golden brown on all sides (you may have to do this in two pans or in batches, depending on the size of the cod cheeks and your pan). Add the butter and let it melt, then add the mushrooms and shallot and cook, stirring occasionally, for 2–3 minutes until the fish is tender when pierced with a fork.

4 Make a dressing by whisking the rapeseed oil in a large bowl with the lemon juice, parsley and seasoning to taste.

5 Remove the fish, mushrooms and shallot from the pan with a slotted spoon and drain off the fat, then place in the bowl of dressing and spoon the dressing over to coat. Serve the fish on top of the champ, with the dressing spooned over and around.

250g basmati rice, well rinsed
2tbsp vegetable oil
1 small red onion, finely sliced
100g butter, diced
1tbsp hot curry paste (e.g. Madras)
300g skinless hot-smoked salmon fillets,
 flaked into large pieces
4 spring onions, trimmed and finely sliced
4tbsp chopped fresh flat-leaf parsley
2tbsp chopped fresh coriander
1tbsp chopped fresh dill
Juice of 1 lime

SERVES FOUR

SALMON KEDGEREE

With its origins in colonial India, a traditional kedgeree made with smoked haddock is quintessentially British, but this posh and sophisticated version using hot-smoked salmon is bang up-to-date. It's a shame to have kedgeree just for breakfast, so why not treat it like a risotto and eat it as a supper dish, or serve it for a weekend lunch topped with soft poached eggs?

1 Pour 600ml cold water into a medium saucepan. Add ½tsp salt and then the rice. Cover and bring to the boil. Stir once, then cover again and turn the heat down to very low. 'Steam dry' the rice for 10–15 minutes until tender. Remove from the heat, keeping the pan covered, and set aside.

2 Heat the oil in a large saucepan or flameproof casserole and cook the onion over a low heat for a few minutes until softened but not coloured. Add the butter and let it melt, then stir in the curry paste and cook for 2–3 minutes until the paste smells fragrant.

3 Add the cooked rice and stir until all the grains are coated with curried butter. Now mix in the salmon, spring onions, herbs and lime juice, taking care not to break up the fish too much. Remove from the heat and taste for seasoning before serving.

2 thick slices from a large bloomer or
 other white loaf, crusts removed
 and cut into 2cm cubes
1kg cleaned squid
1tbsp vegetable oil
100g butter, diced
1tsp coriander seeds, crushed
½tsp cayenne pepper
5 garlic cloves, chopped
1 litre sweet cider
20g fresh flat-leaf parsley, stalks removed
 and leaves finely chopped

SERVES FOUR

SQUID IN CIDER

We tend to think of squid as Mediterranean, but we have squid aplenty off our own coastline. Cooking it with cider may sound an unlikely combination, but it places squid firmly in the British camp. The long, slow simmering lets the squid soak up the apple flavour and creates a comforting, tender stew – a far cry from the rubbery rings we used to get on holiday years ago.

1 Set the oven at 240°C or as high as it will go. Spread out the cubes of bread on a baking tray. Place in the oven and toast for 8–10 minutes until very brown, turning the cubes over halfway. Leave to cool.

2 Cut the squid into rings. Heat the oil in a flameproof casserole over a medium to high heat. Add the butter and wait until it is foaming, then add the squid and cook until golden brown. Reduce the heat to low and add the coriander and cayenne. Cook gently for 1 minute, stirring to prevent the cayenne from burning. Add the garlic and cook for about 1 minute or until softened. Now pour in half of the cider. Cover and bring to the boil, then reduce the heat and simmer for 30 minutes.

3 Crumble the cold toasted bread cubes into the casserole and add seasoning to taste. Pour in the remaining cider and bring back to the boil, stirring to dissolve the toast. Simmer, uncovered, for about 30 minutes or until the sauce is thick, stirring frequently. Stir in the parsley before serving.

FOR THE CAULIFLOWER PURÉE
1 cauliflower, weighing 1–1.25kg
100g butter, diced

12 large or 20 medium scallops,
 patted dry
Vegetable oil
25g butter, diced
A few sprigs of fresh thyme,
 to garnish

FOR THE CAPER SAUCE
25g garlic cloves
100g superfine capers, drained
1tbsp rapeseed oil
250ml fish stock
Lemon juice
Good pinch of chopped fresh thyme

SERVES FOUR

SCALLOPS WITH CAULIFLOWER PURÉE AND CAPER SAUCE

Making cauliflower into a purée turns this humble everyday vegetable into a fitting accompaniment for a special ingredient like scallops. The key here is to use lots of butter, which gives a luxurious lustre to the purée and creates the impression that it's taken lots of time and effort to make.

1 Make the cauliflower purée. Cut the cauliflower into florets, discarding the outer leaves and the bottom two-thirds of the stalks. Cook the florets in salted boiling water for about 5 minutes or until just tender. Drain well and purée in a blender while still hot, then transfer to a clean pan. Season well with salt and set aside.

2 Make the sauce. Peel the garlic and cut into pieces the same size as the capers. Place in a pan with 85g of the capers, the oil and stock. Cover and simmer until the garlic is soft but not coloured, then remove the lid and simmer until the liquid is reduced to about 4tbsp. Tip the contents of the pan into a coarse sieve set over a clean pan and push the garlic and caper pulp through. Add lemon juice to taste and finish with the thyme.

3 Season the scallops. Heat a little oil in a large non-stick frying pan over a medium heat. Place the scallops in the pan and fry for 1 minute. Add the butter and melt until foaming. Turn the scallops over and fry for 3–4 minutes if medium or 5 minutes if large.

4 Reheat the cauliflower purée with the butter, and reheat the caper sauce. Taste both for seasoning. Spoon the purée into the middle of 12 scallop shells or four warmed bowls. Place the scallops on top and spoon the caper sauce around. Garnish with the remaining capers and the thyme sprigs and serve straightaway.

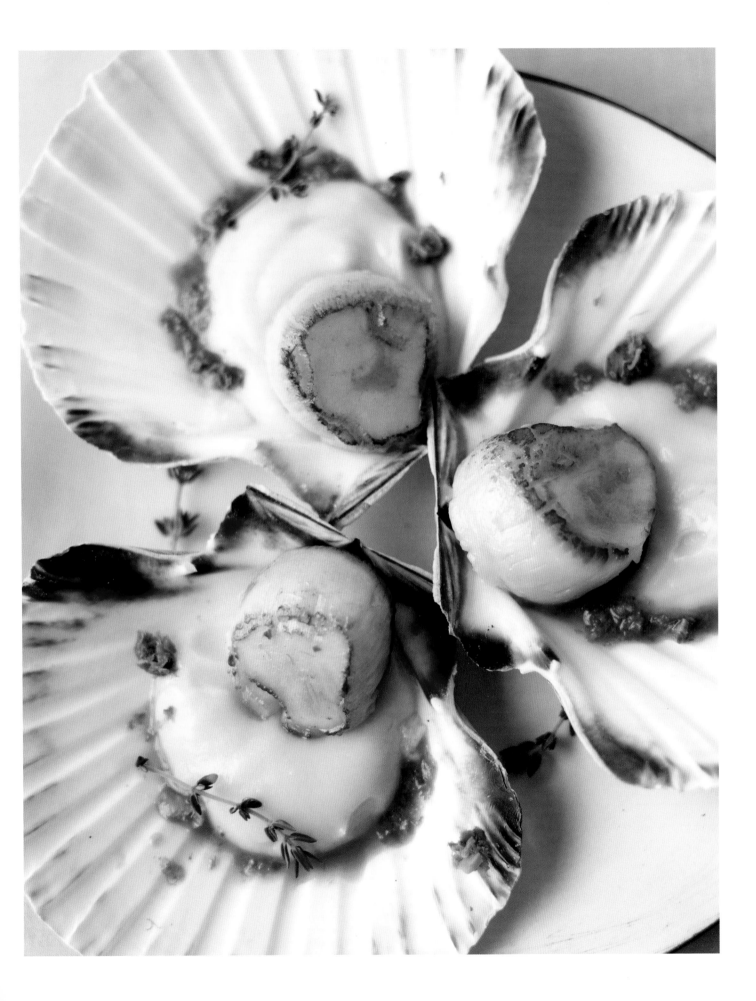

FOR THE MUSHY PEAS
200g dried marrowfat peas
2tsp bicarbonate of soda

200g plain flour
100g cornflour
4tbsp vegetable oil
About 300ml chilled bitter beer (not lager)
4 pollack fillets, weighing about 150g each

FOR THE CHIPS
4 large starchy potatoes
 (such as Maris Piper)
Vegetable oil, for deep-frying

SERVES FOUR

FISH AND CHIPS WITH MUSHY PEAS

To get the best results with fish in batter it must be very fresh, never frozen. The fillets should be thick and fleshy, and pollack is an excellent, sustainable fish that fits this bill. Mushy peas are a uniquely personal thing – some of us like them super-smooth, while others prefer a little texture. It's up to you.

1 Place the peas in a large bowl with plenty of room to expand and pour over about 1 litre boiling water (they need to be covered with two to three times their volume of water). Stir in the bicarbonate of soda, then cover and leave to soak overnight.

2 The next day, drain and rinse the peas, and put them in a pan with enough fresh water to cover. Bring to the boil, then lower the heat and simmer for about 20 minutes or until the peas are soft, scooping up and discarding any skins that come to the surface. Remove from the heat. Crush to the consistency you like using a potato masher and season well. Set aside.

3 Peel the potatoes and cut into thick chips. Heat oil to 150°C in a deep-fat fryer or deep, heavy saucepan. Blanch the potatoes by deep-frying them in batches for 4–6 minutes until they are soft but still white. Remove from the oil and set aside on kitchen paper.

4 In a bowl, whisk together the flour, cornflour, oil and a pinch of salt, adding enough cold beer to make a smooth batter.

5 When you are ready to serve, reheat the oil to 180°C. Coat the fish fillets in the batter and deep-fry in batches for 5–6 minutes, depending on the size of the fish, until the batter is crisp and golden brown. Keep warm on kitchen paper while you fry the remainder.

6 Quickly re-fry the chips in the hot oil for about 5 minutes or until crisp and golden. At the same time, reheat the mushy peas; adjust the consistency with a little water if you like. Drain the chips on kitchen paper and sprinkle with sea salt. Serve them straightaway, with the fish and mushy peas.

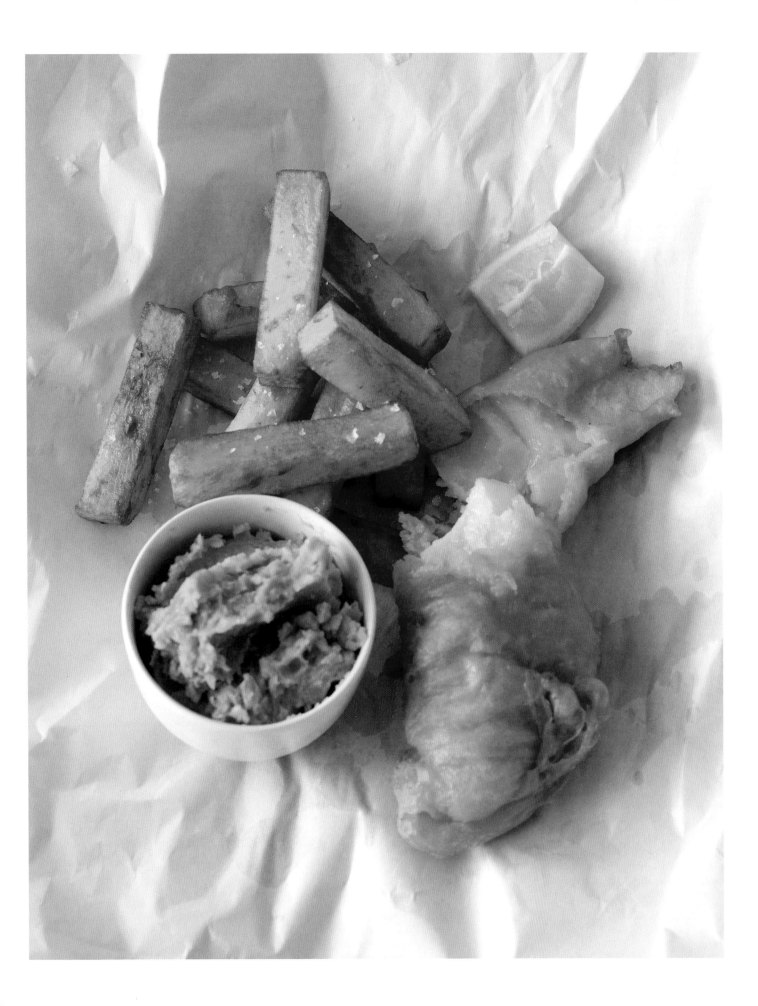

4 partridges, preferably red-leg
4 streaky bacon rashers
Bread sauce (page 253), to serve

FOR THE QUINCE AND CHESTNUTS
2 quinces, weighing about 400g each,
 peeled and cut into wedges
Sprig of fresh thyme
1 garlic clove (unpeeled)
50g butter, diced
150g peeled roasted chestnuts

SERVES FOUR

ROAST PARTRIDGE WITH QUINCE AND CHESTNUTS

The season for partridge is short, from the beginning of September until the end of January, so make the most of it. The strong flavours of game and chestnuts have a particular affinity, as each one holds its own against the other. If you don't have time to prepare fresh chestnuts, you can use frozen or vac-packed. The flavour is sealed in and they come with a crunch, which is all you want.

Peter Paul Rubens, 1577–1640
A View of Het Steen in the Early Morning (detail), probably 1636

The landscape around Rubens's house of Het Steen near Malines, not far from Antwerp, is shown on an autumn morning, facing north, with sharp wintry light and autumn-flowering plants. The partridges in the foreground are being stalked by a huntsman (not seen here).

1 Set the oven at 180°C. Season the partridges inside and out, and lay a rasher of bacon over each breast, cutting the rashers in half to make them fit, if necessary.

2 Place each bird on one of its sides in a roasting tin and roast for 10 minutes. Turn the birds on to their other sides and roast for a further 15 minutes, then turn them breast-side up. Roast for a final 15 minutes or until the juices run clear when the bird is pierced with a skewer between the breast and one of the legs. Remove from the oven, cover loosely with foil and leave to rest in a warm place for 15 minutes.

3 While the partridges are in the oven, roast the quinces in a separate tin with the thyme, garlic and butter for 30 minutes. Stir occasionally during this time to coat the quince wedges with the butter. Add the chestnuts for the last 5 minutes of the roasting time, just to heat them through.

4 To serve, take the legs (drumsticks and thighs) off each bird in one piece, then remove the breast meat from either side of the breastbone, keeping each breast in one piece. Place two legs and two breasts on each of four warmed plates. Season the quince wedges and chestnuts and spoon them alongside. Hand the bread sauce separately.

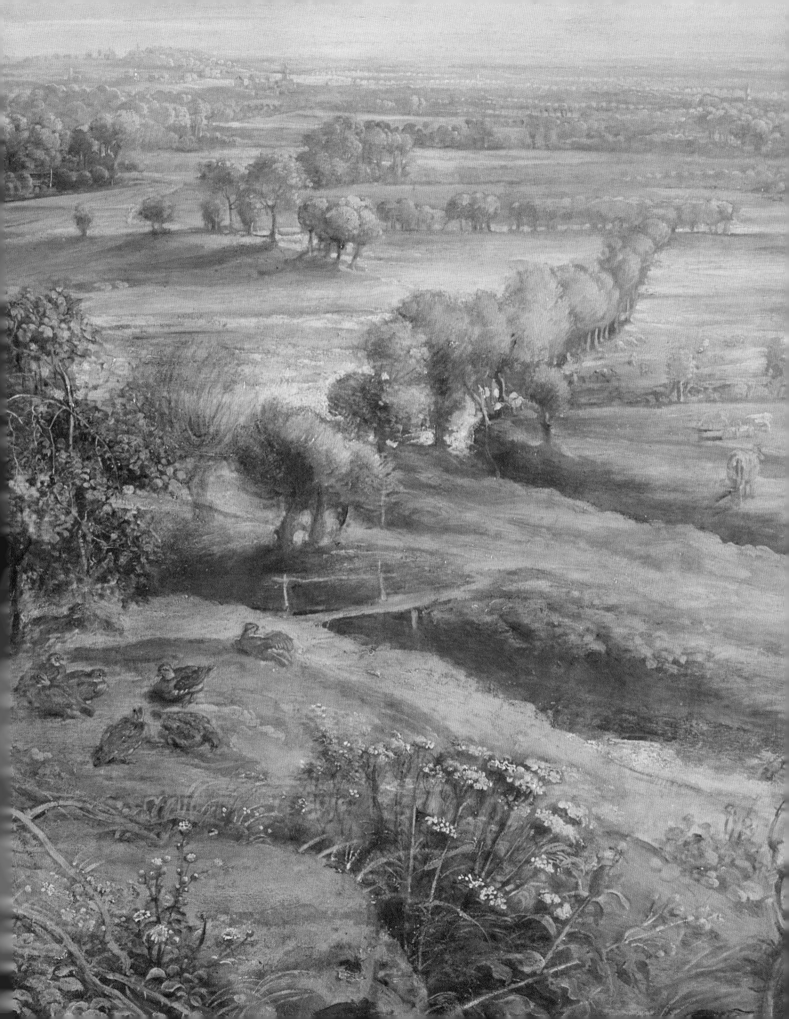

2 pheasants
1 carrot, roughly chopped
1 onion, roughly chopped
1 celery stick, roughly chopped 1 Cox apple
500ml chicken stock 2 heads chicory, halved lengthways
2tbsp dry white wine 75g butter, diced
About 200ml melted duck fat 1tbsp vegetable oil
 or vegetable oil Horseradish cream (page 254), to serve

SERVES FOUR

PHEASANT COOKED TWO WAYS

Everyone expects to see a whole bird come out of the oven perfectly cooked.
This is true of the turkey at Christmas, and also of game birds like pheasant.
For the cook this is unrealistic, as the legs and breast take different times
to cook. Here they are cooked separately, which is the key to perfection.

1 Set the oven at 160°C. Remove the legs and breasts from the
pheasants and set aside. Chop the carcasses and place in a roasting
tin with the carrot, onion and celery. Roast for about 20 minutes
or until browned. Transfer the bones and vegetables to a saucepan,
and reduce the oven to 120°C.

2 Pour the stock into the saucepan and bring to the boil. Simmer
uncovered for 25 minutes. Strain the stock into a clean pan and
simmer until reduced to about 100ml of thin gravy. Set aside.

3 Put the pheasant legs in a casserole, add the wine and cover with
the duck fat (the legs should be totally immersed). Cover and cook
in the oven for about 2 hours or until the meat is falling off the
bones. Remove and set aside. Increase the oven to 150°C.

4 Quarter, core and thinly slice the apple. Insert the slices between
the chicory leaves. Place the chicory in a baking dish and dot with
50g of the butter. Place in the oven and roast for about 40 minutes
or until caramelised on all sides, turning and basting frequently.

5 Heat the oil in a frying pan. Season the pheasant breasts and place
skin-side down in the oil. Add the remaining 25g butter and fry
gently for 5–6 minutes until golden and cooked through, turning
halfway. Remove from the heat and leave to rest for 2–3 minutes.

6 Lift the legs out of the casserole and pat off the excess fat with
kitchen paper. Cut each breast in half on the diagonal. Reheat
the gravy. Serve each person with a leg, two pieces of breast and
a chicory half. Hand the gravy and horseradish cream separately.

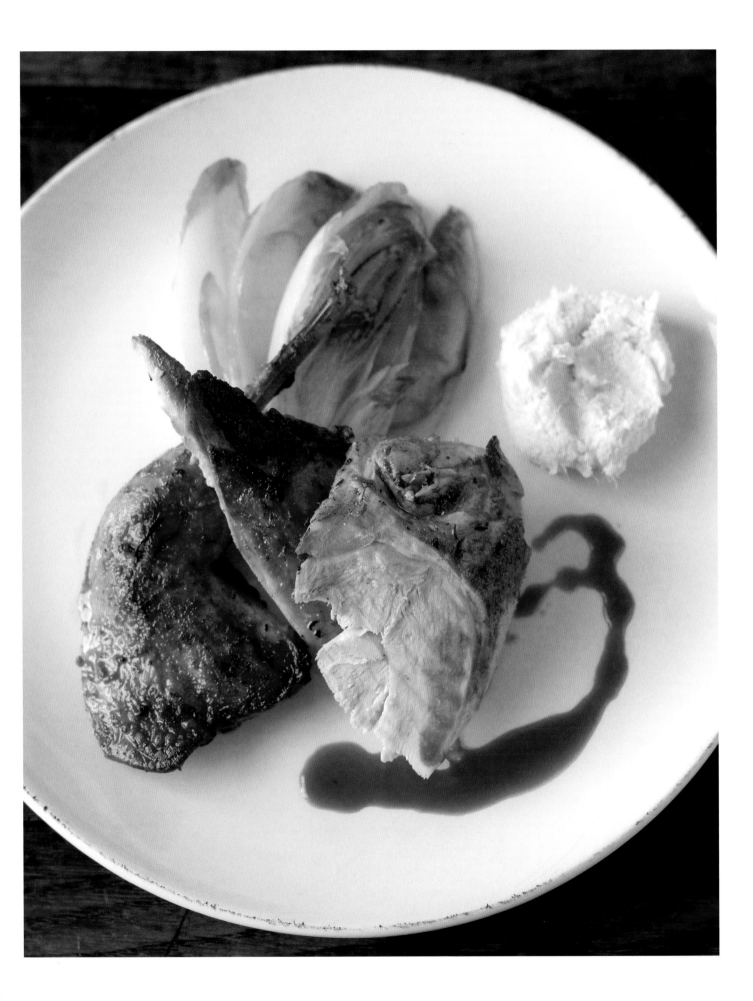

1 rib of beef with 2 bones, weighing
 about 1.8kg, plus the chopped
 bones from the bottom of the rib
4 heaped tbsp English mustard powder
50g soft butter
Yorkshire puddings (page 256), to serve

FOR THE PURÉE
500g watercress
50g butter
2 shallots, finely sliced
150g fresh young shelled peas
 or frozen peas
250ml hot vegetable stock

SERVES FOUR

ROAST RIB OF BEEF WITH A WATERCRESS AND PEA PURÉE

A rib of beef provides a talking point at any dinner table, and cooking it on the bone is the best way to get the tastiest meat. Organic British beef is superb, and these days you don't have to travel far to find a good butcher who sells it.

1 Set the oven at 220°C. Weigh the rib of beef and calculate the cooking time: for rare meat, allow 30 minutes per kg, plus an extra 20 minutes; for medium-rare, allow 35 minutes per kg, plus an extra 20 minutes; for well-done, allow 38 minutes per kg, plus an extra 20 minutes.

2 Mix the mustard powder into the soft butter and smear all over the beef. Stand the joint in a roasting tin, resting it on the chopped bones, and roast for 10 minutes. Reduce the oven temperature to 180°C and continue roasting for the remainder of the calculated time.

3 Meanwhile, make the purée. Reserve a few watercress sprigs for the garnish; remove the stalks from the remainder and coarsely shred the leaves. Heat a pan and melt half the butter until foaming. Add the shallots and cook until softened. Add the peas, stock and remaining butter and cook for 3–4 minutes. Add the shredded watercress, stir well and immediately remove from the heat. Cool for a minute or so before puréeing in a blender until smooth.

4 Take the rib of beef out of the oven and place on a warmed carving dish. Cover loosely with foil and leave to rest for at least 15 minutes. Meanwhile, reheat the purée.

5 To serve, cut out and remove one of the bones from the joint, then carve the meat into thick slices. Garnish with watercress sprigs and serve with the purée. Hand Yorkshire puddings separately.

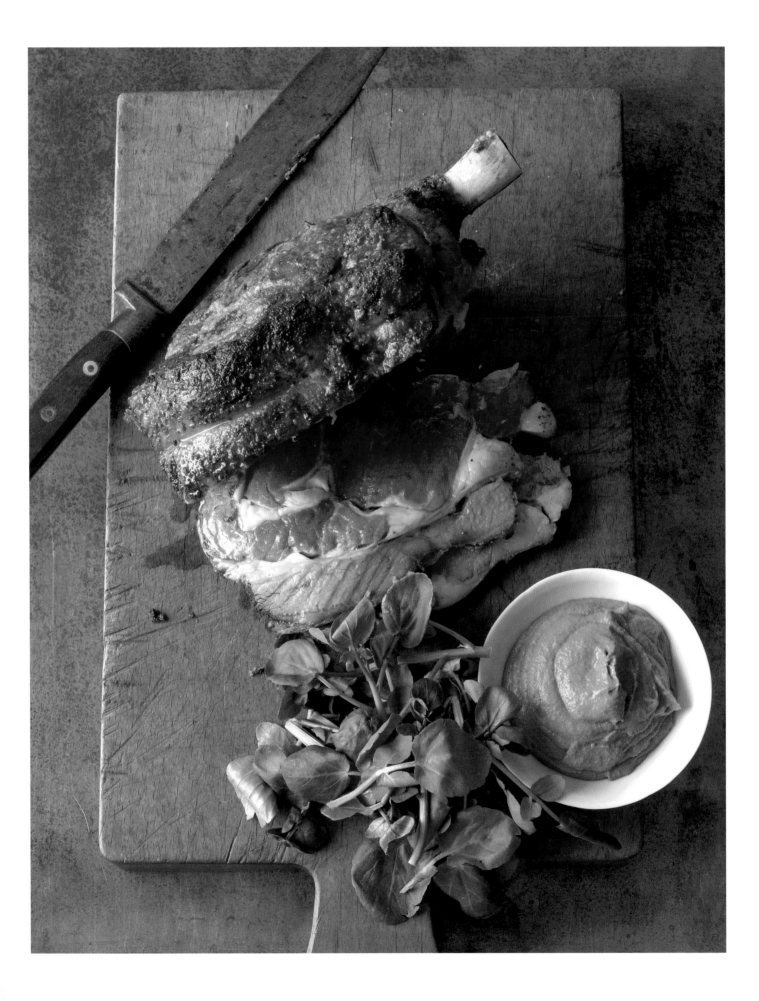

1kg boneless pork belly, with skin scored
2tbsp vegetable oil
20g pearl barley
1 Cox apple, peeled, cored and cut into 5mm dice
150g black pudding, skinned and cut into 5mm dice
3 sprigs of fresh marjoram, leaves shredded
1tbsp sherry vinegar
1tbsp medium sherry
80g watercress, stalks trimmed

SERVES FOUR

PORK BELLY WITH BLACK PUDDING AND APPLE

There's nothing worse than having too much fat on pork belly, and the way to avoid this is by skilful cooking. It's a fine balancing act: you need to get just the right amount of fat rendered off the meat to leave it perfectly succulent, but at the same time you must have crackling so crisp that it shatters when you tap it with a knife. This recipe shows how it's done.

1 Set the oven at 140°C. Cut the pork into four equal pieces. Sprinkle salt and pepper on the meat side, and salt only on the skin.
2 Brush a heavy roasting tray with 1tbsp of the oil and put the pork skin-side up in the tray. Roast for 1½ hours. Turn the oven up to 200°C and roast the pork for a further 30 minutes or until the skin begins to look like glass.
3 Meanwhile, put the pearl barley in a small saucepan and cover with cold water. Bring to the boil, then cover and simmer gently for about 45 minutes or until tender. Drain and set aside.
4 Gently heat the rest of the oil in a pan and fry the apple and black pudding for about 10 minutes or until cooked. Add the pearl barley, marjoram, vinegar and sherry and boil to reduce slightly. Season to taste.
5 Spread the black pudding and apple mixture in the centre of four warmed plates. Put the pork belly on top and surround with the watercress sprigs.

500–600g lambs' sweetbreads

100g smoked streaky bacon rashers (without rinds), cut into matchsticks

½ small onion, diced

1 small carrot, diced

1 celery stick, diced

225g Puy lentils, soaked in cold water overnight and drained

2tbsp vegetable oil

1 shallot, finely chopped

500g mixed mushrooms (e.g. oyster, chanterelle, chestnut, portabello), cut into large bite-sized pieces

25g butter

3tbsp white port or sweet dessert wine

200ml hot chicken stock

SERVES FOUR

BRAISED SWEETBREADS WITH LENTILS AND MUSHROOMS

Offal had all but lost its place at the table in this country, but now we're on the cusp of a revival as more and more people are realising just how good it is. If you're relatively new to eating offal, sweetbreads are a good place to start because they're tender and tasty without being too strong. Here they are braised with lentils, bacon and mushrooms, three robust ingredients that go well with their earthy flavour.

1 Remove any excess fat from the sweetbreads, then soak them in a bowl of cold water for at least 2 hours, changing the water frequently. Drain the sweetbreads and plunge into a saucepan of salted boiling water. Bring back to the boil and simmer for 3 minutes. Drain and refresh under cold running water.

2 Set the oven at 150°C. Heat a large flameproof casserole over a low to medium heat and cook the bacon for about 10 minutes to melt the fat. Remove the bacon from the pan with a slotted spoon and reserve it. Soften the diced vegetables in the bacon fat for a few minutes. Return the bacon to the pan, then add the lentils and toss to combine. Set aside.

3 Heat 1tbsp of the oil in a frying pan. Season the sweetbreads and colour on all sides in the hot oil. Remove and set aside.

4 Heat the remaining oil in the frying pan, add the shallot and soften for a few minutes without colouring. Add the mushrooms and butter and toss to combine. Add the port and boil to reduce by half. Add the stock and reduce by half, then combine with the lentil mixture in the casserole. Place the sweetbreads on top. Cover the casserole with a lid and braise in the oven for about 30 minutes or until the sweetbreads and lentils are tender. Serve hot.

½ leg of mutton, weighing about 1.25kg,
 thigh bone removed and chopped
4tsp vegetable oil
200ml hot lamb or chicken stock
4tsp made English mustard
4tsp chopped fresh chives
4tsp chopped fresh flat-leaf parsley
2tsp finely chopped fresh thyme
2tsp finely chopped fresh rosemary
Redcurrant jelly, to serve

SERVES FOUR

LEG OF MUTTON WITH MUSTARD AND HERBS

Most people have a problem with mutton because they think it is always boiled and tough. In this recipe the mutton is roasted rare, so it's pink and juicy – the complete antithesis of what we expect. Mutton cooked this way is as tender and tasty as the best spring lamb.

Jan Jansz. Treck, 1605/6–1652
***Still Life with a Pewter Flagon
and Two Ming Bowls* (detail), 1649**

The muted tones of this still life play down the sumptuousness of the precious objects on display. The two bowls (just seen here) are late Ming blue and white, of a type first imported into Holland not long before this picture was painted. The blue has discoloured over the years because the artist used smalt, a chemically unstable pigment.

1 Set the oven at 190°C. Smear the mutton with the oil and season well. Sear over a high heat in a roasting tray until well coloured all over, then place in the oven with the chopped thigh bone. Roast for about 50 minutes or until 45°C in the centre when tested with a meat thermometer.

2 Remove the meat from the tray and place on a wire rack set over a plate to collect the juices. Cover with foil and leave to rest while you make the gravy.

3 Put the roasting tray over a high heat on top of the stove. Pour in the stock and bring to the boil, stirring constantly and scraping up all the residue from the tray. Add any collected meat juices from the plate and continue boiling to reduce until you have enough gravy for four people. Remove the bones.

4 Brush the leg all over with the mustard, then roll in the mixed herbs to cover completely. Slice the meat and serve with the gravy and redcurrant jelly on the side.

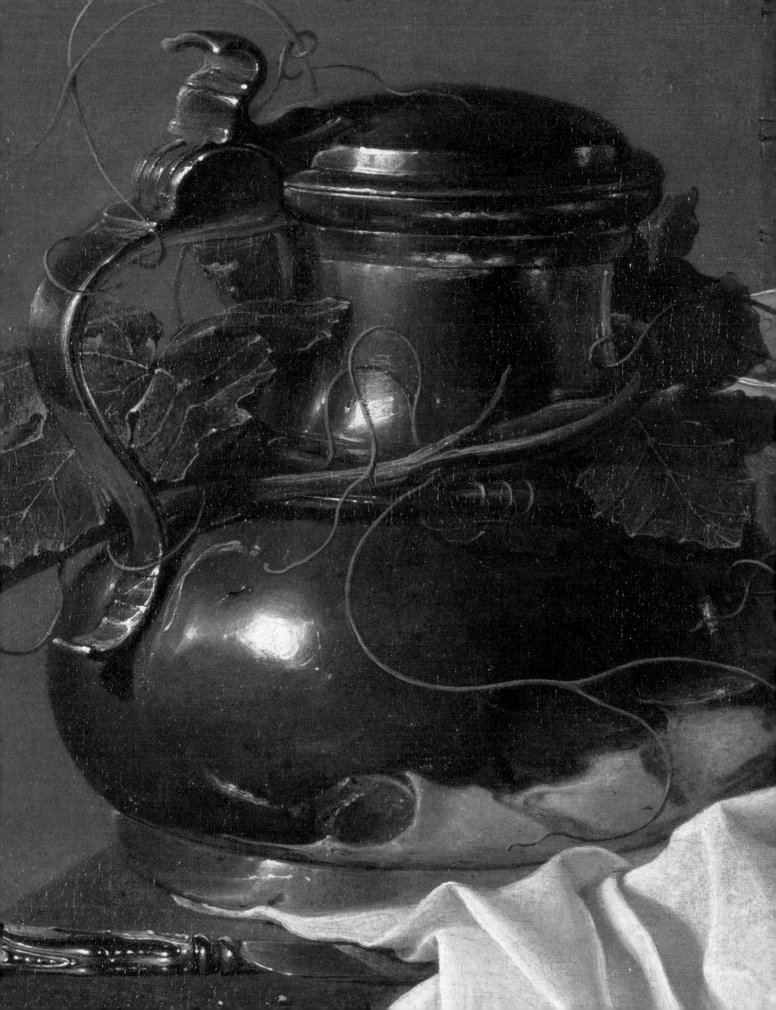

500g floury potatoes (Maris Piper,
 King Edward or Desirée),
 peeled and diced
1tsp curry powder
200g butter, diced
150g plain flour
50g currants
½tsp cumin seeds

FOR THE ROAST PUMPKIN
1 small pumpkin or piece of pumpkin,
 weighing about 1kg
50g butter, melted
1tbsp honey
¼tsp ground allspice
2.5cm piece of fresh root ginger,
 peeled and cut into matchsticks
1tbsp vegetable oil

SERVES FOUR

CUMIN AND CURRANT POTATO CAKES WITH ROAST PUMPKIN

The influence of Indian food on modern British cuisine has awakened our tastebuds far more than anything else, and future generations will consider curry to be just as English as Bakewell pudding. The potato cake has long been traditional British fare, but this curried version is more adventurous than usual.

1 Set the oven at 160°C. Remove the seeds from the pumpkin, and wash and dry them. Cut the pumpkin into small wedges and peel off the skin. Place the wedges on a roasting tray and brush with the melted butter mixed with the honey and allspice. Sprinkle the ginger on top. Cover with foil and roast for 30–40 minutes until tender.

2 Meanwhile, mix the seeds with the oil and ½tsp salt and spread over a baking tray covered with non-stick baking parchment. Roast in the oven with the pumpkin for about 15 minutes or until golden brown (the seeds will pop and jump about).

3 Make the potato cakes while the pumpkin and seeds are roasting. Put the potatoes into a saucepan of salted cold water, cover and bring to the boil, then simmer for 15–20 minutes until tender. Drain well and toss with the curry powder, then push through a potato ricer or sieve into a bowl (or mash vigorously until smooth). Add half of the butter and stir until melted into the potato, then add the flour and currants with seasoning to taste and mix well. Shape into eight round cakes. Press the cumin seeds into one side of each cake.

4 Melt the remaining butter in a frying pan until foaming. Add the potato cakes and fry over a medium heat for about 5 minutes on each side or until golden. Serve the potato cakes cumin-side up, with the pumpkin and roasted seeds.

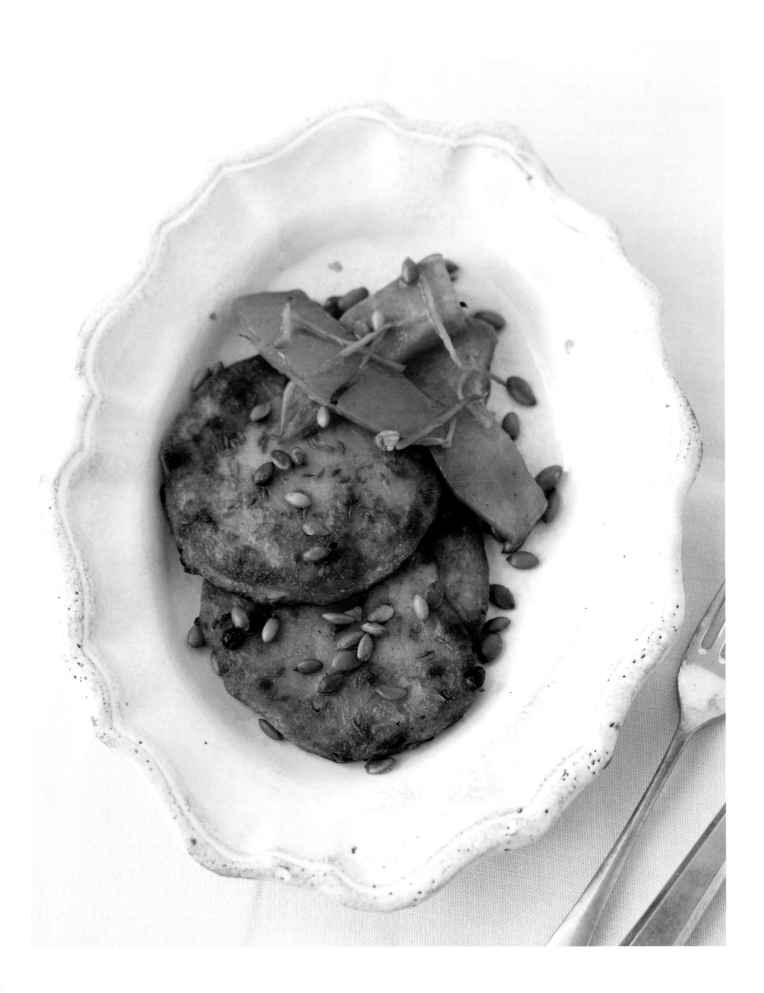

1 large vegetable marrow, weighing about 1.25kg
100g butter, diced
2 onions, finely chopped
2 garlic cloves, crushed
2 heaped tsp grated fresh root ginger
1tbsp chopped mixed fresh rosemary and thyme
350g red plums (e.g. Victoria), halved and stoned
500g cobnuts, shelled and coarsely chopped
150g field mushrooms, quartered, or sliced if large
4 ripe tomatoes, chopped

SERVES FOUR

MARROW STUFFED WITH COBNUTS AND PLUMS

Anyone coming to your house in the autumn will be impressed with this seasonal combination. Living in an urban area is no excuse – this is an opportunity to free yourself from the shackles of the supermarket and learn to cook with ingredients that change with the season. Enjoy nature's bounty – nothing could be more quintessentially English than marrow, cobnuts and plums.

1 Set the oven at 170°C. Split the marrow in half lengthways and remove the seedy, central pith. Place the two halves cut-side up on a baking tray.

2 Melt half of the butter in a frying pan and soften the onions, garlic and ginger with the herbs. Tip into a bowl and add the plums, nuts, mushrooms and tomatoes. Mix well and add seasoning to taste.

3 Divide the filling between the marrow halves and dot with the rest of the butter. Cover with foil and bake for about 1 hour or until the marrow is tender when pierced with a skewer. Serve hot.

4 large, wide-cap mushrooms
2tbsp vegetable oil
½ small onion, finely chopped
25g fresh wholemeal breadcrumbs
1tsp dried marjoram
30g pine nuts or sunflower seeds
85g drained canned sweetcorn kernels
Fresh flat-leaf parsley, to garnish

SERVES FOUR

STUFFED MUSHROOMS

If you are lucky enough to find wild field mushrooms for this healthy dish, you will be more than halfway there in terms of body and flavour. Field mushrooms are strong and punchy, with an earthiness you will never get from the bland mushrooms sold in the shops all year round.

1 Set the oven at 170°C. Wipe the mushrooms clean, then remove and finely chop the stalks. Heat 1tbsp of the oil in a frying pan and soften the onion over a low heat for a few minutes. Add the mushroom stalks and cook for a few minutes, stirring frequently, until tender. Remove from the heat and mix in the breadcrumbs, marjoram, pine nuts and sweetcorn. Season with plenty of pepper and a pinch of salt.

2 Place the mushroom caps, gills up, in a shallow baking dish and pile the filling into them. Drizzle with the remaining oil. Bake for about 15 minutes or until the filling is becoming crisp and brown on top. Serve hot, garnished with parsley.

50g panko breadcrumbs
175g yellow lentils (dhal), soaked
 in cold water for 12 hours
1tbsp vegetable oil
2 celery sticks, finely chopped
2 fresh sage leaves, finely chopped
1 small fresh thyme sprig, leaves only

1 small fresh rosemary sprig, leaves only
125g peeled roasted chestnuts
 (fresh, frozen or vacuum-packed),
 coarsely chopped
1tbsp chopped fresh flat-leaf parsley
4 large red onions
1tsp vegetable oil

SERVES FOUR

ROASTED RED ONIONS WITH A CHESTNUT AND LENTIL STUFFING

In the autumn, especially around Bonfire Night, there's something about the smoky smell of roasting chestnuts that seems to get under your skin. Here they're partnered with red onions and lentils, which complement them so well.

1 Set the oven at 180°C and make the stuffing. Spread the breadcrumbs on a baking tray and bake for 5–7 minutes until golden, shaking the tray once or twice. Set aside.

2 Drain the lentils, tip them into a saucepan and add twice their volume of fresh water. Cover the pan and bring to the boil, then simmer for 25–30 minutes until the lentils are soft but still retaining their shape. Drain well.

3 Heat the oil in a saucepan and add the celery, sage, thyme and rosemary. Cover the pan and cook gently for 10 minutes, stirring occasionally. Add the chestnuts and cook for a minute, then add the lentils, breadcrumbs and parsley. Season well and leave to cool.

4 Peel the onions and cut a thick slice off each root end so that the onions will sit flat. Cut off the tops and discard. Rub the oil all over the onions and sprinkle with pepper. Roast for 20–30 minutes until they start to soften. Leave until cool enough to handle.

5 Push the flesh out through the bottom of each onion to leave a hollow shell. Chop half of the flesh and mix into the stuffing. Turn the onions upside down and fill with stuffing, then sit them the right way up on a greased baking tray. Squeeze the leftover stuffing into balls and place on the tray alongside the onions.

6 To finish, roast the onions at 180°C for 30 minutes. Serve hot.

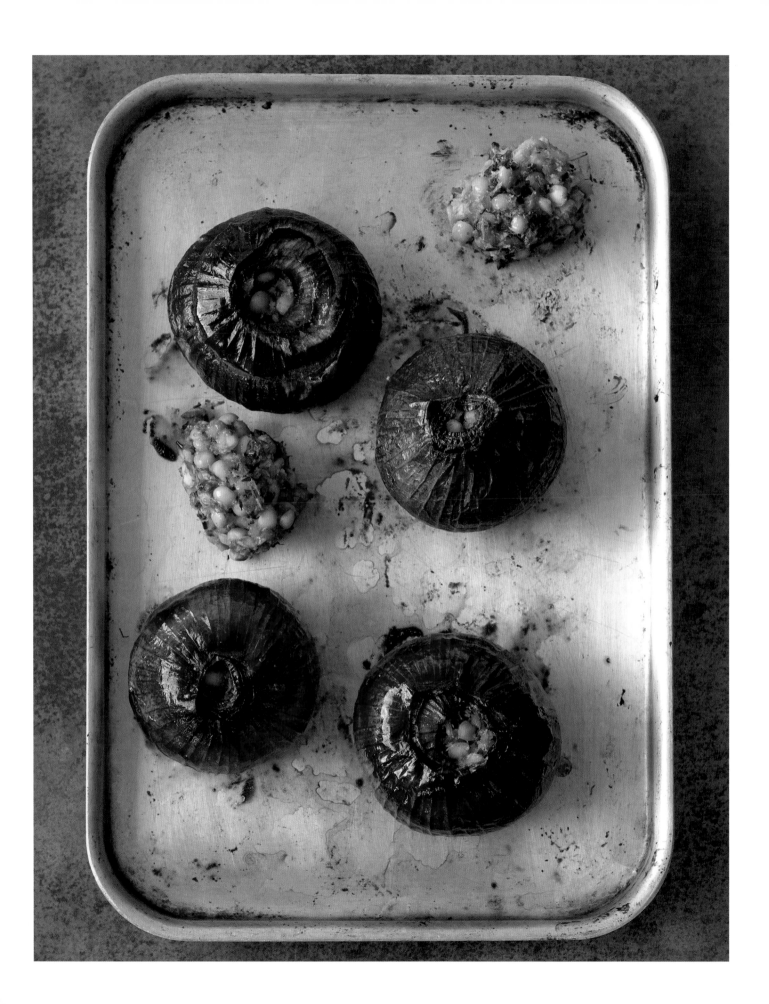

150g swede
150g carrots
150g turnips
150g parsnips
1 bunch of red radishes
4tbsp vegetable oil

FOR THE BATTER
3 eggs
115g plain flour
275ml milk

SERVES FOUR

ROOT VEGETABLE TOAD-IN-THE-HOLE

When root vegetables are roasted, their sugars caramelise. This enhances the colour and brings out the flavour, and the juices seep into the batter to give a mouthwatering result. The dish is delicious as it is, but you could include some chopped fresh rosemary or thyme, sesame seeds or crushed garlic, or even a sprinkling of chopped red chillies if you want to add some fire.

Follower of Quinten Massys, 1465–1530
Saint Luke painting the Virgin and Child (detail), about 1520?

According to legend, Saint Luke painted the Virgin and Child and he is therefore often shown at an easel or with brushes and palette in hand. The theme was especially popular with Netherlandish painters of the fifteenth and sixteenth centuries.

1 Make the batter by whisking the eggs in a bowl, then mixing in the flour and a pinch of salt. Slowly add the milk, whisking all the time, until you have a runny batter. Leave to rest, covered, for about an hour.

2 Set the oven at 220°C. Peel the swede, carrots, turnips and parsnips and cut into small, even-sized wedges. Trim the leaves and stalks off the radishes, then cut the radishes in half lengthways.

3 Mix the vegetables and oil in a roasting tin (about 30 × 20cm), spreading the vegetables out in an even layer. Roast for 15 minutes.

4 Pour the batter over the vegetables and bake for 30–35 minutes until the batter is puffed and golden brown. Serve hot.

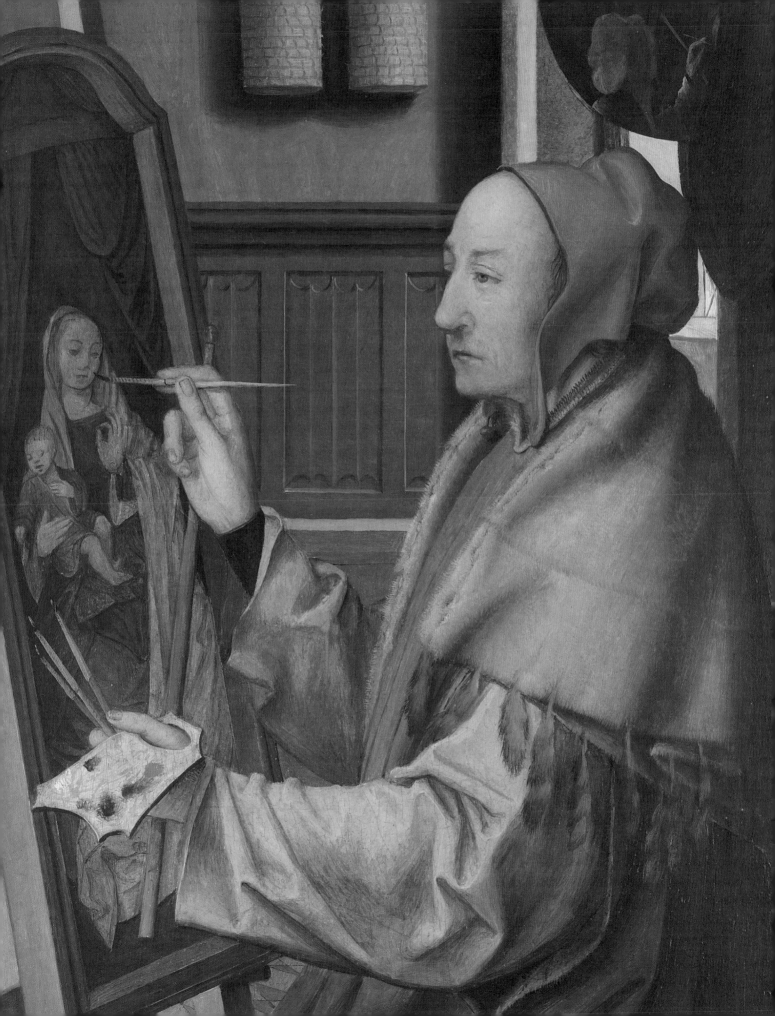

1 piece of pumpkin or butternut squash,
 weighing about 750g
2tbsp vegetable oil
1 onion, chopped
500g mixed mushrooms (oyster, chanterelle,
 black ear, chestnut, field), chopped

250g baby spinach leaves
150g log goat's cheese
4 pancakes (page 256)
375g rectangular ready-rolled
 puff pastry (thawed if frozen)
1 egg, beaten

SERVES FOUR

PUMPKIN, SPINACH AND MUSHROOM WELLINGTON

You want to make a special effort when you cook for vegetarians, especially if you are entertaining meat-eaters at the same time. This dish makes a big visual impact, both when it's brought to the table and when it's served in slices on the plate. It tastes really good, too.

1 Set the oven at 180°C. Peel the pumpkin and discard the seeds, then cut 12 even-sized strips out of the flesh. Place the strips on a roasting tray and rub with half of the oil and seasoning to taste. Roast for about 40 minutes or until tender.

2 Meanwhile, cook the onion in the remaining oil for a few minutes or until soft. Add the mushrooms with some seasoning and cook until they are tender and all the juices have evaporated. Leave to cool.

3 Plunge the spinach into a saucepan of salted boiling water, stir and bring back to the boil. Drain well and squeeze out the excess water, then chop roughly. Cut the goat's cheese lengthways into quarters.

4 Remove the pumpkin from the oven; leave the oven on. Lay the pancakes side by side in two rows, overlapping them so there are no gaps in between, to make a rectangular shape. Cover with the spinach, then spread the mushrooms on top. Now lay half of the pumpkin strips over the mushrooms. Top with the goat's cheese followed by the remaining pumpkin strips.

5 Lay the sheet of pastry on a floured surface. Wrap the pancakes around the filling to make a parcel and place seam-side down on the pastry. Brush the edges of the pastry with the egg, then bring up the long edges to overlap in the middle slightly. Brush with egg to seal, then turn the parcel over and fold under the short ends.

6 Place the parcel on a baking sheet covered with non-stick baking parchment and brush all over with egg. Bake for 30–35 minutes until the pastry is golden brown. Serve hot.

Sweet pastry (page 257)
1 egg, beaten
1tsp caster sugar

FOR THE FILLING
115g light soft brown sugar
100g caster sugar
2tsp plain flour
Juice of 1 lemon
1tsp ground cinnamon
1.25kg mixed cooking and dessert
 apples, peeled, cored and sliced
175g raisins

SERVES EIGHT
APPLE PIE

For most of us, the perfect apple pie has a high dome with lush layers of thickly sliced, sweet and juicy apples. Getting this right is more tricky than you might think. There's a tradition in this country, especially in the north of England, of stewing the apples before they go into the pie, but the modern way is to use a mixture of sliced raw apples, both sharp cookers and sweet dessert varieties. This gives different textures and flavours throughout the pie, as well as height.

1 Combine the sugars for the filling in a large bowl with the flour, lemon juice and cinnamon. Add the apples and raisins and stir until the fruit is well coated. Cover and set aside for about half an hour.

2 Meanwhile, grease a deep 23cm pie dish with butter and dust with flour. Take one-quarter of the pastry and reserve for the lid. Roll out the rest and use to line the dish.

3 Set the oven at 200°C. Spoon the apple mixture into the dish. Roll out the reserved pastry to make a lid and place on top of the filling, then seal the pastry edges with water, and trim and flute them. Cut a hole in the middle of the lid to allow the steam to escape during baking. Lightly glaze the top of the pie with beaten egg and sprinkle with the sugar.

4 Bake the pie for about 55 minutes or until the apples feel tender when pierced with a skewer. Cover the pie with foil after about 30 minutes when the pastry turns golden brown. Cool on a wire rack for about 30 minutes before serving.

Joachim Beuckelaer, active 1560–1574
The Four Elements: Earth (detail), 1569

The produce is depicted with tremendous bravura; vegetables tumble from the basket and cascade towards the viewer. Sixteen different varieties of vegetable and fruit have been identified in this picture.

250g whole Medjool dates,
 pitted and chopped
175g self-raising flour
1tsp bicarbonate of soda
60g soft butter
125g dark muscovado sugar
2 eggs, beaten
1tbsp black treacle
100ml milk
Vanilla custard (page 255), to serve

FOR THE SAUCE
250g light muscovado sugar
75g butter, diced
400ml whipping or double cream

SERVES EIGHT

STICKY TOFFEE PUDDING

Invented in the Lake District, this pudding has become a national favourite and there are many variations. What it must have is a real sense of toffee, and the way to get this is to use plenty of good sticky dates, dark muscovado sugar and black treacle. Soaking the sponge in the sauce at the end is truly inspired.

1 Start the pudding the day before serving. Put the dates in a bowl with 150ml boiling water and soak for about half an hour. Set the oven at 160°C. Grease an 18cm square cake tin, line the bottom with non-stick baking parchment and dust the sides with flour.

2 Sift the flour and soda into a bowl. Cream the butter and sugar together in another bowl until fluffy and paler in colour. Beat in the eggs a little at a time. Beat in the treacle, then gently fold in the flour and milk using a large metal spoon. Take care not to overmix.

3 Lightly mash the soaked dates with a fork, then stir them into the pudding mixture. Pour into the cake tin and place in the oven on a baking sheet. Bake for about 45 minutes or until the top of the pudding feels springy when gently pressed.

4 Make the sauce. Put the sugar and butter in a saucepan with half of the cream. Bring slowly to the boil over a medium heat, stirring until the sugar has dissolved. Simmer for 4–5 minutes until the sauce is a rich toffee colour, stirring occasionally. Remove from the heat and stir in the rest of the cream.

5 Remove the pudding from the oven and slowly pour half of the sauce over it. Cool, then cover the tin and leave the pudding to soak in the fridge for 24–48 hours. Keep the rest of the sauce in the covered pan in the fridge.

6 To finish, reheat the pudding in a 140°C oven for 20 minutes. Reheat the remaining sauce in the pan on top of the stove. Serve the pudding cut in squares, with the extra sauce and custard.

8 thin slices of bloomer or other
 white bread, crusts removed
50g soft butter
About 3tbsp orange marmalade
50g currants
3 eggs
275ml milk
4tbsp whipping or double cream
50g caster sugar
Finely grated zest of ½ lemon
Whole nutmeg, for grating

SERVES FOUR

MARMALADE BREAD AND BUTTER PUDDING

Choosing the ingredients for a simple pudding like this is more important than in a complicated recipe where they might go unnoticed. A traditional-style bloomer loaf soaks up the custard well and gives it a good flavour and texture. If you arrange the slices in a neat pattern, it will look good too. As for the marmalade, avoid high-sugar varieties and go for the thick-cut, chunky kind. Use as much of the peel as you can, then you will see, feel and taste the marmalade with every spoonful.

**Carlo Crivelli,
about 1430/5–about 1494
La Madonna della Rondine
(*The Madonna of the Swallow*)
(detail), after 1490**

This altarpiece represents the Virgin and Child enthroned with Saints Jerome and Sebastian, but it is named after the swallow (*rondine* in Italian) perched above, which may be intended as a symbol of the Resurrection. According to legend, Saint Jerome removed a thorn from a lion's paw, and is often shown with a tame lion – one of the saint's 'attributes' or identifiers.

1 Set the oven at 180°C. Liberally grease the bottom and sides of a 1 litre baking dish with butter.
2 Spread both sides of the bread with butter, then spread marmalade on one side. Cut each slice into two triangles.
3 Layer half of the triangles in the dish, pointing them all in the same direction and marmalade-side up. Scatter half of the currants evenly on top. Cover with the remaining bread, arranging the triangles in the opposite direction to the first layer. Sprinkle the remaining currants evenly on top.
4 Whisk the eggs in a jug with the milk, cream, sugar and lemon zest. Pour this mixture over the pudding and grate nutmeg liberally on top. Bake for 40–45 minutes until the custard is set and the pudding is golden brown. Serve warm.

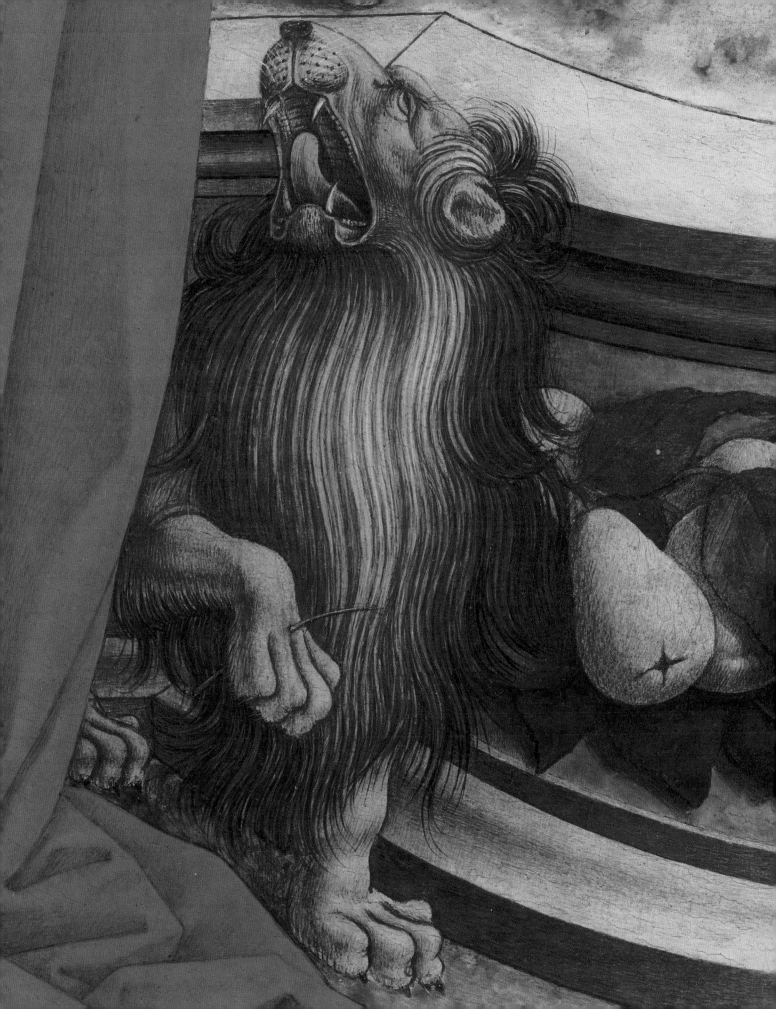

450g blackcurrants or blackberries
900g Bramley apples
25g light or dark soft brown sugar
1tsp ground cinnamon
¼tsp ground cloves

FOR THE CRUMBLE
225g plain flour
1tsp baking powder
75g butter, diced
150g light or dark soft brown sugar
100g blanched hazelnuts, toasted
 and coarsely chopped

SERVES SIX

APPLE AND BLACKCURRANT CRUMBLE

Crumble is all about striking a happy balance. If you think of it as a fruit pudding you'll get it right – it should be about two-thirds fruit and one-third crumble. Made really fruity like this, you could be forgiven for thinking you're eating a healthy pud. Top it off with an indulgent scoop of ice cream, and you needn't feel guilty.

1 Set the oven at 180°C. Strip the blackcurrants from their stalks. Peel, core and slice the apples. Put the apples in a saucepan with the sugar and spices, and sprinkle with 2tbsp water. Cover and cook gently, stirring occasionally so the apples don't catch on the bottom of the pan, for about 25 minutes or until the apples are soft and fluffy. Spoon the apples into a baking dish measuring about 25 × 18cm and 5cm deep, and top with the blackcurrants.

2 For the crumble, sift the flour and baking powder into a bowl. Add the butter and rub it into the flour with your fingertips until it resembles sand. Add the sugar and hazelnuts and stir to combine well.

3 Sprinkle the crumble over the fruit. Use a fork to even it out, but don't press it down at all. Bake for about 30 minutes or until the crumble is tinged golden brown. Serve hot.

200g good-quality puff pastry
 (preferably made with butter)
150g good-quality Victoria plum jam
100g soft butter
100g caster sugar
25g ground almonds
¼tsp almond oil or extract
4 egg yolks
2 egg whites

SERVES SIX

VICTORIA PLUM BAKEWELL PUDDING

This simple English pudding is one of the best in the world, yet over the years Bakewell tart has taken over. The tart is not the same thing at all, and nowhere near as good. Puff pastry is used for the pudding, not shortcrust like the tart, and the filling is rich and sumptuous with butter and eggs – and no flour whatsoever. It's a classic example of how history has ruined a perfectly good recipe. Now is the time to turn the clock back.

1 Set the oven at 180°C, with a heavy baking sheet inside. It is important that the sheet is hot when the pudding goes in the oven, or the pastry will not cook properly.

2 Roll out the pastry on a floured surface and line a loose-bottomed 20cm tart tin that is 2.5cm deep, letting the pastry hang over the edge of the tin slightly. (This will ensure the pastry does not shrink back too far during baking.) Spread the jam evenly over the bottom of the pastry case.

3 Beat the butter and sugar together until light and fluffy. Mix in the ground almonds and almond oil, then gradually mix in the egg yolks. In a separate bowl, whisk the egg whites to soft peaks. Fold the whisked whites into the almond mixture. Pour and spread lightly over the jam in the pastry case.

4 Place the tart tin on the hot baking sheet. Bake for 40–45 minutes until the pastry is golden brown and the filling is set. Check after 30 minutes and cover the top with foil if it is getting too dark.

5 Remove from the oven and leave to cool slightly (the top will sink a little), then carefully trim off the excess pastry with a sharp knife to give a clean edge. Serve warm.

600ml full-fat milk
360ml Jersey double cream
150g caster sugar
Finely grated zest of 1 orange
1 vanilla pod, split lengthways
½ cinnamon stick
150g short-grain pudding rice

CREAMY RICE PUDDING

Anyone who says they don't like rice pudding hasn't had one like this. A good rice pud is rich and creamy, so you need a lot of very good cream. Jersey cream is the absolute best for richness, and it's worth going out of your way to buy some especially for this rice pudding. One word of caution: you need to be subtle with the spicing, so don't add more cinnamon than the amount here or you will kill the vanilla and overpower the whole dish.

1 Set the oven at 140°C. Bring the milk and cream to a simmer in a saucepan over a low heat. Add the sugar, orange zest, vanilla pod and cinnamon. Bring the milk slowly to a simmer again, stirring to help dissolve the sugar.

2 Remove the cinnamon stick. Add the rice to the milk and stir well to mix, then pour into a 1.2 litre baking dish. Bake for about 1½ hours or until the rice is tender, giving the pudding a stir after the first 30 minutes to ensure the rice doesn't stick to the bottom of the dish. Serve hot or cold.

FOR THE SPONGE

3 eggs

85g caster sugar

85g plain flour, sifted

30g butter, melted and cooled

250ml cream sherry

4tbsp brandy (optional)

4tbsp raspberry jam

450g blackberries

450g raspberries

Syllabub (page 255)

30g flaked almonds, toasted

FOR THE CUSTARD

4 egg yolks

100g caster sugar

500ml whipping or double cream

SERVES TEN

NATIONAL DINING ROOMS TRIFLE

Here is a classic that deserves to be presented in a cut-glass bowl so you can see the layers of cake, fruit and custard underneath the creamy top. This is a traditional boozy version for adults, so if you're making it when children will be at the table, reduce the amount of sherry and omit the brandy. The taste of too much alcohol could put them off trifle for life, which would be a terrible shame.

1 Make the sponge. Set the oven at 170°C. Grease a Swiss roll tin measuring 30–33 × 20–23cm, and line the bottom with non-stick baking parchment. Whisk the eggs with an electric hand whisk to break them up, then whisk in the sugar until evenly combined. Set the bowl over a pan of gently simmering water and whisk for about 5 minutes or until the mixture leaves a ribbon trail when the whisk is lifted. Remove the bowl from the pan and fold in the flour and melted butter. Pour into the tin. Bake for about 15 minutes or until the cake springs back when lightly pressed. Let cool slightly before removing from the tin, then leave on a wire rack until cold.

2 Cut the cake into squares and place in a large serving bowl (about 2 litres). Pour over the sherry and the brandy (if using), and let them soak in while you warm the jam in a small pan. Drizzle the jam over the cake, then scatter the fruit over the jam.

3 Make the custard. Whisk the egg yolks and sugar in a bowl to mix. Heat the cream in a heavy saucepan and whisk into the yolk mix. Return to the saucepan and bring just to the boil, whisking constantly (don't allow to boil). Cook gently for 3–5 minutes until the custard is thick enough to coat the back of a spoon. Strain and cool. When tepid, pour over the fruit. Spoon the syllabub over the custard. Cover the trifle and chill for several hours.

4 Before serving, sprinkle the top of the trifle with the almonds.

225g walnut halves
200g caster sugar
200g soft margarine
4 eggs
200g self-raising flour
2tbsp coffee essence

TO FINISH
250g full-fat soft cheese
45g light muscovado sugar

SERVES TEN

COFFEE AND WALNUT CAKE

A genuine English teatime cake, this just asks to be eaten in slabs, not slices. Definitely no dainty cake forks or fine pâtisserie here. This kind of earthy, wholesome cake needs no embellishment to show it off. The brown sugar icing studded with nuts is simple and restrained, and it looks really classy.

1 Set the oven at 180°C. Grease a deep 20cm springform cake tin and line the bottom with non-stick baking parchment.

2 Spread the walnuts on a baking tray and toast in the oven for 10 minutes. Remove and set aside until cool enough to handle, leaving the oven on.

3 Roughly crush 60g of the walnuts with your hands. Finely chop 140g with a sharp knife, and chop the remaining 25g into larger pieces for the centre of the cake.

4 Cream the caster sugar and margarine together, then slowly beat in the eggs until evenly incorporated. Fold in the flour and crushed walnuts, and stir in the coffee essence. Spread the mixture evenly in the tin and bake for 40–45 minutes until springy to the touch and a skewer inserted in the middle comes out clean. Leave to cool in the tin for 5 minutes, then turn out on to a wire rack. Cool completely before peeling off the lining paper.

5 Make an icing by beating the soft cheese and muscovado sugar together until smooth. Spread about three-quarters of the icing over the side of the cake, then roll in the finely chopped nuts to cover the icing. Now spread the remaining icing on the top of the cake. Cover the top with the remaining finely chopped nuts and press the larger pieces into the centre.

6 eggs, separated
150g caster sugar, plus extra for sprinkling
100g plain flour
45g cocoa powder

FOR THE FILLING
250g good-quality dark chocolate
 (70% cocoa solids)
250ml double cream
4tbsp whipping cream
200g raspberries

SERVES EIGHT

CHOCOLATE SPONGE CAKE

Fruit, cream and chocolate is a marriage made in heaven, and this cake has
them all. Some chocolate cakes fall short of expectations and leave us wanting,
but this recipe will not disappoint. It's the perfect chocolate cake for a special
occasion, with a guarantee of fresh raspberries in every luscious bite.

1 Make the cake. Set the oven at 180°C, and line a greased 25cm
springform cake tin with non-stick baking parchment.
2 Whisk the egg whites and sugar to a meringue in a clean bowl,
then fold in the egg yolks. Sift the flour and cocoa powder together
and fold into the egg mix until evenly incorporated. Pour into the
tin and level the surface. Bake for 25–30 minutes until a skewer
inserted in the centre comes out clean. Place the tin on a wire
rack and leave the cake to cool.
3 Make the filling. Chop the chocolate into pieces and place in
a bowl set over a pan of gently simmering water. Heat gently,
stirring occasionally, until the chocolate has melted. Remove from
the heat and stir in the double cream until evenly mixed. Cool.
4 Whip the whipping cream to soft peaks, then fold into the
chocolate mix with the raspberries. Split the cold cake in half
and sandwich together with the filling. Sprinkle caster sugar
over the top before serving.

500g good-quality puff pastry
 (preferably made with butter)
Egg yolk, for glazing
Caster sugar, for sprinkling

FOR THE FILLING
45g butter, diced
60g light soft brown sugar
175g currants
50g cut mixed peel
1tsp ground cinnamon
1tsp ground mixed spice

MAKES TWELVE

ECCLES CAKES

There are some tea-time favourites that have unfortunate names and this is one
of them (unless you come from Eccles). They don't look that spectacular either,
but they taste amazing. Light, flaky and fruity, they collapse sensuously in your
mouth when you bite into them. For a peculiarly eccentric British treat, try
eating them with cheese.

1 Make the filling. Melt the butter with the sugar in a saucepan
over a low heat. Mix the currants, peel and spices in a bowl, pour
in the melted mixture and stir well to mix.

2 Roll out the pastry on a floured surface until about 3mm thick.
Leave to rest in the fridge for about 10 minutes.

3 Meanwhile, set the oven at 180°C and cover a baking sheet with
non-stick baking parchment.

4 Cut the pastry into twelve 10cm discs and put 1 heaped tsp of the
filling in the centre of each disc. Dampen the edges of the pastry
with a little water. Fold the pastry over the filling to meet in the
centre and press the edges together to seal, then place seam-side
down on the baking sheet and flatten slightly with the heel of your
hand. Make three parallel slits on the top of each cake. Brush the
pastry all over with egg yolk and sprinkle with caster sugar.

5 Bake for about 20 minutes or until the pastry is golden brown.
Cool on a wire rack before serving.

275ml milk
100g caster sugar
650g strong white bread flour
1tbsp active dried yeast
140g soft butter
1 egg, plus 1 egg yolk, beaten
1½tsp salt

FOR THE FILLING
45g butter
60g Demerara sugar
Whole nutmeg, for grating
125g currants

TO FINISH
Beaten egg, to seal
75g caster sugar

MAKES FIFTEEN

CHELSEA BUNS

Don't buy croissants for breakfast, serve home-made Chelsea buns instead. All you need to do is put a tin of unbaked buns in the fridge the night before, then take them out in the morning, heat up the oven and bake them. When they're freshly made they're gorgeous, and they don't need butter or jam. Think of them as British *viennoiserie*.

Simon Vouet and studio, 1590–1649
Ceres and Harvesting Cupids (detail),
probably 1634–5

The naked figure of Ceres, goddess of the earth's fertility, is typical of the figures produced by Vouet and his studio. She wears a crown of cornstalks and watches the harvesters in the distance.

1 Make the starter dough (also called a 'flying sponge'). Warm the milk and 1tbsp of the sugar in a saucepan to 30°C. Mix 150g of the flour with the yeast in a large bowl, pour in the milk and sugar, and mix to a dough. Let rise at room temperature in a draught-free place for 1 hour or until the dough starts to wrinkle and deflate.
2 Beat the butter into the dough, then add the remaining flour and sugar with the egg, egg yolk and salt. Mix to a dough again. Leave as before for another hour or until risen.
3 Roll out the dough on a floured surface to a 45 × 30cm rectangle. Melt the butter for the filling and brush over the dough. Sprinkle with the Demerara sugar. Grate nutmeg evenly over the top and scatter on the currants.
4 Roll up the dough from one long side like a Swiss roll. Brush the end with beaten egg and seal. Cut the dough across into 15 slices, each about 2.5cm thick. Place the slices in a buttered Swiss roll tin measuring 30–33 × 20–23cm, arranging them cut-side down in five rows of three and leaving space around the edges for them to expand. Leave as before for about an hour or until risen.
5 Set the oven at 180°C. Bake the buns for about 25 minutes or until golden brown. Meanwhile, make a syrup by warming 50g of the sugar in 50ml water until the sugar has dissolved. When the buns come out of the oven, brush them with the syrup and sprinkle with the remaining sugar. Cool in the tin and serve warm.

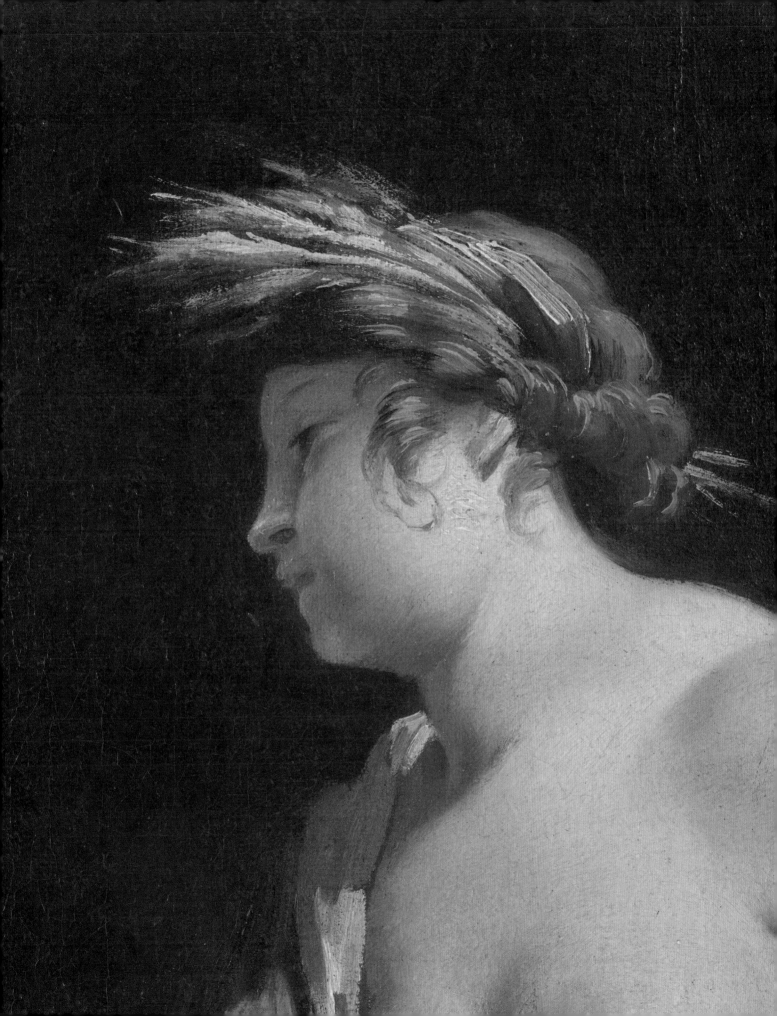

BLOODY ORANGE

25ml dry gin
25ml Triple Sec
Juice of 1 blood orange
Ice cubes

Put the gin and Triple Sec in a shaker and pour in the orange juice. Add ice and shake well, then strain over ice in a highball glass.

PEAR-TINI

1 ripe Williams pear, cored
 and chopped
1tsp caster sugar
50ml sloe gin
Ice cubes

Crush the pear and sugar with a pestle or the end of a rolling pin and put into a shaker with the gin. Add ice and shake well, then strain into a Martini glass.

LIGHT COOLER

2.5cm piece of fresh root
 ginger, peeled and grated
10ml elderflower syrup
Ice cubes
5 fresh mint leaves
Sparkling water

Mix the ginger with the elderflower syrup. Put ice in a highball glass or similar and add the mint. Strain the elderflower syrup over the ice and top up with sparkling water.

APPLE MARTINI

1 red-skinned apple,
 cored and chopped
1tsp caster sugar
50ml vodka
Ice cubes

Crush the apple and sugar with a pestle or the end of a rolling pin and put into a shaker with the vodka. Add ice and shake well, then strain into a Martini glass.

Clockwise from the top:
Bloody orange, Pear-tini,
Light cooler and Apple
martini

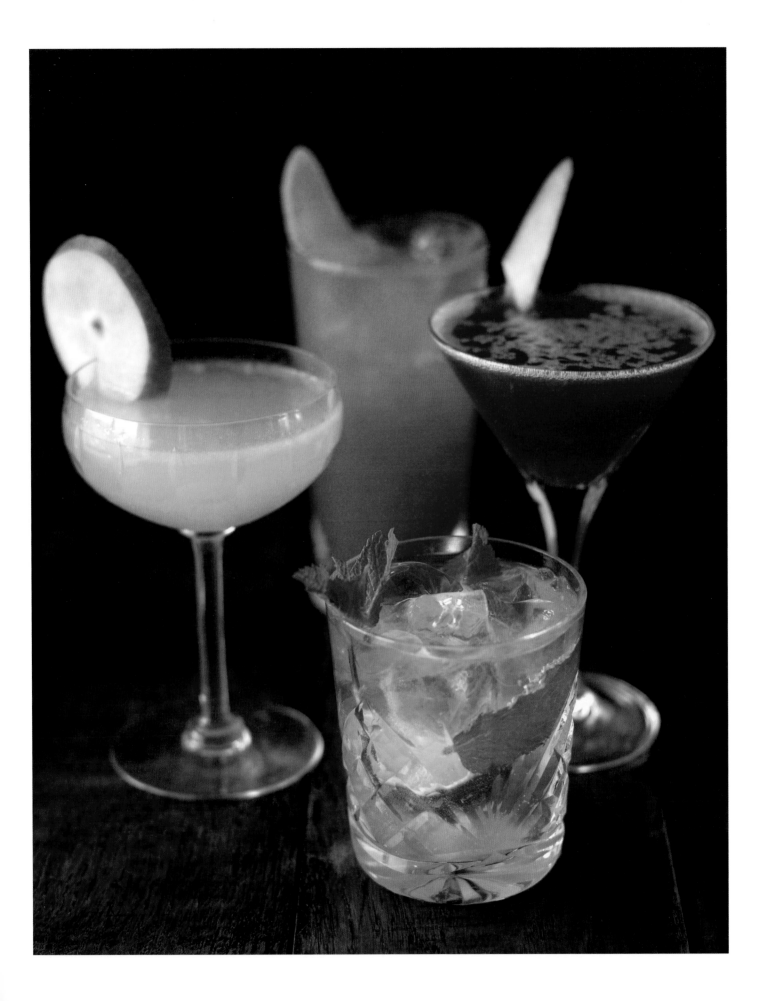

SPRING
SUMMER
AUTUMN
WINTER

Claude-Oscar Monet, 1840–1926
Lavacourt under Snow (detail), about 1878–81

Lavacourt is a hamlet on the other side of
the Seine from Vétheuil, where Monet had
settled in 1878. Although signed and dated
1881, this work was probably painted slightly
earlier. The artist often signed his works long
after completion, adding dates that were
sometimes inaccurate.

Despite the exotic ingredients now available year round and the abundance of food on our shelves, if not on the land around us, it is still conditioned in us somehow to know that winter can be a time of hardship.

The coldest February ever recorded was in 1947, when rationing was even more severe than during the war. The winter of 1963 (overall, the coldest ever across England and Wales since 1740) saw frozen roads, lakes, rivers and even ports – and significant food shortages. Thus, it is in our DNA that winter food needs to feed us, but also to warm and add variety to the darkest of days.

Soups are just right for winter of course – piping hot and blessed with a depth of flavour that lifts the spirits. Comforting dishes like fish pie and shepherd's pie are just what we need for a family supper, or informal gathering, eaten in a warm kitchen or in front of an open fire.

For many cooks at this time of the year, there is reward too in the work and sense of well-being that comes from time spent in the kitchen. Baking is a very satisfying pastime, and cheers those who enjoy the results. And the preparations for the magnificent feast of the season – Christmas – bring much pleasure to the cook.

The food of British winter should lift the spirit and warm the heart, savoured for being of no other time.

1 head of broccoli, weighing
about 800g
150ml double cream
50g butter
1 small onion, finely sliced
1 celery stick, finely sliced
1 garlic clove, finely sliced
1tbsp finely chopped fresh
lemon thyme
100g Stilton, diced

FOR THE CROÛTONS
100ml vegetable oil
1 small mild chilli, deseeded
and roughly chopped
1 garlic clove, roughly chopped
3 thick slices of bloomer or other
white bread, crusts removed

SERVES FOUR

BROCCOLI AND STILTON SOUP

You can make this soup all year round, but it's especially good in winter when broccoli florets are their darkest green. Rich in colour and flavour, broccoli is the perfect vegetable for soups. You could make this one without the cheese if you prefer – it will still have lots of body and taste. A traditional bloomer is best for the croûtons, which should be big and chunky so they get drenched in soup.

Jacopo Tintoretto, 1518/19–1594
Saint George and the Dragon
(detail), about 1555

There are as many paintings as there are versions of this story, and several of them are in the National Gallery. Here, the dragon, painted by the Venetian artist Tintoretto, is speared by Saint George.

1 First make the croûtons. Set the oven at 180°C. Blitz the oil, chilli and garlic together in a blender until smooth. Cut the bread into chunky cubes and toss in the flavoured oil, then spread out on a baking sheet and bake for about 15 minutes or until crisp. Drain on kitchen paper and keep warm.

2 Cut all the stalks off the broccoli. Finely slice the florets and set aside. Roughly chop the stalks and place in a saucepan. Cover with about 750ml cold water and bring to the boil, then simmer for 5 minutes. Strain the water into a clean pan, add the cream and heat gently without boiling. Remove from the heat.

3 Melt the butter in another saucepan. Add the onion, celery, garlic and a pinch of salt, cover the pan and sweat over a low heat for 5 minutes without colouring. Add the broccoli florets and thyme, cover the pan again and sweat without browning for about 10 minutes or until the broccoli is tender.

4 Pour the creamy stock over the broccoli. Bring to the boil and simmer for a couple of minutes. Taste for seasoning and add the cheese, then blitz in a blender until smooth. Taste for seasoning again, reheat if necessary and serve with the croûtons.

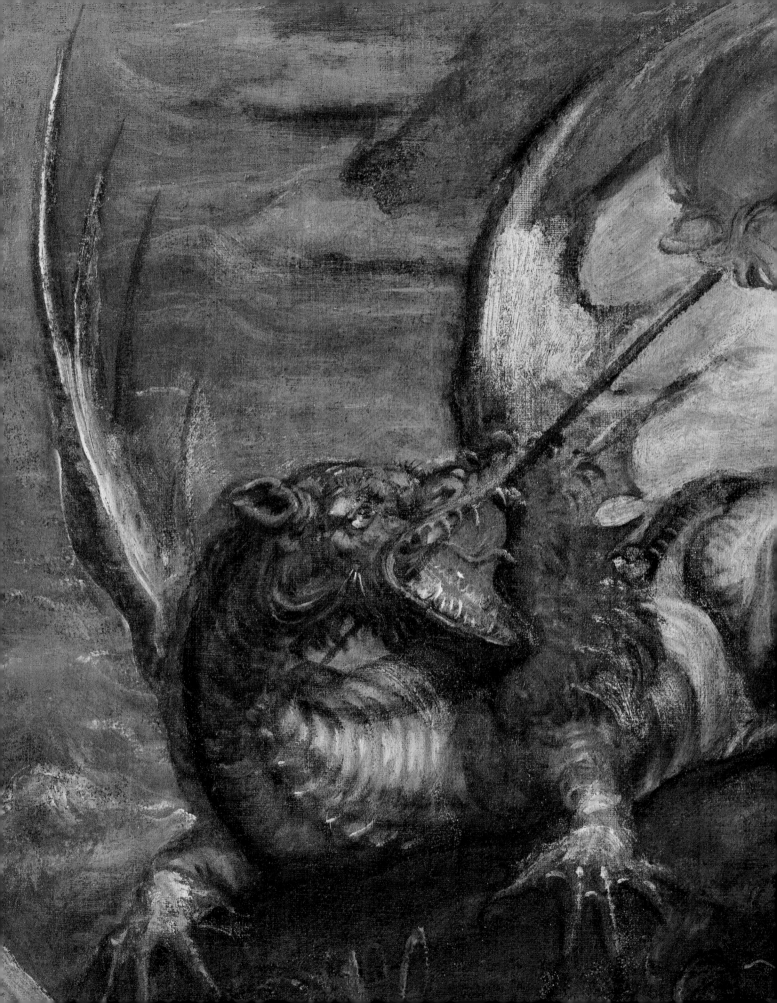

4 raw red or golden beetroot, weighing
 about 150g each
4 oranges
4tbsp rapeseed oil
125g lamb's lettuce
300g skinless hot-smoked salmon fillets,
 flaked into large pieces
1 spring onion, trimmed and thinly
 sliced on the diagonal

SERVES FOUR

HOT-SMOKED SALMON WITH BEETROOT AND ORANGE

This salad is pretty impressive and impressively pretty, yet not at all challenging to make. Hot-smoked salmon is better looking than traditional cold-smoked varieties because it shows off the natural colour of the fish, which should be pale pink or off white and not orange. The subtle colour of golden beetroot goes well with hot-smoked salmon, so buy it if you see it in the shops and try it as an alternative to the ruby red – it has a slightly gentler flavour.

1 Set the oven at 160°C. Wrap each beetroot in foil and roast for about 1 hour or until the beetroot feels soft when gently squeezed. Cool in the foil, then peel the beetroot, trying to keep them as round as possible. Slice the beetroot into a total of 12 equal wedges.
2 Cut the top and bottom off each orange. Working from top to bottom, remove the skin and white pith. Hold the orange over a bowl and cut out the segments, working between the membranes so the segments fall into the bowl. Squeeze the juice from the leftover membrane into another bowl, discarding any pips.
3 Make a dressing by whisking the orange juice with the oil and seasoning to taste.
4 Gently mix the beetroot wedges and orange segments together, then combine with the lamb's lettuce in four bowls. Top with the chunks of smoked salmon. Drizzle over the dressing and garnish with the spring onion.

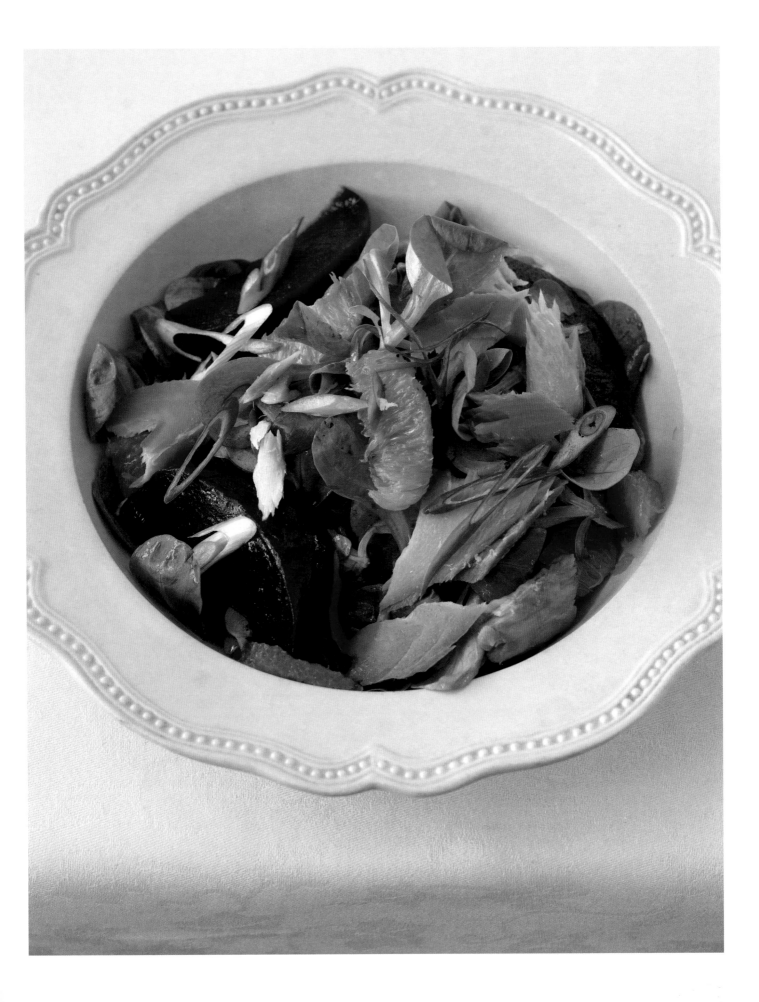

1 rabbit
2 back bacon rashers, without rinds
2 carrots, roughly chopped
2 onions, roughly chopped
1 bay leaf
1 sprig each of fresh rosemary and thyme
4 cloves

3 allspice berries
4tbsp dry sherry
100ml perry (pear cider)
12 prunes, halved and pitted
500g butter, diced
Ground mace
Hot toast, to serve

SERVES EIGHT

POTTED RABBIT WITH PERRIED PRUNES

Rabbit, perry and prunes – only the British could come up with such a unique combination of ingredients. For the very best flavour, ask your butcher for wild rabbit, not farmed. There is no comparison between the two. As for the perry, it imparts a slight sweetness that lifts the flavour of the rabbit in this dish, which will taste even better with a small glass of perry on the side.

1 Cut the legs from rabbit and cut the saddle into four pieces (your butcher will do this for you). Discard the liver and kidneys. Put the rabbit legs and pieces of saddle into a saucepan with the bacon, vegetables, herbs, spices, sherry and 600ml cold water. Bring just to the boil, then cover the pan and stew very gently for about 1¼ hours or until the rabbit is tender and the meat will separate easily from the bones.

2 Meanwhile, gently heat the perry in a pan until lukewarm, then pour over the prunes in a bowl. Cover and set aside to soak.

3 Clarify the butter by melting it slowly in a heavy saucepan over a low heat. Skim off the froth from the surface, then very carefully pour off the golden liquid into a bowl, leaving the sediment behind in the bottom of the pan (discard the sediment). Leave the liquid butter to cool.

4 Remove the rabbit meat from the bones, and flake the meat into tiny pieces with the bacon. Reserve eight prune halves and chop the remainder into tiny pieces. Mix the rabbit and bacon with the chopped prunes. Season with mace, salt and pepper to taste.

5 Place a reserved prune half in each of eight ramekins (about 125ml capacity). Press the meat on top and cover with the clarified butter. Cover the ramekins with cling film or foil and refrigerate overnight to develop the flavours. Serve chilled, with hot toast.

4tbsp whipping or double cream
1 egg yolk
600g cleaned queen scallops

FOR THE CHEESE SAUCE
300ml milk
20g plain flour
20g butter
25g mature Cheddar cheese, grated
25g creamy Lancashire cheese, grated

SERVES FOUR

QUEEN SCALLOPS WITH A RICH CHEESE SAUCE

Queen scallops are small and perfectly formed, and they should be cooked whole and served rare, in fact almost raw. Ten minutes is all it takes to make this entire dish, with its all-in-one cheese sauce enriched with egg yolk and cream. If you serve it in scallop shells, it will look very stylish indeed.

1 Make the sauce. Put the milk, flour and butter in a saucepan over a low heat. Bring just to the boil, whisking constantly to make a smooth sauce. Simmer very gently for 5 minutes, then add the cheeses and whisk until melted. Add seasoning to taste and remove from the heat.

2 Preheat the grill to high. Whip the cream to a soft peak and mix with the egg yolk.

3 Season the scallops, then spread out on a roasting tray. Warm under the grill for just 1 minute.

4 Reheat the cheese sauce and stir in the whipped cream mix. Lift the scallops off the tray with a slotted spoon and drain off any liquid, then divide the scallops equally among four scallop shells or flameproof dishes and coat with the sauce. Place under the grill for about 30 seconds or just until golden brown. Serve hot.

1kg sprats
Plain flour, for dusting
Vegetable oil, for frying

TO SERVE
Lemon wedges
Crusty bread and butter

SERVES FOUR

FRIED SPRATS

Good old-fashioned simplicity, tasty and inexpensive – what more could anyone want? Sprats have a limited season, so you must enjoy them, just as they come, when you can. Absolutely no embellishments are needed.

1 Wash the fish, remove the heads and trim the tails. Make a slit in each belly and remove the guts. Rinse the fish inside and out, then pat dry with kitchen paper. Dust with flour.

2 Set the oven at 170°C, and line a large baking dish with kitchen paper. Set aside.

3 Heat 2cm oil in a large frying pan over a medium to high heat until hot. Fry the sprats in batches for a few minutes until golden brown, turning once. Drain well and place in the baking dish. Sprinkle with salt to help keep them crisp. Keep the sprats warm in the oven while frying the remainder.

4 Serve hot, with lemon wedges and crusty bread and butter.

400g green split peas
1 onion, sliced
2tsp vegetable oil
White pepper

FOR THE HAM STOCK
1 knuckle or piece of gammon on the bone,
 weighing about 750g
1 onion, halved
1 carrot, halved
1 leek (white part only), halved lengthways

SERVES SIX

PEA AND HAM SOUP

The charm of this soup, traditionally known as London Peculiar, comes from the combination of smooth soup and chunky ham, providing a perfect balance of contrasting textures, flavours and colours. The ham is cooked separately, then pulled off the bone into thick pieces and stirred into the soup at the end.

Claude-Oscar Monet, 1840–1926
The Thames below Westminster
(detail), about 1871

This is one of the pictures produced by Monet when he moved to London during the Franco-Prussian War (1870–1). He shows the misty atmosphere of the capital on a spring day, with the Houses of Parliament and Westminster Bridge in the background.

1 Soak the split peas in cold water for at least 24 hours, changing the water after 12 hours.

2 Make the stock. Put the gammon and vegetables in a large saucepan and pour in enough cold water to cover – about 1.5 litres. Bring to the boil, then lower the heat and cover the pan. Simmer until the meat falls from the bone. This should take 1¼–1½ hours, and you will need to keep skimming off the scum.

3 Lift out the gammon and set aside. Pass the stock through a fine sieve into a large jug or bowl. When the ham is cool enough to handle, pull and pick the meat off the bone, then shred into thick, chunky pieces. Set aside.

4 Now make the soup. Heat the oil in a saucepan and cook the sliced onion over a low heat until softened. Add the drained split peas and 1 litre stock. Bring to the boil, then reduce the heat and cook for about 40 minutes or until the peas are soft.

5 Purée the contents of the pan while still hot, then reheat with the chunks of ham and adjust the consistency with stock or water, if necessary. Taste for seasoning. Ham hock can be quite salty, so you may only need pepper.

1.5kg floury potatoes (Maris Piper,
 King Edward or Desirée), peeled
 and cut into chunks
150ml whipping or double cream
75g butter, diced
Freshly grated nutmeg
1 large leek (white part only),
 thinly sliced
450g skinless salmon fillet
250g skinless haddock fillet
Juice of ½ lemon
1 large shallot, finely chopped
100ml dry white wine

FOR THE PARSLEY SAUCE
75g butter, diced
45g plain flour
500ml warm milk
100ml whipping or double cream
Large bunch of fresh flat-leaf parsley
 (about 45g), stalks removed and
 leaves finely chopped

SERVES FOUR

FISH PIE

Historically, pies were everyday dishes that filled you up, made with whatever
was to hand. Cooks expressed their individuality in a pie, and recipes were rarely
followed. Nowadays, a fish pie can be luxurious with turbot, lobster and prawns,
but the simple combination of salmon and haddock in this recipe is really all you
need for a warming winter pie. Our bodies crave calories at this time of the year,
so don't skimp on the butter and cream in the sauce or the mash.

1 Put the potatoes into a saucepan of salted cold water. Cover
and bring to the boil, then simmer for 15–20 minutes until tender.
Drain well and mash. Beat in the cream and 60g of the butter with
nutmeg and seasoning to taste.

2 Cook the leek in the remaining butter until soft.

3 Make the sauce. Melt the butter in a heavy saucepan over
a low heat, sprinkle in the flour and cook for 2 minutes, stirring
constantly. Slowly add the warm milk, increasing the heat under
the pan to medium and whisking after each addition until a smooth
sauce is formed. Simmer gently for 3–5 minutes, stirring often.
Remove from the heat and stir in the cream and then the parsley.

4 Set the oven at 200°C, and butter a baking dish (about 2.5 litres).
Cut the raw fish into pieces and place in the dish. Season lightly
and sprinkle over the lemon juice, chopped shallot and wine.
Pour the hot sauce on top and scatter the cooked leeks evenly
over the sauce. Cover with the mash. Bake for about 30 minutes
or until the top is crisp and brown – the fish will be perfectly
cooked in the sauce. Serve hot.

4 hake steaks on the bone, weighing
about 200g each
Lemon oil, for rubbing and drizzling
½ small Savoy cabbage (about 350g),
trimmed and shredded

FOR THE BROTH
1tbsp lemon oil
4 shallots, peeled and left whole
1tbsp coriander seeds
1 bay leaf
Juice of 1 lemon

SERVES FOUR

HAKE IN A LEMON AND SHALLOT
BROTH WITH SAVOY CABBAGE

We need sustaining food at this time of the year, and this dish really delivers.
Surrounded by shreds of rich, crinkly cabbage floating in a spicy lemon broth,
chunky hake steaks make an inviting and warming winter meal. The simple
secret of succulent fish is to cook it on the bone, then take it off before serving.
It's easier to eat without the bone, and most people prefer it this way.

1 Make the broth. Put the lemon oil in a saucepan with the shallots,
coriander and bay leaf, and pour in 400ml cold water. Bring to the
boil and simmer for 10 minutes. Add the lemon juice and cook for
a further 5 minutes until the shallots are tender. Strain the broth
into a clean pan and set aside.

2 Set the oven at 160°C, and brush a roasting tray with oil. Place
the fish steaks on the tray, rub with a little lemon oil and season
well. Roast for 15–20 minutes, depending on thickness, until the
flesh flakes easily when tested with a fork.

3 Meanwhile, plunge the cabbage into a saucepan of salted boiling
water. Leave for 1 minute, then drain and refresh in iced water.
Drain again. Squeeze out the excess water and set aside.

4 To serve, reheat the broth until simmering, then taste for
seasoning. Add the cabbage to the broth and warm through.
Remove the central bone from each fish steak. Place the fish in
warmed bowls and ladle the broth and cabbage around. Finish
by drizzling with a little lemon oil.

750g Jerusalem artichokes,
 peeled and chopped
Juice of ½ lemon
125g soft butter
300ml milk
A few sprigs of fresh thyme
4 skinless pieces of haddock fillet,
 weighing about 225g each
20g fresh flat-leaf parsley, 4 sprigs
 kept whole and the rest chopped
Lemon wedges, to serve

SERVES FOUR

POACHED HADDOCK WITH JERUSALEM ARTICHOKE CRUSH

Haddock has been used and abused in fish and chip shops for years; it deserves better treatment at home. Nowadays, we get such good-quality fresh haddock that there's no excuse for serving it up badly – it just needs to be cooked simply. To preserve its subtle flavour and soft texture, poach it gently in milk. Served here with nutty Jerusalem artichokes, its flavour is brought out really well.

1 Put the artichokes into a saucepan of salted cold water. Cover and bring to the boil, then simmer for 10–12 minutes until tender. Drain. Put the artichokes into a bowl with the lemon juice and 75g of the butter, and crush with a potato masher or the back of a fork until semi-smooth. Place the crush in a saucepan, season to taste and keep warm.

2 Pour the milk into a sauté pan or deep frying pan and add the thyme and the remaining butter. Pour in enough cold water (about 200ml) so the fish will be covered in liquid. Bring to a gentle simmer over a medium heat. Season the fish and place in the milk. Cover and poach for about 6 minutes or until the fish flakes easily when tested with a fork.

3 To serve, reheat the artichoke crush gently, then add the chopped parsley. Lift the fish out of the milk. Place a spoonful of the crush on each of four warmed plates and top with the fish. Garnish each serving with a wedge of lemon and a sprig of parsley.

4 skinless halibut fillets, weighing
 about 225g each
2tsp smooth mild mustard

FOR THE MASH
250g parsnips
1tbsp vegetable oil
250g floury potatoes (King Edward,
 Maris Piper or Desirée), peeled
 and cut into chunks
25g butter
1 egg yolk

SERVES FOUR

HALIBUT WITH A PARSNIP MASH CRUST

Halibut is an expensive fish that should be cooked with care. The key is to not overcook it, and this can't be emphasised enough. You will know it's perfectly cooked if it falls easily into flakes when teased with a fork, and it must still look slightly oily and translucent in the middle. Turbot, monkfish, sea bass and sole are other premium fish that are very good cooked with a crust like this, but you could also use less expensive fillets such as gurnard, haddock or cod.

1 Set the oven at 180°C. Peel the parsnips and cut each one into quarters lengthways. Place in a roasting tin and coat with the oil. Roast for about 30 minutes or until golden and tender.

2 Meanwhile, put the potatoes into a saucepan of salted cold water. Cover and bring to the boil, then simmer for 15–20 minutes until tender. Drain the potatoes well. While they are still hot, press them through a potato ricer or sieve into a bowl, or mash vigorously until smooth.

3 Transfer the hot parsnips to a food processor, add the butter and blend until smooth. Stir into the potatoes with the egg yolk and seasoning to taste.

4 Place an ovenproof frying pan over a high heat. Season each halibut fillet, then place fleshy side down in the hot pan and sear for 15 seconds. Turn and sear the other side. Remove from the heat. Spread mustard evenly over the fleshy side of the fish and top with the mash. Transfer to the oven and roast for 12–15 minutes until the flesh flakes easily when tested with a fork. Serve hot.

4tbsp vegetable oil
1 small white onion, diced
¼ bulb of fennel, diced
100ml dry white wine
300g boned and skinned monkfish tails,
 cut into 1cm thick pieces
4 large scallops, cleaned and coral removed
100ml pressed tomato juice
2 ripe tomatoes, peeled, deseeded
 and chopped
20 fresh marjoram leaves

SERVES TWO

MONKFISH AND SCALLOP STEW

There were no proper recipes for the humble fish stews in the old days. In the past they were just made of bits and bobs – anything and everything that was to hand, the vegetables and fish simmered together. That was their beauty and their charm, and no two stews were alike from one day to the next or one season to another. More often than not these days, a fish stew is posh nosh for a special occasion – and this one is no exception.

Hendrick Avercamp, 1585–1634
A Winter Scene with Skaters near a Castle (detail), about 1608–9

This busy scene of winter pursuits is full of closely observed detail. It is filled with people from all walks of life going about their business as well as enjoying themselves. This circular picture was once extended into a square shape. During cleaning in 1983 it was discovered that these were later additions, so they were removed.

1 Set the oven at 180°C. Heat half of the oil in a shallow flameproof casserole and add the onion, fennel and seasoning to taste. Cover the casserole and sweat the vegetables over a low heat for about 10 minutes or until they are soft. Add the wine and boil uncovered until reduced by half.

2 Meanwhile, season the monkfish and scallops, then sear quickly in the remaining oil in a hot non-stick frying pan until coloured. Add to the casserole. Cover the fish with the tomato juice and tomatoes. Sprinkle in the marjoram. Bring quickly to the boil, then transfer to the oven and bake uncovered for 5 minutes.

3 Remove the fish from the pan and place in two warmed bowls. Taste the sauce for seasoning and pour over the fish, then serve.

1 oven-ready goose, weighing about 5kg
2 sprigs of fresh marjoram
2 sprigs of fresh sage
2 sprigs of fresh thyme
(lemon thyme if you can get it)
1 garlic bulb, halved crossways
1 red onion, roughly chopped
3tbsp apple jelly
1tbsp honey

3tbsp Somerset apple brandy
Brussels sprouts with bacon
(page 260), to serve

FOR THE POTATOES
2kg floury potatoes (King Edward, Maris
Piper or Desirée), peeled and halved
or quartered
150ml goose fat (from roasting the goose)

SERVES SIX

GLAZED ROAST GOOSE WITH GOOSE-FAT ROAST POTATOES

Goose is the perfect seasonal bird for a small gathering at Christmas. It will be just enough for six servings, and every part of it is rich, moist and gorgeous. It's never dry like turkey often is, and goose fat makes the best roast potatoes ever.

1 Set the oven at 200°C. Season the goose inside and out with salt and pepper. Place on a rack in a roasting tin and roast for 30 minutes.

2 Reduce the oven to 180°C. Take the roasting tin out of the oven and lift off the goose on the rack. Carefully pour the hot fat from the tin into a measuring jug; reserve the fat. Set the rack back on the tin and place the herbs, garlic and onion inside the goose. Return to the oven and roast for 2 hours and 50 minutes or until the juices run clear when a skewer is inserted into the thickest part of a thigh. Baste the goose with the hot fat throughout, pouring off and reserving the excess fat. Cover the bird with foil for the last hour of roasting to prevent overbrowning.

3 Meanwhile, put the potatoes in a saucepan of salted cold water and bring to the boil over a medium heat. Drain and set aside to cool.

4 About 20 minutes before the goose has finished roasting, pour 150ml goose fat into a large roasting tray and warm in the oven for about 10 minutes or until the fat is very hot. Add the potatoes and roast for 45–50 minutes, turning and basting them occasionally, until they are crisp and golden brown.

5 Warm the jelly, honey and brandy in a pan until melted. Lift the goose off the rack. Drain off the fat from the tin, then sit the goose in the tin. Pour the jelly glaze over the bird. Return to the oven to roast for 10 minutes, basting every 3 minutes with the juices in the tin.

6 Remove the goose from the oven, tent with foil and leave to rest in a warm place for 20–30 minutes. Serve with the potatoes and sprouts.

FOR THE APPLE AND PEAR PURÉE
1tbsp honey
1 dessert apple, peeled, cored and chopped
1 ripe pear, peeled, cored and chopped
2tbsp Madeira
1tbsp ruby port

4 venison medallion loin steaks,
centre-cut and 4–5cm thick,
weighing about 150g each
Cracked black pepper
1tbsp vegetable oil
15g butter
2 sprigs of fresh rosemary
4 sprigs of fresh thyme
1 garlic clove, bruised

FOR THE CURLY KALE
3tbsp vegetable oil
1 large onion, sliced
2 sprigs of fresh rosemary
4 garlic cloves, sliced
250g curly kale, trimmed of tough stalks
and cut into 1cm thick slices

SERVES FOUR

VENISON MEDALLIONS WITH APPLE AND PEAR PURÉE AND CURLY KALE

The flavour of venison is rich and intense, calling out for other strong flavours to set it off. The boozy fruit purée does the trick here, plus the kick of the garlic in the curly kale. Do be brave and serve venison pink – if you cook it more than rare it will start to toughen up.

1 Make the purée. Heat the honey in a saucepan until sizzling, then add the fruit and cook over a high heat, stirring, until lightly caramelised all over. Add the Madeira and port and simmer for about 10 minutes or until syrupy but still quite moist. Purée while hot in a blender, then pass through a sieve into a clean pan.

2 Heat the oil for the kale in a deep saucepan over a low heat. Add the onion, cover and sweat gently until very soft but not coloured.

3 Meanwhile, season the venison with salt and cracked black pepper. Heat the oil over a high heat in a frying pan until almost smoking. Add the medallions and sear quickly on both sides, then lower the heat. Add the butter, rosemary, thyme, garlic clove and a little salt. Continue cooking the medallions, turning and basting frequently – for rare meat, the total cooking time should be no more than 5 minutes. Remove from the heat and keep warm.

4 Now continue with the kale. Add the rosemary and garlic to the softened onion and fry for 1 minute. Add the kale and season with salt. Cover tightly, reduce the heat to as low as possible and cook gently for 5–7 minutes until tender. Taste for seasoning.

5 Reheat the fruit purée and serve with the venison and kale.

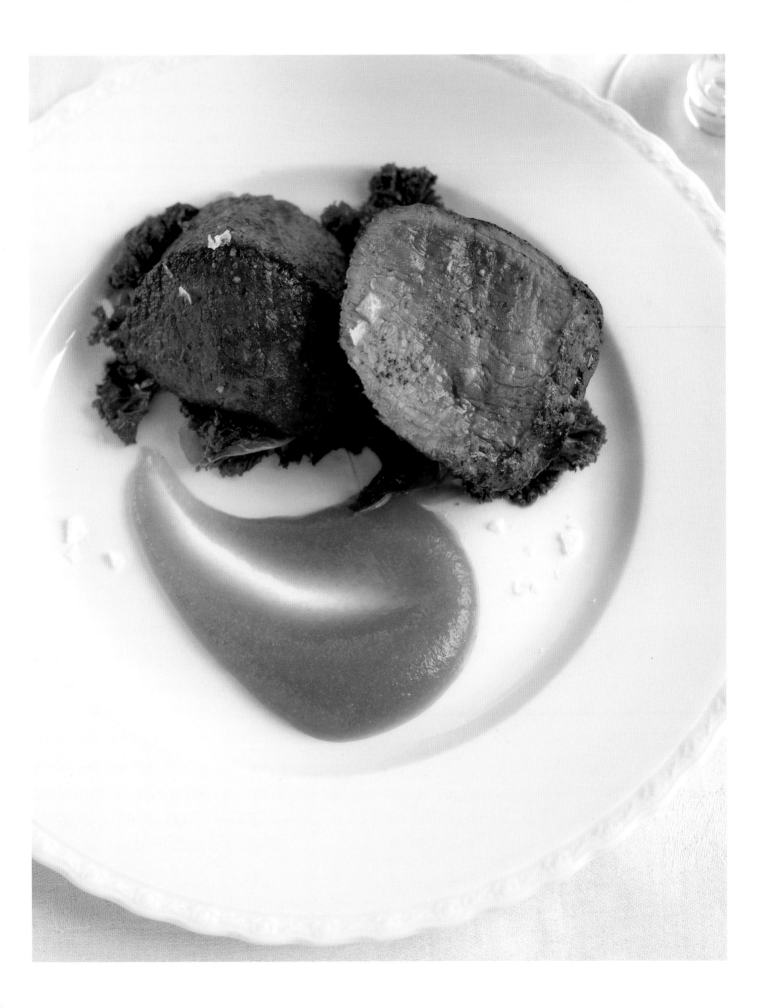

1tbsp vegetable oil
1 shallot, finely chopped
10 black peppercorns, crushed
2tbsp cider vinegar
150ml hot brown chicken stock (page 250)
1tbsp Worcestershire sauce
1tbsp plain flour
2tbsp English mustard powder
Cayenne pepper
8 lambs' kidneys, skinned, halved and cored
50g butter

FOR THE MASH
900g floury potatoes (King Edward,
 Maris Piper or Desirée), peeled
 and cut into chunks
100ml milk
100g butter, diced

SERVES FOUR

DEVILLED KIDNEYS WITH BUTTER-SOFT MASH

Kidneys are vastly underrated. They make such a quick and easy dinnertime dish, and yet they always have that foodie look and feel, especially when nestled on a soft bed of mash. Take care not to overcook them or they will be rubbery.

Joseph Mallord William Turner, 1775–1851
Rain, Steam, and Speed – The Great Western Railway (detail), 1844

The scene is probably Maidenhead railway bridge, across the Thames between Taplow and Maidenhead. The bridge, which was begun to Isambard Kingdom Brunel's design in 1837 and finished in 1839, has two main arches of brick, very wide and flat. The view is to the east, towards London.

1 Put the potatoes for the mash in a pan of salted cold water. Cover and bring to the boil, then simmer for 15–20 minutes until tender.
2 Meanwhile, heat a small saucepan over a medium heat, then add the oil, shallot and peppercorns and cook for 2 minutes. Add the vinegar and boil until it has evaporated. Add the stock and Worcestershire sauce and boil until reduced by two-thirds. Strain this sauce and set aside.
3 Drain the potatoes and return to the pan over a low heat for about 2 minutes to remove as much moisture as possible. Remove from the heat and mash with a potato ricer or masher until smooth. Bring the milk and butter to the boil in another saucepan, then beat into the mash until evenly combined. Season and set aside in a warm place.
4 On a large plate, mix the flour and mustard with a pinch each of cayenne and salt. Coat the kidneys in the seasoned flour. Melt the butter in a small frying pan and cook the kidneys over a gentle heat for 10 minutes, tossing and rolling them in the butter so they become evenly coloured. They should be just pink inside.
5 While the kidneys are cooking, reheat the mash and sauce if necessary. Serve the kidneys on the mash, with the sauce poured over and around.

2tbsp vegetable oil

1 onion, finely chopped

2 celery sticks, finely chopped

100g swede, finely diced

2 carrots, finely diced

2 garlic cloves, crushed

600g minced lamb

2tsp chopped fresh thyme

1½tbsp plain flour

200ml hot lamb or chicken stock

2tbsp mushroom ketchup or
 Worcestershire sauce

1tbsp tomato purée

900g floury potatoes (King Edward,
 Maris Piper or Desirée), peeled
 and cut into chunks

100g soft butter, diced

75–100g mature Cheddar cheese, grated

SERVES FOUR

SHEPHERD'S PIE

For a good shepherd's pie, choose your ingredients carefully, get the proportions of meat and potato right, and take time making it. It's one of our favourite national dishes after all, so it deserves special treatment.

1 Put a large frying pan over a medium heat, add the oil and cook the onion gently for about 5 minutes until softened, stirring occasionally. Add the remaining vegetables and the garlic and cook for another 5 minutes, stirring occasionally. Remove the vegetables with a slotted spoon and set aside.

2 Turn the heat up to high and brown the minced lamb in batches, using a wooden spoon to break up any lumps. Drain each batch in a sieve to remove excess fat. Return all the meat to the pan with the cooked vegetables and the thyme. Sprinkle in the flour and stir to mix into the meat. Add the stock and stir in the mushroom ketchup and tomato purée. Bring to the boil, then turn the heat down to low and simmer for about 30 minutes or until the liquid has reduced, stirring occasionally to prevent the meat mixture from sticking to the pan.

3 Meanwhile, put the potatoes into a saucepan of salted cold water. Cover and bring to the boil, then simmer for 15–20 minutes until tender. Drain the potatoes and return them to the pan over a low heat for about 2 minutes to remove as much moisture as possible. Remove from the heat and mash with a potato ricer or masher until smooth, then beat in the butter and seasoning to taste.

4 Set the oven at 180°C. Spoon the meat into a baking dish measuring about 25 × 18cm and 5cm deep. Level it out and spread the mashed potato evenly on top, then mark the surface with the prongs of a fork. Bake for 30 minutes. Sprinkle cheese evenly over the top and bake for a further 15 minutes or until golden brown.

2 oxtails, weighing about 1.5kg
 in total, each cut into 4 pieces
2tbsp plain flour
½tsp English mustard powder
2tbsp vegetable oil
2 large onions, finely chopped
1 garlic clove, finely chopped
2 carrots, finely diced

1 small leek, finely sliced
750ml hot beef stock
300ml red wine
2tbsp tomato purée
250g button mushrooms, sliced
3tbsp chopped fresh flat-leaf parsley
1tbsp chopped fresh thyme

SERVES FOUR

BRAISED OXTAIL IN RED WINE

Oxtail meat is rich and meltingly tender when cooked long and slow, and
nothing could be more nourishing and comforting in winter. This dish needs
mash or champ to soak up the gravy, and it's also good with roasted winter
vegetables – red onions, pumpkin, squash and parsnips – which you can
cook in the oven at the same time.

1 Set the oven at 160°C. Coat the oxtail pieces in the flour mixed
with the mustard and salt and pepper. Heat the oil over a high heat
in a large flameproof casserole. Add the oxtail in batches and fry
until evenly browned. Remove from the pan with a slotted spoon.
2 Lower the heat and add the onions, garlic, carrots and leek. Stir to
scrape up the sediment from the bottom of the casserole and cook
gently for about 3 minutes, then add any remaining seasoned flour
and stir well. Pour in the stock and wine, add the tomato purée
and stir well. Return the oxtail to the pan and bring to the boil.
Cover and transfer to the oven. Cook for about 3 hours or until
the oxtail is tender.
3 Add the mushrooms and herbs. Continue to cook for a further
30 minutes. Skim off any fat before serving if necessary, and taste
the gravy for seasoning.

2tbsp vegetable oil
250g leeks, finely sliced
1 onion, finely chopped
350g carrots, cut into small dice
250g parsnips, cut into small dice
250g swede, cut into small dice
90ml whipping or double cream
2tsp English mustard powder

1tbsp chopped fresh thyme
500g good-quality puff pastry (preferably made with butter)
1 Cox apple, peeled, cored and chopped
125g Stilton cheese, crumbled
100g peeled roasted chestnuts (fresh, frozen or vacuum-packed), coarsely crushed
1 egg, beaten

SERVES SIX

VEGETABLE AND STILTON PIE

This is a pie full of surprises. Nuggets of Stilton melt through the mix, while chestnuts provide the occasional crunch. You can vary the vegetables and use a different cheese if you like, but don't think of leaving out the mustard. Hidden deep within the creamy sauce, mustard accentuates the taste of the cheese, and lifts the flavour of the whole dish.

Francisco de Goya, 1746–1828
The Duke of Wellington (detail), 1812–14

Goya painted three portraits of Wellington, whom he admired. Originally this showed the Duke in red uniform with the Peninsular Medal; Goya later repainted it to show him wearing full dress uniform and the rosette and gold badge of the Order of the Golden Fleece, Spain's highest honour, and later still, he added the Military Gold Cross.

1 Set the oven at 200°C. Heat the oil in a saucepan over a low heat. Add the leeks and onion, then cover the pan and sweat for about 10 minutes or until softened but not coloured, stirring occasionally. Add the other vegetables, cover the pan again and sweat for a further 20 minutes or until just tender.

2 Mix the cream, mustard and thyme in a jug. Add to the vegetables and bring to the boil. Remove from the heat, season with salt and pepper, and leave to cool.

3 Roll out the pastry on a floured surface and cut out two pieces, one large enough to line a deep 20cm pie dish and the other to make a lid. Line the dish with the larger piece of pastry.

4 Stir the apple, Stilton and chestnuts into the vegetable mixture, then spoon into the dish. Brush the edge of the pastry case with a little water, then place the lid on top. Trim, seal and crimp the edge, and cut a couple of slits in the centre of the lid. Brush the pie with the beaten egg and bake for about 30 minutes or until golden brown. Serve hot.

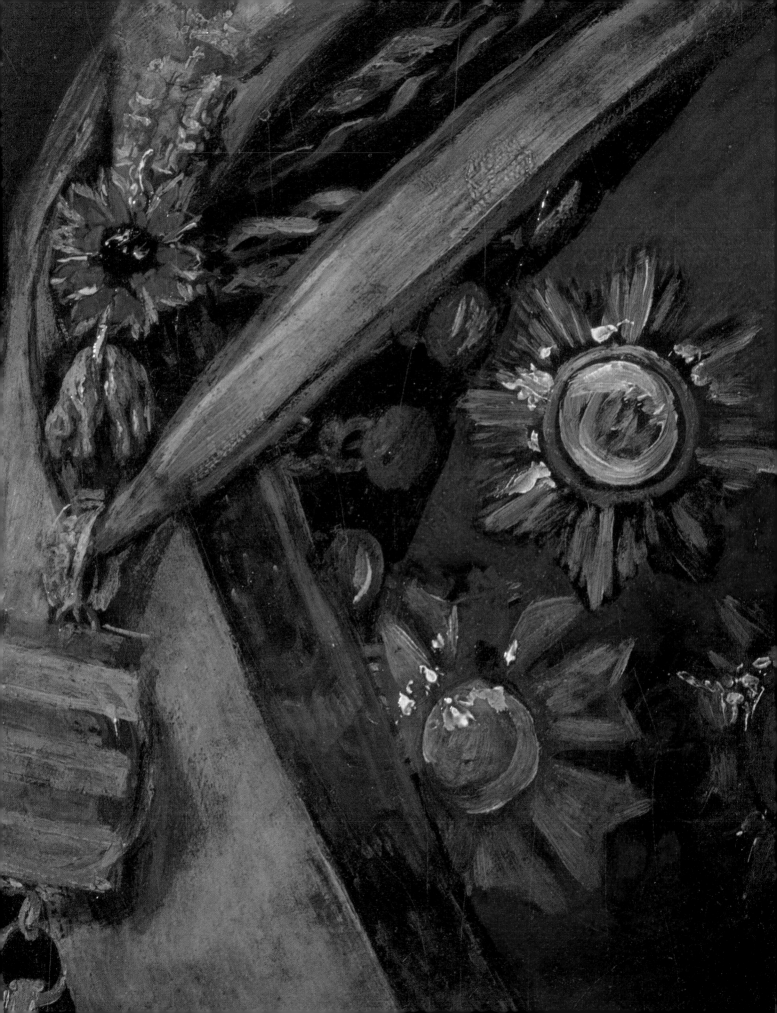

450g celeriac
450g carrots
2 red onions
1 lemon
200g peeled roasted chestnuts
 (fresh, frozen or vacuum-packed)
1tbsp vegetable oil
5tbsp wild thyme honey
A few sprigs of fresh thyme

FOR THE MASH
900g floury potatoes (King Edward,
 Maris Piper or Desirée), peeled
 and cut into chunks
50–100g butter, diced
100ml whipping or double cream
2tsp freshly grated horseradish

SERVES FOUR

HONEY-ROASTED VEGETABLES WITH HORSERADISH MASH

Roast vegetables are one of the easiest dishes to make for vegetarians. All you have to do is put the veg in the oven and give them the occasional stir as they roast, yet they always come out looking and tasting really good. Freshly roasted chestnuts are best here if you can get them, or you can roast them yourself, because there's nothing like their smell, let alone the taste. When you're making mash, you really can't have too much butter, so ignore any recipe that suggests a stingy amount and put in as much as you like.

1 Set the oven at 200°C. Cut the celeriac and carrots into thick wedges. Cut the onions into quarters lengthways and the lemon in half crossways. Spread the vegetables in a single layer in a roasting tin with the lemon and chestnuts and drizzle over the oil and honey. Sprinkle over the thyme and plenty of seasoning. Roast for 45–50 minutes until the vegetables are cooked, stirring from time to time to coat everything in the honey glaze.

2 Meanwhile, make the mash. Put the potatoes into a saucepan of salted cold water. Cover and bring to the boil, then simmer for 15–20 minutes until tender. Simmer the butter, cream and horseradish in a separate saucepan for 3 minutes. Drain the potatoes well and mash, then beat in the horseradish cream and seasoning to taste. Serve hot, with the vegetables.

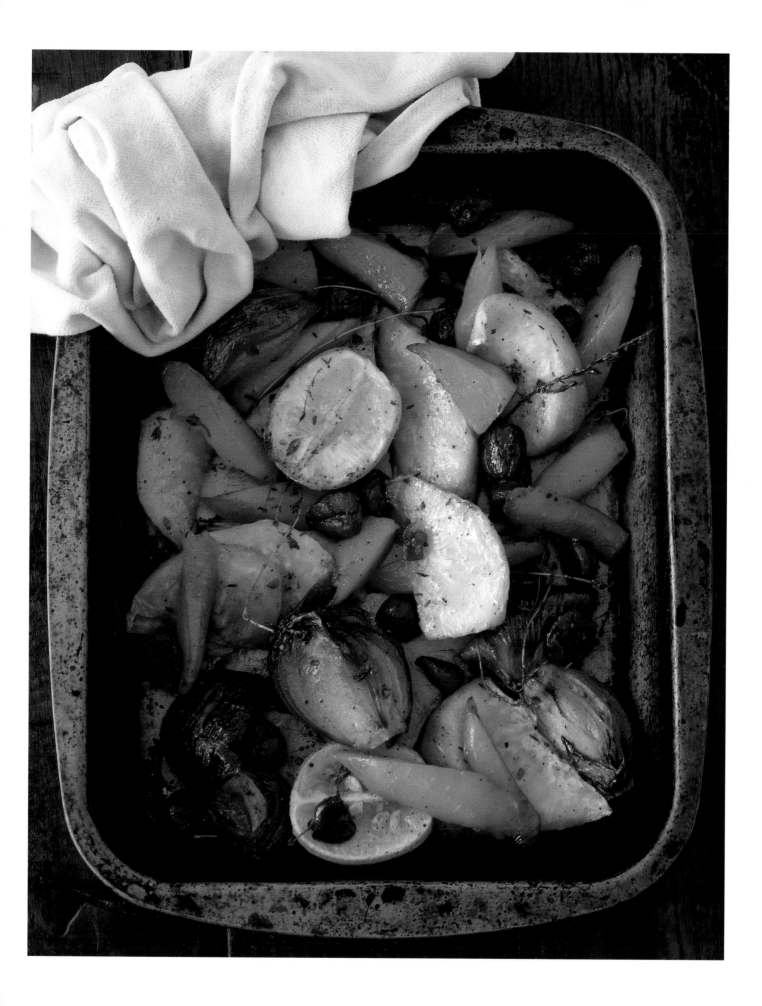

750ml milk

1 onion, peeled and halved

1tsp chopped fresh thyme leaves

50g butter, diced

75g plain flour

1tbsp chopped fresh flat-leaf parsley

1 onion, chopped

6 carrots, chopped

5 celery sticks, chopped

1 leek (white part only), chopped

1tbsp vegetable oil

2 × 400g cans chopped tomatoes, drained

400g can butter beans, drained and rinsed

1 long, red finger chilli, finely chopped
 with all or some of the seeds

FOR THE TOPPING

75g Cheddar cheese, grated

150g panko breadcrumbs

100ml vegetable oil

SERVES SIX

BUTTER BEAN BAKE

You have to work hard to bring out the character and flavour of butter beans, which is why they taste so good when they're cooked with lots of vegetables and a liberal spicing of chillies. This is a great way to serve them, but feel free to experiment with different herbs and spices – fresh sage, rosemary, parsley and thyme would all go well, and so too would cumin, coriander and curry.

1 Sauté the onion, carrots, celery and leek in the oil, stirring occasionally, for about 10 minutes or until softened. Mix in the tomatoes followed by the butter beans and chilli, and cook over a low heat for 15–20 minutes, stirring occasionally. Remove from the heat and season well.

2 Set the oven at 190°C, and make the sauce. Bring the milk just to the boil in a heavy saucepan with the onion and thyme. Strain the milk into a jug. Melt the butter in the saucepan over a low heat, sprinkle in the flour and cook for 2 minutes, stirring constantly. Slowly add the milk, increasing the heat under the pan to medium and whisking after each addition until a smooth sauce is formed. Simmer gently, stirring often, for 3–5 minutes. Remove from the heat and add the parsley and seasoning to taste.

3 Tip the bean mixture into a baking dish (about 33 × 25cm and 6cm deep) and pour the sauce evenly over the top. Make the topping by mixing the cheese with the breadcrumbs and oil, then scatter evenly over the sauce. Bake for about 25 minutes or until the top is golden and everything is bubbling underneath.

1 large cauliflower, weighing about 1kg,
 broken into florets and stalks trimmed
60g butter
30g plain flour
450ml warm milk
100g Cornish Yarg cheese, crumbled
150ml single cream
50g white breadcrumbs
50g walnuts, chopped
1 bunch of fresh chives, snipped

SERVES FOUR

CAULIFLOWER CHEESE

Most recipes for this dish make the cheese sauce with Cheddar and finish with
a crisp breadcrumb topping. Not this one. Here tender-crisp cauliflower florets
are tossed with butter-fried breadcrumbs and walnuts, then coated in a rich
and creamy sauce made with Yarg. This departure from the norm gives a totally
different dimension to the texture and the flavour is exceptionally good.

1 Plunge the cauliflower into a large saucepan of salted boiling
water and simmer for about 5 minutes or until just tender.
Drain well and keep warm.

2 Make the cheese sauce. Melt half of the butter in a heavy
saucepan over a low heat, sprinkle in the flour and cook for
2 minutes, stirring constantly. Slowly add the warm milk,
increasing the heat under the pan to medium and whisking after
each addition until a smooth sauce is formed. Simmer gently for
3–5 minutes, stirring often. Remove from the heat and add half
of the cheese. Stir until the cheese has melted, then stir in the
cream. Taste the sauce and season with salt and pepper.

3 Preheat the grill. Melt the remaining butter in a large frying pan,
add the breadcrumbs and walnuts, and season with salt and pepper.
Fry for about 10 minutes or until the crumbs are golden. Add the
cauliflower to the pan, and toss and roll the florets around until
they are coated. Transfer to a flameproof serving dish.

4 Pour the sauce over and around the cauliflower. Sprinkle with
the remaining cheese and brown under the grill. Garnish with
the chives before serving.

125g spelt grains or pearled spelt
1 bay leaf
1 red onion
1 parsnip
2–3tbsp honey
1tbsp vegetable oil
1 cooked beetroot, peeled and cut
 lengthways into wedges
30g watercress, trimmed
About 2tbsp walnut oil
100g Stilton, Cheddar or goat's cheese

SERVES FOUR

WARM SPELT WINTER SALAD

Spelt is a great grain for vegetarian dishes, both hot and cold. In salads it soaks up the flavours of the ingredients around it, and it goes especially well with cheese. Keep a packet in your storecupboard, and use as an alternative to lentils, couscous or rice. It's healthy and nutritious, with a delicate nutty bite.

1 Wash the spelt and place in a pan with the bay leaf and 1 litre cold water. Bring gently to the boil, then cover and simmer for 15–20 minutes. The spelt should be tender, but still have a little bite. Drain and keep warm.

2 Set the oven at 180°C. Peel the onion and parsnip, and cut lengthways into wedges. Place on a roasting tray with the honey and oil and add seasoning to taste. Roast for 20 minutes. Add the beetroot and continue roasting for about 10 minutes or until the vegetables are lightly caramelised. Remove the vegetables from the oven and leave to stand for a few minutes.

3 Just before serving, transfer the vegetables to a bowl and combine with the spelt and watercress. Dress lightly with walnut oil and season to taste, then crumble the cheese over the top.

175g blanched hazelnuts
100g Brazil nuts
75g walnut halves or pieces
400g can chopped tomatoes, drained
100g mushrooms, chopped
1 large onion, finely chopped
1 garlic clove, crushed
1tsp vegetable bouillon powder
½tsp dried basil
½tsp dried oregano
2 eggs, well beaten
Mushroom gravy (page 252), to serve

SERVES FOUR

NUTTY NUT ROAST

A nut roast used to be a dowdy dish, but nowadays there's such a huge variety of nuts to choose from that you can experiment and re-invent it every time you make it. Go to your local supermarket or health food shop and hunt out the different nuts on offer, then try adding a handful or two of seeds – pumpkin, sunflower, sesame and linseeds are all good.

1 Put the nuts in a large frying pan (or two pans if they won't all fit in one layer) and toast for a few minutes over a medium heat, shaking the pan frequently and turning the nuts over to ensure even browning. Coarsely grind the nuts in a food processor, then tip into a bowl.

2 Set the oven at 200°C. Lightly oil a 1kg loaf tin and line with non-stick baking parchment.

3 Add the tomatoes and mushrooms to the nuts together with the onion, garlic, bouillon powder, herbs and eggs. Season well with pepper and a little salt. Mix until all the ingredients are thoroughly combined. Turn the mixture into the loaf tin and smooth the surface with the back of a spoon.

4 Bake for 30–40 minutes until the roast has browned on top and shrunk slightly from the sides of the tin. Leave to cool for a few minutes, then run a knife around the edges and turn the roast out on to a plate or board. Serve hot, with the mushroom gravy.

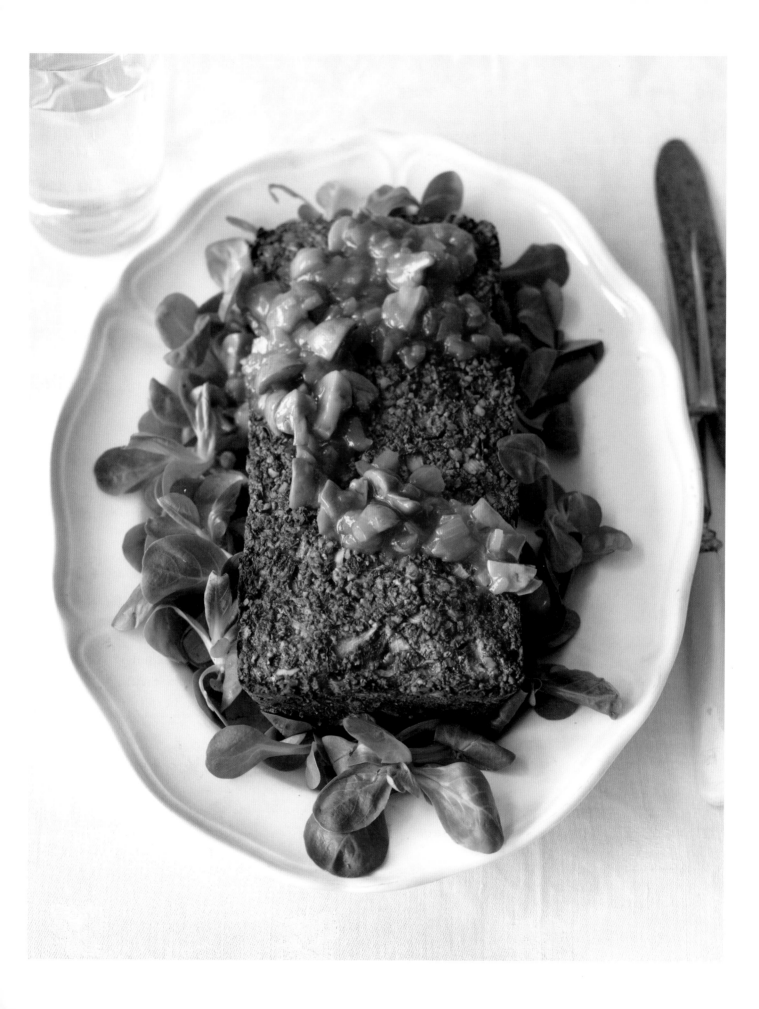

80g dried marrowfat peas

¾tsp bicarbonate of soda

500g floury potatoes (Maris Piper, King
 Edward or Desirée), peeled and diced

100g butter

1 large white onion, finely chopped

200g strong Lancashire cheese,
 lightly crumbled

FOR THE PASTRY

250g plain flour

125g butter, diced

Beaten egg, for glazing

SERVES SIX

POTATO PIE WITH CHEESE AND ONION

Potatoes, cheese and onion – a very British combination, as we know from our favourite crisps. For this pie these ingredients are mixed with mushy peas, another traditional favourite. You must use a strong cheese. The distinctive flavour of Lancashire has got what it takes, but you could equally well use a mature Cheddar or a Cornish Yarg – or even a blue cheese such as Stilton.

Follower of Rembrandt, 1606–1669
A Seated Man in a Lofty Room (detail), early 1630s

One of a number of paintings once believed to be by Rembrandt himself, but now thought to be by a contemporary working in the same style.

1 Place the peas in a bowl and pour over 500ml boiling water. Stir in the bicarbonate of soda, then cover and leave to soak overnight.
2 The next day, drain and rinse the peas, then put them in a pan with plenty of cold water. Bring to the boil, then lower the heat and simmer for 20 minutes or until the peas are soft, scooping up and discarding any skins that come to the surface. Drain and set aside.
3 Make the pastry. Sift the flour and ½tsp salt into a bowl and rub in the butter with your fingertips. Mix in 4–5tbsp cold water to form a dough. Wrap and rest in the fridge while you make the filling.
4 Cook the diced potatoes in a saucepan of salted boiling water for 15–20 minutes until tender. Meanwhile, melt 25g of the butter in a small saucepan, add the onion and a pinch of salt, and sweat, covered, for about 5 minutes or until softened but not coloured.
5 Drain the potatoes and return to the pan to dry out, then mash with the remaining butter using a potato masher. Mix the peas into the mash with the onion, cheese, and salt and white pepper to taste.
6 Set the oven at 180°C. Roll out the pastry on a floured surface. Cut out a lid for a deep 20cm pie dish and a strip to go around the rim. Moisten the rim of the dish and press the strip on to the rim, then spoon the filling into the dish. Moisten the pastry strip and place the lid on top of the pie. Trim the edge, press and crimp to seal, then make a hole in the centre of the lid. Brush with beaten egg. Bake the pie for 40–45 minutes until glazed golden brown. Serve hot.

6 apples, such as Bramley, Cox, Granny
 Smith and Russet
6 pears, such as Conference and Comice
1 vanilla pod, split lengthways
125g caster sugar
½tsp freshly grated nutmeg
½tsp ground ginger
¼tsp each white and black peppercorns
¼tsp ground cloves
20g butter

FOR THE CRUMBLE
90g peeled roasted chestnuts (fresh, frozen
 or vacuum-packed), roughly chopped
125g plain flour
125g ground almonds
200g golden granulated or Demerara sugar
200g cold butter, diced

SERVES SIX

SPICED APPLES AND PEARS WITH CHESTNUT CRUMBLE

Different textures and flavours are brought together here by different varieties of apples and pears. Combined with chestnuts and spice, the whole effect is very Christmassy. Cooking the crumble separately is a clever way to keep it chunky and prevent it from going mushy.

1 Peel and core one apple and one pear and cut into small cubes. Put the cubes in a large saucepan with the vanilla pod and sugar. Cover with cold water (about 150ml) and cook over a medium heat for about 15 minutes or until soft. Remove the vanilla pod and mash the fruit with a fork (or blitz with a hand blender) to make a smooth sauce. Set the pan aside.

2 Set the oven at 170°C. Peel and core the remaining apples and pears and slice into bite-size pieces. Put the pieces in a bowl with the spices and mix well. Melt half of the butter in a large frying pan and fry half of the apples and pears over a medium heat, stirring frequently, for about 10 minutes or until the fruit begins to turn golden brown. Add the fruit to the sauce in the other pan. Repeat with the remaining butter and fruit. Stir all the fruit and sauce together and cook over a medium heat for 10 minutes or until soft.

3 Meanwhile, make the crumble. Blitz the chestnuts in a food processor with the flour, almonds and sugar until evenly combined. Gradually add the butter in small amounts, pulsing the mixture just until it looks crumbly. Spread the crumble over a baking tray and bake for 20–25 minutes until golden brown, stirring and breaking up any clumps every 5 minutes to ensure even cooking.

4 Divide the cooked fruit among six shallow ovenproof bowls and cover with the sauce. Top with the crumble. Bake for 10 minutes to heat up the fruit. Serve hot.

397g can condensed milk
300g shortcrust pastry (page 257)
3 firm, ripe bananas, weighing about 500g in total
300ml whipping or double cream
1tbsp icing sugar
¼tsp cocoa powder

SERVES EIGHT

BANOFFI PIE

Created in the early seventies at The Hungry Monk in Sussex, banoffi pie has become something of a national institution. There are countless variations on the original theme, and the twist in this recipe is the way crushed bananas are mixed in with the cream. It makes a big difference to the texture and taste.

1 Immerse the unopened can of condensed milk in a deep saucepan of boiling water. Cover and boil for 4 hours, making sure the pan does not boil dry. (It is extremely important to top up the pan of boiling water frequently during cooking – 4 hours is a very long time and the can could explode if it is allowed to boil dry.) Remove the can from the water and leave to cool completely.

2 Meanwhile, make the pastry case. Roll out the pastry on a floured surface. Use to line a 20cm loose-bottomed tart tin placed on a baking sheet, letting the surplus pastry hang over the edge of the tin. Do not stretch the pastry or it will shrink during baking. Prick the bottom all over with a fork, then leave the case to rest in the fridge for about half an hour before baking.

3 Set the oven at 180°C. Line the pastry case with a disc of non-stick baking parchment that is at least 2cm larger than the diameter of the tin. Fill with baking beans or uncooked pulses or rice, and bake for 15 minutes. Slide the baking sheet out of the oven and lift out the paper and beans, then slide the sheet back in and bake the pastry case for a further 15 minutes. Leave to cool, then trim the excess pastry from the edge.

4 Open the can of condensed milk – the milk will have become toffee. Spread the toffee over the bottom of the pastry case. Peel the bananas and slice them on the diagonal. Use about half of the slices to cover the toffee in a single layer.

5 Lightly crush the remaining bananas with a fork. Whip the cream and sugar together in a bowl until soft peaks form, then fold in the crushed bananas. Swirl on top of the sliced bananas. Dust the pie with the cocoa powder just before serving.

200g raisins
150g currants
100g flaked almonds
75g cut mixed peel, finely chopped
75g glacé cherries, rinsed, dried and
 finely chopped
1 cooking apple, cored and grated
1 carrot, grated
140g beef or vegetarian suet
140g plain flour
140g Demerara sugar

75g fresh white or brown breadcrumbs
2 eggs, beaten
4tbsp stout or dark ale
4tbsp orange juice
Finely grated zest of 1 lemon
3tbsp lemon juice
2tbsp brandy
1tsp salt
½tsp ground cinnamon
Caster sugar, to finish
Brandy butter (page 255), to serve

SERVES EIGHT

CHRISTMAS PUDDING

There's no excuse for buying a Christmas pudding because it's so easy to make your own, and shop-bought puddings always seem synthetic no matter how expensive they are. A taste of alcohol is essential, and to intensify the almond flavour in this pudding you could add a dash of Amaretto, keeping the amount below the level of the brandy or it will be overpowering. If you can, make the pudding in October and feed it with a splash of brandy once a month, then just before serving pour warmed brandy over the pudding and set it alight. A bit of theatre is a must on Christmas Day.

English or French (?)
The Wilton Diptych (detail),
about 1395–9

This beautiful painting was a portable altarpiece for the private prayers of Richard II, King of England 1377–99. It is called The Wilton Diptych because it came from Wilton House in Wiltshire. A diptych is a painting, carving or piece of metalwork on two panels, usually hinged to open like a book. Inside, Richard II is presented by Saints Edmund, Edward the Confessor (shown here) and John the Baptist, to the Virgin and Child and a company of eleven angels.

1 Mix all the ingredients together and pack into a buttered 1 litre pudding basin. Cover the pudding with a disc of non-stick baking parchment, then cover the basin with a double thickness of foil. Tie the foil on securely with string, and make a handle of string across the top to help get the basin in and out of the pan.

2 Place the basin on a trivet or upturned saucer in a saucepan and pour in enough boiling water to come about halfway up the basin. Bring the water to the boil, then cover the pan and simmer over a low to medium heat for 4–5 hours, checking the water level frequently and topping up with more boiling water when needed. Remove from the pan and leave to cool.

3 Renew the baking parchment and foil and tie with string as before. Store in a cool, dry cupboard, or in the fridge, until Christmas Day.

4 To serve, repeat step 2 above, cooking the pudding for 2 hours. Turn out, sprinkle with caster sugar and serve with brandy butter.

2 egg whites
½tsp vinegar
100g caster sugar
1tsp cornflour

TO FINISH
250ml whipping or double cream
2tbsp caster sugar
½tsp ground cinnamon
2 clementines, peel and white pith
 removed, and segmented
1tbsp chopped toasted walnuts
1tbsp chopped toasted hazelnuts
1tbsp dried cranberries, soaked in
 1tbsp warmed sherry

SERVES FOUR

CHRISTMAS PAVLOVA

With its clementine and cranberry topping, this squidgy meringue makes a great dinner party dessert for the festive season. For a special occasion at other times of the year, swirl the meringue into one large cake and cut the top off after cooling, then fill the bottom with cream and seasonal fruits. Be generous with the filling, pop the top back at a jaunty angle, and you have a dessert to impress.

1 Set the oven at 120°C, and cover a baking sheet with non-stick baking parchment.
2 Whisk the egg whites in a clean bowl until soft peaks form. Add the vinegar, then whisk in the caster sugar a little at a time until the mixture will form stiff peaks when the whisk is lifted. Add the cornflour and gently stir through the meringue mixture.
3 Pipe or spread the mixture into four 12cm discs on the baking parchment. Bake for about 2 hours or until the meringue is crisp to the touch on the outside. Remove from the oven and leave to cool. Carefully peel away the baking parchment and place the meringues on four plates.
4 To finish, whip the cream until it will hold a soft shape, then stir in the sugar and cinnamon. Spoon the cream on the meringues, then top with the clementines, nuts and cranberries.

500g shortcrust pastry (page 257)
Milk, for brushing
1 egg, beaten with a pinch of salt
Caster and icing sugar, for sprinkling and dusting

FOR THE FILLING
100g raisins or sultanas, or a mixture of the two
100g cut mixed peel
2½tbsp brandy or port
75g butter, diced
100g light soft brown sugar
Finely grated zest of ½ orange or lemon
½tsp ground cinnamon
½tsp ground mixed spice
About 45g marzipan (optional)

MAKES TWELVE

MINCE PIES

Nowadays there are as many good mince pies as jars of mincemeat in the shops, so there's no point in making mince pies yourself unless they really do look homemade. These extra-special pies have juice bubbling up through the hole in the centre and out of the sides, and they are not overly pretty, so no-one will be in any doubt that you have made them yourself.

1 Make the filling. Soak the fruit and peel in the brandy or port for up to 48 hours, stirring occasionally.
2 Melt the butter and sugar in a saucepan over a low heat, then mix into the fruit with the zest and spices.
3 Set the oven at 180°C. Roll out the pastry on a floured surface until about 3mm thick. Cut out 12 discs with a 7.5cm pastry cutter and use to line a 12-hole patty tin. If using marzipan, roll it into 12 small balls and place one ball in the bottom of each pastry case. Top each with about 2tsp fruit mixture and brush the edges of the pastry with milk.
4 Cut out 12 lids with a fluted 6cm round cutter (or use a star cutter if you prefer), then place on top of the mincemeat and press to seal the pastry edges together. Brush the egg wash over the pies and sprinkle with caster sugar. Make a hole in the centre of each lid with the tip of a skewer.
5 Bake for about 20 minutes or until golden brown. Serve warm or cold, dusted with sifted icing sugar.

Andrea Mantegna, about 1430/1–1506
The Introduction of the Cult of Cybele at Rome (detail), 1505–6

The artist has painted this as if it were a sculpted frieze of grey marble figures, against a background of veneered coloured marble. It was probably intended as a room decoration, to be seen high up on a wall.

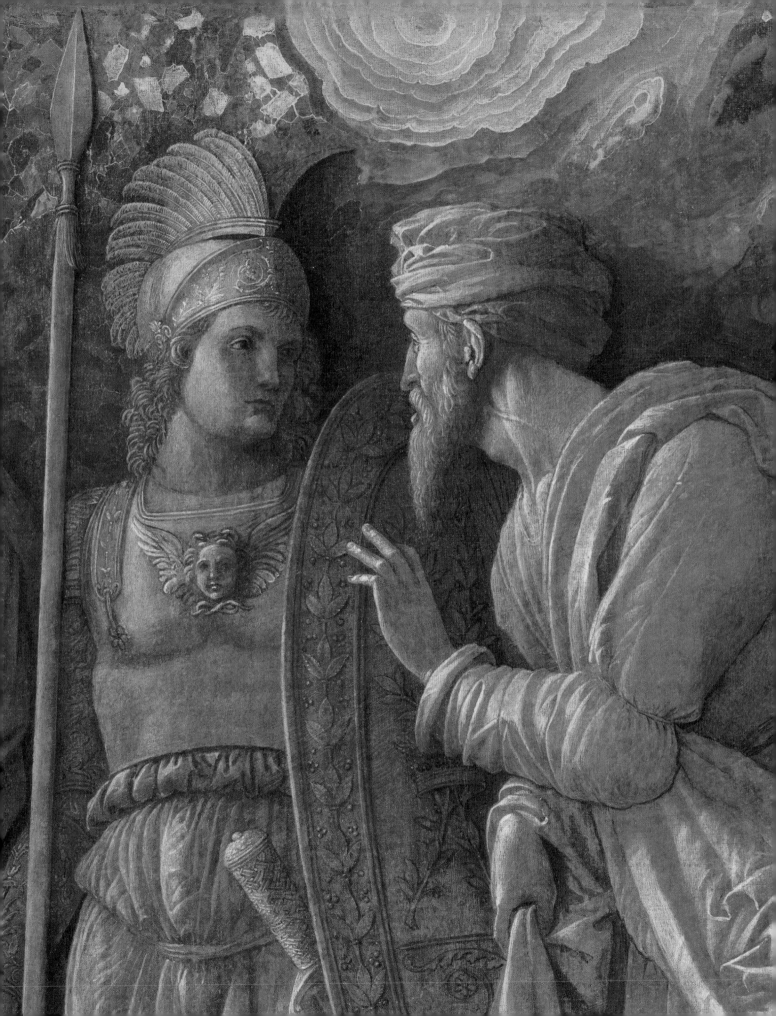

350g plain flour
2½tsp ground ginger
1tsp bicarbonate of soda
100g butter, diced
150g light soft brown sugar
1 egg, beaten
4tbsp golden syrup

MAKES EIGHTEEN

GINGERBREAD MEN

Although children may prefer to have sweets or currants for the buttons and eyes, gingerbread men need no embellishment at all to make them look cute. The more natural the better. Size is another important consideration, as large gingerbread men never seem to get finished, so look out for small cutters. Not surprisingly, they come in lady shapes too.

1 Set the oven at 180°C, and cover a baking sheet with non-stick baking parchment.

2 Sift the flour, ginger and bicarbonate of soda into a bowl. Rub in the butter with your fingertips until the consistency of sand, then stir in the sugar. Add the beaten egg mixed with the golden syrup and mix to form a dough.

3 Roll out the dough on a floured surface to about 3mm thick, then cut out shapes – a 12cm tall cutter will give you 18 gingerbread men. Place them on the baking parchment, spacing them out evenly, then make holes for their eyes and coat buttons, and cut out smiles for their mouths. Bake for about 10 minutes or until golden brown. Leave to firm up on the baking sheet before transferring to a wire rack to cool before serving.

200g soft butter
100g caster sugar
100g semolina
200g plain flour

FOR THE TOPPING
300g butter, diced
140g caster sugar
75g golden syrup
397g can condensed milk
300g plain chocolate (70% cocoa solids), broken into pieces

MAKES EIGHTEEN BARS

MILLIONAIRE'S SHORTBREAD

Crisp buttery shortbread, gooey toffee caramel and melt-in-the-mouth chocolate – you can almost see the amount of calories in the three distinct layers. It should be called squillionaire's shortbread, it's so over the top. You can fashion the shortbread to look like coins, as shown in the photograph, or simply follow the recipe and cut into bars.

1 Set the oven at 160°C. Lightly grease a Swiss roll tin measuring 30–33 × 20–23cm. Place all the ingredients for the shortbread in a food processor and blend to a smooth dough. Press the dough into the tin and prick with a fork. Bake for 15–20 minutes until golden and firm. Set aside to cool.

2 Put the butter, sugar, syrup and condensed milk for the topping into a saucepan and stir over a low heat until the butter has melted. Simmer gently, stirring all the time, for 20 minutes or until the mixture looks like thick fudge. Pour this caramel over the cold shortbread in an even layer. Leave to cool.

3 Melt the chocolate in a bowl set over a pan of gently simmering water. Pour the chocolate over the caramel layer and spread it out evenly with a palette knife. Leave to set, then cut into bars or other shapes with a sharp knife.

450g currants

225g sultanas

225g raisins

85g glacé cherries, rinsed, dried and
 finely chopped

85g cut mixed peel, finely chopped

3tbsp brandy, plus extra to feed the cake

275g soft butter

275g light or dark soft brown or
 muscovado sugar

Finely grated zest and juice of 1 lemon

Finely grated zest of 1 orange

4 eggs

275g plain flour

1tsp ground mixed spice

½tsp ground cinnamon

½tsp freshly grated nutmeg

½tsp salt

85g chopped almonds (skin left on)

1tbsp black treacle

100g whole blanched almonds

SERVES TWENTY

CHRISTMAS CAKE

This is a rich and densely fruited cake topped with almonds, like a Dundee. It looks suitably festive at Christmas with a ribbon tied tastefully around it, but you'll also find it useful for other times in the year when you need a celebration cake. Then you can top it with marzipan and icing instead of the nuts.

Luis Meléndez, 1716–1780
*Still Life with Oranges
and Walnuts* (detail), 1772

In addition to the oranges and walnuts seen here, on the wooden shelf there are chestnuts, a melon, earthenware jugs, a small barrel and some boxes. The jugs probably contain wine, while the barrel possibly contains olives. The round boxes were normally used for cheese, while the rectangular ones were used for sweets, such as *dulce de membrillo*, a thick quince jelly eaten in slices.

1 Soak the dried fruit, cherries and peel in the brandy overnight (for at least 12 hours).

2 Set the oven at 150°C. Grease a 23cm round cake tin and line with non-stick baking parchment. Tie a double thickness of brown paper around the outside of the tin.

3 Cream the butter and sugar in a large bowl with the lemon and orange zest until fluffy and paler in colour. Beat in the eggs one at time. Sift the flour, spices and salt over the creamed mixture, then fold in gently until evenly combined. Now fold in the soaked fruit, lemon juice, chopped almonds and treacle.

4 Spoon the mixture into the cake tin, making sure the surface is flat and there are no air pockets. Arrange the whole blanched almonds in circles on top of the cake, pressing them in lightly.

5 Cover the top of the cake with a disc of double thickness baking parchment and cut a small hole in the middle. Bake on the lowest shelf of the oven for 3½–4 hours until a skewer inserted in the centre comes out clean. Cool the cake in the tin for about 30 minutes, then remove to a wire rack.

6 When the cake is cold, turn it upside down and make small holes in the base with a skewer, then pour in extra brandy. Double wrap the cake in baking parchment and secure with an elastic band. Store in an airtight container in a cool, dry cupboard for up to 3 months, feeding it with more brandy every month if you like.

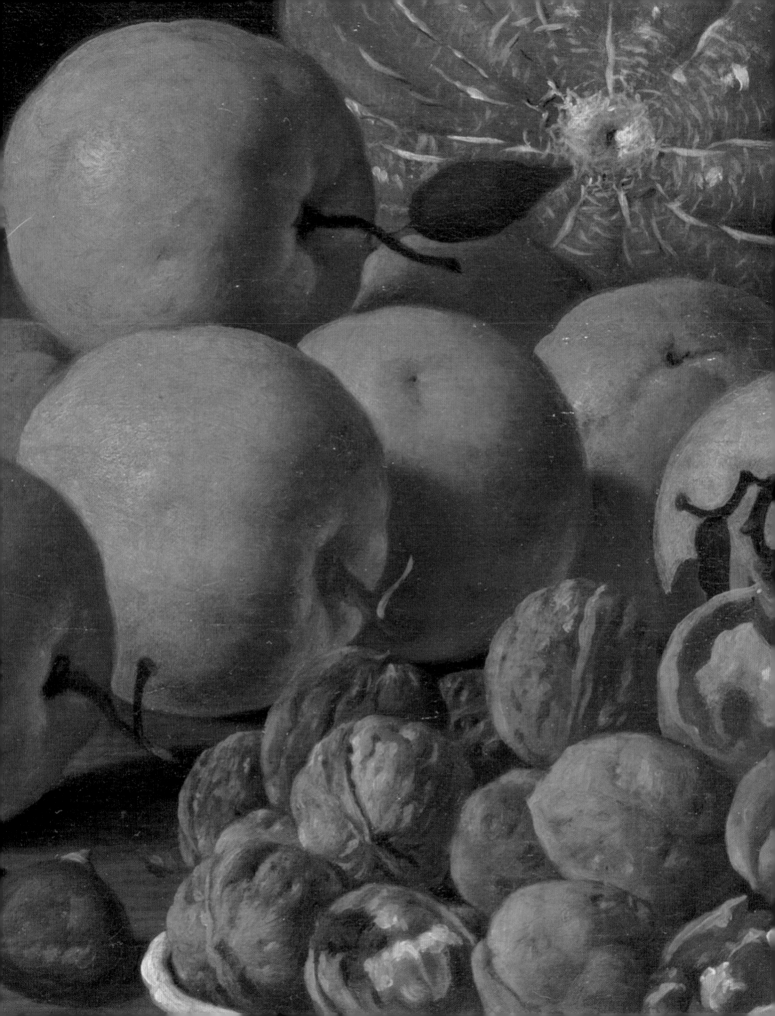

MAKES ONE

POMEGRANATE PASSION

Seeds of ½ pomegranate
1tsp caster sugar
50ml vodka
20ml grapefruit juice
Ice cubes

Crush the pomegranate seeds and sugar with a pestle or the end of a rolling pin. Put into a shaker with the vodka and grapefruit juice. Add ice and shake well, then strain over ice in a large Martini glass.

MAKES ONE

HOT LEMONADE

Juice of 1 lemon
1tsp clear honey

Mix the lemon juice and honey in a thick, heatproof highball glass and top up with hot water.

PER SERVING

MULLED WINE

100ml red wine
1 slice of lemon
1 slice of orange
1 cinnamon stick
Caster sugar (optional)

Put the wine in a pan with the lemon and orange slices and the cinnamon. Bring just to the boil, then taste and add sugar if you like. Serve in thick heatproof glasses with handles, or in cups.

MAKES ONE

IRISH TODDY

50ml Irish whiskey
Juice of ½ lemon
1tsp clear honey

Stir the whiskey with the lemon juice and honey in a tumbler. Add hot water if you like.

Clockwise from the top:
Pomegranate passion,
Hot lemonade, Mulled
wine and Irish toddy

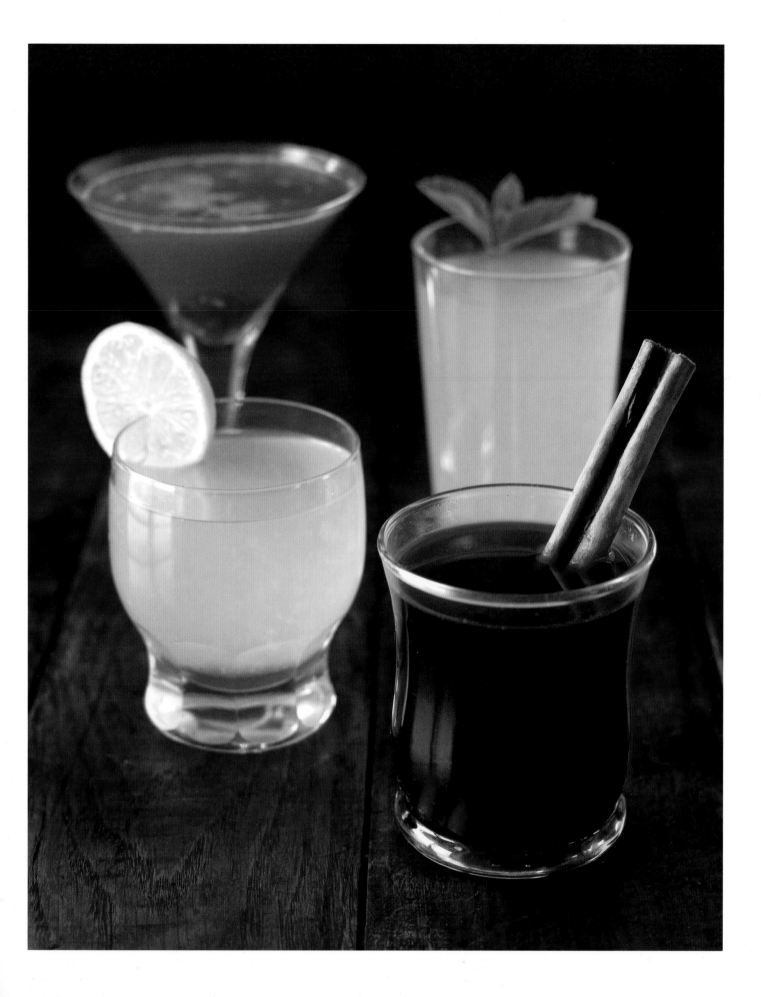

A BRITISH CHEESEBOARD

Left to right:

Tally Mountain Welsh goat's cheese. Creamy like Camembert, strong flavours but not overpowering. Expensive but worth it.

Cornish Yarg (back). Cow's cheese made in East and West Cornwall. Natural rind covered in fresh nettles. Smooth, creamy flavours, slightly crumbly in texture.

Alex James's Little Wallop (front). Created by Alex James from the group Blur, this is a goat's cheese washed in cider brandy, wrapped in chestnut or vine leaves and aged so it develops some interesting moulds and complex flavours.

Cropwell Bishop Stilton. From Nottinghamshire, a fine example of a classic Stilton. Spicy, creamy and smooth.

Isle of Mull Cheddar. The pride of Scotland and the Scots' cheddar of choice. Wild, gamey and acidic flavours.

BASIC RECIPES
& ACCOMPANIMENTS

CHICKEN STOCK
MAKES 1.5 LITRES

1 raw chicken carcass (including the wings),
 roughly broken or chopped
1 onion, chopped
1 leek, chopped
2 celery sticks, chopped
2 carrots, chopped
4 garlic cloves, peeled (optional)
4 black peppercorns
1 bay leaf
4 sprigs of fresh thyme
4 sprigs of fresh parsley

1 Put the chicken bones in a very large saucepan or stockpot, pour in enough cold water to cover (about 3 litres) and bring to the boil. Turn the heat down to low so the liquid is simmering, then add the vegetables, garlic, peppercorns and herbs. Simmer, uncovered, for 1 hour, skimming frequently.
2 Remove the stock from the heat and pass through a sieve lined with a double thickness of muslin. Degrease the surface of the stock and add seasoning to taste. Use straightaway, or cool and refrigerate in a covered container for up to 3 days, or freeze for up to 3 months.

BROWN CHICKEN STOCK
MAKES 1 LITRE

1 raw chicken carcass (including the wings),
 roughly broken or chopped
2tsp vegetable oil
1 large carrot, chopped
1 large onion, chopped
1 large celery stick, chopped
1 leek, chopped
125ml dry white wine
Pinch of dried thyme
1 bay leaf
A few black peppercorns

1 Set the oven at 200°C. Put the bones in a roasting tin and roast for 20–30 minutes until very dark brown.
2 Heat the oil in a very large saucepan or stockpot, add the vegetables and cook over a medium heat until they start to turn golden brown. Add the chicken bones and cook for a further 5 minutes.
3 Meanwhile, heat the roasting tin on top of the stove, add the wine and stir to dislodge the sediment from the bottom of the tin. Pour the liquid over the chicken bones and vegetables, then add enough cold water to cover everything generously (about 4 litres). Add the herbs and peppercorns and bring to the boil, then simmer gently, uncovered, for 3 hours, skimming frequently. Leave to cool.
4 Remove the chicken bones and vegetables from the liquid using a slotted spoon. Strain the liquid into a clean pan. Boil for about 20 minutes or until reduced by one-third, then degrease the surface. Add seasoning to taste and use straightaway, or cool and refrigerate in a covered container for up to 3 days, or freeze for up to 3 months.

FISH STOCK
MAKES 1 LITRE

50g butter
1 small onion, chopped
1 celery stick, chopped
½ small leek, chopped
500g fish bones and trimmings, well
 rinsed and chopped into small pieces
125ml dry white wine
Juice of 1 lemon
75g fennel bulb, chopped
4 sprigs of fresh parsley
2 sprigs of fresh thyme
1 bay leaf

1 Melt the butter in a large saucepan and
cook the vegetables gently for a few minutes
until softened. Add the fish bones and
trimmings, the wine and lemon juice, and
bring to the boil. Simmer until all the liquid
has evaporated. Pour in enough cold water
to cover the bones and trimmings (about
1.2 litres) and bring to a gentle simmer.
Add the fennel and herbs and allow to
tick over, uncovered, for 20 minutes,
skimming frequently.
2 Remove the stock from the heat and pass
through a sieve lined with a double thickness
of muslin. Add seasoning to taste and use
straightaway, or cool and refrigerate in a
covered container for up to 24 hours, or
freeze for up to 1 month.

VEGETABLE STOCK
MAKES 2 LITRES

1 large onion
1 leek
2 carrots
2 celery sticks
½ bulb of fennel
25g butter
2 bay leaves
2 cloves

1 Roughly chop the vegetables. Melt the
butter in a very large saucepan or stockpot.
Add the onion and leek, cover the pan
and sweat gently over a low heat for about
5 minutes or until softened. Add the
remaining vegetables with the bay leaves
and cloves, cover the pan again and sweat
for a further 10 minutes.
2 Pour in 3 litres cold water and bring to
the boil. Simmer uncovered for 20 minutes.
Strain through a cloth or sieve and season
to taste. Use straightaway, or cool and
refrigerate in a covered container for up
to 3 days, or freeze for up to 3 months.

BEEF STOCK
MAKES 1.5 LITRES

1kg beef or veal bones
500g beef or veal shins
1 calf's foot
2tbsp vegetable oil
1 carrot, chopped
1 onion, chopped
100g celeriac, chopped
4 garlic cloves, chopped (optional)
100g streaky bacon, chopped
100g tomato purée
300ml dry white wine
400g can tomatoes
10g fresh parsley
10g fresh sage
10g fresh thyme
10 bay leaves

1 Set the oven at 180°C. Put the bones and shins in a roasting tin with the calf's foot and 1tbsp of the oil. Roast for about 20 minutes or until browned.
2 Heat the remaining oil in a very large saucepan or stockpot over a high heat and add the chopped vegetables, garlic and bacon. Cook for about 10 minutes or until starting to brown. Stir in the tomato purée and cook for a couple of minutes, then add the wine and boil for 5 minutes to reduce a little.
3 Add the bones, shins and calf's foot to the pan. Pour in enough cold water to cover (about 4 litres) and bring to a gentle simmer. Skim the surface, then add the tomatoes and herbs. Simmer gently, uncovered, for 4–6 hours, skimming frequently.
4 Strain the stock, then degrease the surface. Add seasoning to taste and use straightaway, or cool and refrigerate in a covered container for up to 3 days, or freeze for up to 3 months.

MUSHROOM GRAVY
MAKES ABOUT 600ML

1tbsp vegetable oil
1 onion, finely chopped
350g baby button mushrooms, quartered
3tbsp soy sauce (light or dark)
1tbsp sherry vinegar
250ml hot vegetable stock
1tbsp cornflour mixed to a paste with 2tbsp water

1 Heat the oil in a saucepan and cook the onion over a low heat for about 5 minutes or until soft. Add the mushrooms and cook, stirring frequently, for about 5 minutes or until softened.
2 Add the soy sauce and vinegar and bring to the boil, stirring constantly. Pour in the stock and bring back to the boil. Slowly add the cornflour paste, stirring, then simmer for 3–5 minutes until the gravy thickens. Add seasoning to taste and serve hot.

BREAD SAUCE

SERVES FOUR

2 thick slices of bread from a large bloomer or
 other white loaf, crusts removed (100g crumb)
50g piece of smoked bacon or 2 smoked bacon
 rashers (without rind)
2 large shallots, chopped
30g butter
250ml milk
100g walnut pieces, toasted
1tbsp sherry vinegar

1 Set the oven at 240°C (or as high as your
oven will go).
2 Cut the bread into 1cm pieces and spread
out on a baking sheet. Bake for 8–10 minutes
until very brown and almost burnt, turning
the pieces occasionally.
3 Remove the fat from the bacon and
cut the bacon into chunks. Sauté the bacon
and shallots in half of the butter with a pinch
of salt until lightly coloured. Add the bread,
milk and 250ml cold water and bring to
the boil. Cover and simmer for 10 minutes,
stirring occasionally to prevent the sauce
from catching on the bottom of the pan.
4 Stir in the walnuts and bring back to
the boil, then remove from the heat and
cool slightly. Remove and discard the
bacon. Purée the sauce in a blender or food
processor until smooth. Finish by beating
in the remaining butter, the vinegar,
and seasoning to taste.

WHITE SAUCE

MAKES ABOUT 250ML

250ml milk
¼ onion, peeled
½tsp fresh thyme leaves
20g butter
20g plain flour

1 Bring the milk slowly to the boil in a
heavy saucepan with the onion and thyme.
Remove from the heat and strain into a jug.
2 Melt the butter in the saucepan over a
low heat, sprinkle in the flour and cook for
2 minutes, stirring constantly. Slowly add
the milk, increasing the heat under the pan
to medium and whisking after each addition
until a smooth sauce is formed. Simmer
gently for 3–5 minutes, stirring often.

HOLLANDAISE SAUCE
SERVES FOUR

115g butter
2 egg yolks
1tsp white wine vinegar
1tbsp lemon juice

1 Clarify the butter. Melt the butter slowly in a heavy saucepan over a low heat. Skim off the froth from the surface, then very slowly pour the golden liquid into a jug, leaving the sediment behind in the bottom of the pan. Discard the sediment.
2 Half fill a saucepan with water and place over a low heat until hot but not boiling. Quickly whisk the egg yolks, vinegar and 2tbsp hot water in a heatproof bowl. Set the bowl over the pan of hot water and whisk until the eggs have the consistency of semi-thick cream – they should hold a ribbon trail when the whisk is lifted.
3 Take the pan off the heat and very slowly trickle the clarified butter on to the egg mix. Whisk vigorously all the time and add a few spoonfuls of water if the sauce becomes too thick. Keep mixing until all the butter is added, then remove the bowl from the pan. Add the lemon juice and seasoning to taste.
4 To keep the hollandaise until you are ready to serve, cover the surface of the sauce with cling film and leave in a warm place.

MAYONNAISE
MAKES 300ML

2 eggs
2tsp smooth or grainy mustard
1tbsp lemon juice or white wine vinegar,
 or more to taste
250ml rapeseed oil

1 Blitz the eggs, mustard and 1tbsp lemon juice in a food processor until mixed. With the machine running, slowly drizzle the oil through the funnel. When you have a thick, smooth emulsion, add the oil more quickly in a thin, steady stream.
2 Add salt and pepper to taste, and more lemon juice if you like. Keep in a covered container in the fridge for up to 3 days.

HORSERADISH CREAM
SERVES FOUR

75g fresh horseradish
4tbsp caster sugar
100ml crème fraîche

1 Peel the horseradish and cut into 1cm dice. Bring a saucepan of water to the boil with the sugar and ¼tsp salt. Add the diced horseradish and simmer for about 10 minutes or until it is tender.
2 Drain the horseradish and rinse thoroughly under the cold tap, then purée in a blender with the crème fraîche. Keep in a covered bowl in the fridge until ready to serve.

VANILLA CUSTARD

SERVES EIGHT

500ml milk
100ml double cream
1 vanilla pod, split lengthways
6 egg yolks
75g caster sugar
2tsp cornflour

1 Put the milk and double cream in a
heavy saucepan with the vanilla pod and
bring just to the boil. Remove from the
heat. Mix the egg yolks and sugar together
in a bowl. Pour in a little of the hot creamy
milk and stir well to mix. Pour in a little
more of the creamy milk and stir again.
2 Add the cornflour to the egg mixture
and whisk until smooth. Slowly pour in
the remaining creamy milk, whisking
constantly.
3 Pour the custard into the rinsed-out pan
and cook over a low to medium heat for
about 5 minutes or until thickened and
smooth, stirring constantly with a wooden
spoon. Strain through a sieve and serve hot.
Or, leave to cool with a sheet of cling film
on the surface to prevent a skin from
forming, then gently reheat (without
the cling film) to serve.

BRANDY BUTTER

SERVES EIGHT

4tbsp brandy
150g soft butter
150g light soft brown sugar

Blitz all the ingredients together in a blender
until evenly mixed. Keep in a covered
container in the fridge for up to 3 weeks,
or in the freezer for up to 2 months.

SYLLABUB

SERVES FOUR

125ml cream sherry
2tsp lemon juice
85g caster sugar
250ml whipping or double cream
Pinch of freshly grated nutmeg

1 Pour the sherry and lemon juice into a
bowl. Add the sugar and stir until dissolved.
2 Add the cream and nutmeg and whisk
gently until the mix just holds its shape.
Don't over-whisk, or whisk too vigorously,
because this could cause the cream to
separate or look curdled.

YORKSHIRE PUDDINGS
MAKES TWELVE

3 eggs
115g plain flour
275ml milk
Vegetable oil

1 Beat the eggs in a bowl, then whisk in
the flour and a pinch of salt. Add the milk,
whisking all the time, until you have a
smooth, runny batter. Leave to rest,
covered, for about 1 hour.
2 Set the oven at 220°C. Pour a thin layer
of oil into each section of a 12-hole muffin
tin, then heat in the oven for about
12 minutes or until very hot.
3 Pour the batter into the tin and bake
for about 25 minutes or until the puddings
are golden brown, puffed up and crisp.
Do not open the oven door while they
are baking. Serve immediately.

PANCAKES
MAKES EIGHT

100g plain flour
1 egg, beaten
250ml milk
Vegetable oil, for frying

1 Sift the flour and a pinch of salt into a bowl,
then whisk in the egg and milk to make a
smooth batter. Set aside for at least an hour.
2 Lightly oil a 16–18cm non-stick frying pan
and place over a medium heat until hot.
Whisk the batter to mix, then pour a small
ladleful into the pan and swirl it around until
it completely covers the bottom in a thin,
even layer. Cook for about 2 minutes or
until bubbles appear on the surface and the
underside of the pancake is tinged golden
brown, then turn or flip the pancake over
and cook the other side for 1 minute.
3 Slide the pancake out of the pan and repeat
with the remaining batter to make eight
pancakes in all, adding more oil to the pan
when needed.

SHORTCRUST PASTRY

MAKES 500G

300g plain flour
150g butter, cut into rough 1cm cubes

1 Sift the flour and a pinch of salt into
a bowl and rub in the butter with your
fingertips. Do this very gently and just
long enough to make the mixture resemble
crumbly sand – a few lumps are fine.
2 Sprinkle over 3tbsp cold water and stir
in with a table knife until the mixture binds
together. Now bring it together in a rough
ball shape with your fingertips, adding
another ½–1tbsp water if needed. When
enough liquid has been added, the pastry
should leave the bowl fairly clean.
3 Wrap the pastry in cling film and allow
to rest in the fridge for at least 30 minutes
before using.

TO MAKE 300G PASTRY
Use 185g plain flour, 85g butter
and 2½–3tbsp cold water.

SWEET PASTRY

MAKES ABOUT 575G

300g plain flour
150g butter, cut into rough 1cm cubes
75g granulated sugar
2 medium eggs, lightly beaten

1 Sift the flour and a good pinch of salt into
a bowl. Beat the butter in another bowl with
an electric hand whisk until softened. Add
the sugar and beat until light and fluffy, then
gradually add the eggs, beating just until
incorporated – don't overbeat or the butter
will separate and look curdled. Add the flour
all at once and mix just until a ball of dough
is formed. Don't overmix or the pastry will
be hard when baked.
2 Turn the dough on to a floured surface
and flatten into a disc. Wrap in cling film
and allow to rest in the fridge for at least
30 minutes before using.

Piccalilli and Apple
and onion chutney
(recipe on page 260)

PICCALILLI
MAKES ABOUT 1KG

250g cucumber
200g carrots
200g silverskin or small pickling onions
200g cauliflower
150g green beans
5 good handfuls of fine sea salt

FOR THE PICKLING LIQUID
250ml white (distilled) vinegar
60g caster sugar
30g fine sea salt
1tsp pickling spice

FOR THE SPICE MIX
½tsp turmeric
½tsp English mustard powder
½tsp ground ginger
2½tsp caster sugar
1tbsp cornflour

1 Prepare the vegetables, keeping them separate. Cut the cucumber and carrots into balls using a small melon baller, or into small dice. Peel and halve or quarter the onions, depending on size. Break the cauliflower into small florets, discarding the stalks. Trim the beans and cut into short lengths. Place each type of vegetable in a separate bowl and sprinkle with a good handful of salt. Cover and keep in the fridge overnight. During this time the salt will draw out excess water and partially 'cook' the vegetables.
2 Rinse the vegetables under cold running water, still keeping them separate, then place each type in a bowl of cold water. Leave for about 30 minutes, changing the water every 10 minutes, then drain. Mix the carrots, onions, cauliflower and beans in a large bowl and put the cucumber on top.

3 Combine all the ingredients for the pickling liquid in a saucepan and bring to the boil. Strain and return to the pan, then bring back to the boil and pour over the vegetables. Leave to cool, stirring occasionally, then drain the vegetables, saving the liquid.
4 Heat the turmeric, mustard and ginger in a small saucepan over a low heat, stirring constantly until the spices smell fragrant. Add the sugar and the reserved pickling liquid and bring to the boil. Mix the cornflour to a paste with a few drops of water, then add to the boiling liquid and stir until thickened slightly. Remove the pan from the heat and leave to cool.
5 Mix the vegetables with the cooled spiced liquid and decant into sterilised Kilner or screw-topped jars. Store the piccalilli in the fridge; it will keep for 3 months.

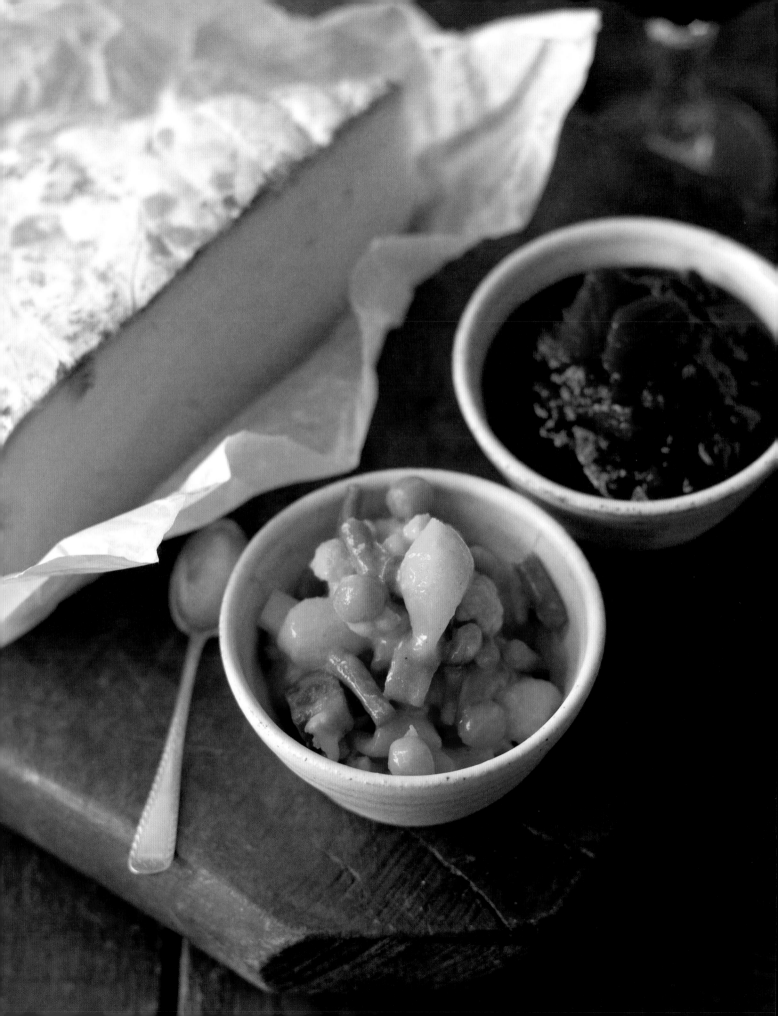

APPLE AND ONION CHUTNEY

MAKES ABOUT 2.5KG

2kg Bramley apples, peeled,
 cored and roughly chopped
1kg dark or light soft brown sugar
5 onions, chopped
5 garlic cloves, chopped
1 litre white wine vinegar
400g raisins
20g white mustard seeds

1 Put all the ingredients in a large heavy saucepan and bring slowly to the boil, then cook over a very low heat, stirring frequently, until the apples and onions have broken down and are very soft. This should take 2½–3 hours.
2 Remove the pan from the heat and leave to cool. Decant the chutney into sterilised Kilner or screw-topped jars. Store in a cool, dry cupboard or in the fridge for up to 1 year. The longer the chutney is left, the more intense the flavour will become.

FENNEL AND RED ONION SALAD

SERVES SIX

2 bulbs of fennel
2 red onions, finely sliced
10 leaves of fresh flat-leaf parsley, finely shredded
Juice of 1 lemon
4tsp rapeseed oil

1 Trim the fennel bulbs, reserving the feathery leaves to garnish, then slice the bulbs finely.
2 Put the sliced fennel in a bowl with all the other ingredients. Add salt to taste and toss together. Serve garnished with the reserved fennel leaves.

BRUSSELS SPROUTS WITH BACON

SERVES SIX

750g–1kg Brussels sprouts
6 slices of thick-cut unsmoked streaky bacon,
 chopped into large matchstick pieces
1 shallot, thinly sliced
2 garlic cloves, cut into thin slivers
A good knob of butter

1 Clean the sprouts by taking away the outer leaves and trimming off the stalk ends. Cut a cross in the bottom of each sprout. Drop the sprouts into a saucepan of salted boiling water and simmer for 3–5 minutes until tender when pierced with the point of a knife. Drain and refresh in a bowl of iced water, then drain again. If the sprouts are large, cut them in half.
2 In a frying pan over a medium heat, cook the bacon for about 5 minutes or until almost crisp. Add the shallot and garlic and cook for a further 5 minutes or until the shallot is soft and the bacon is crisp. Add the sprouts and butter and season well, then toss until the sprouts are hot.

POTATO AND APPLE FRITTERS
MAKES FOUR

25g butter
3 floury potatoes (King Edward, Maris Piper
 or Desirée)
1 Bramley apple
10g fresh flat-leaf parsley leaves, chopped
2tsp finely grated fresh or bottled horseradish
About 4tbsp duck fat or vegetable oil

1 Set the oven at 180°C and clarify the butter. Melt it slowly in a small, heavy saucepan over a low heat. Skim off the froth from the surface, then very carefully pour the golden liquid into a medium bowl, leaving the sediment behind in the bottom of the pan (discard the sediment).
2 Peel the potatoes and grate into a sieve. Squeeze out as much liquid from the potatoes as possible, then tip them into the bowl with the clarified butter. Peel and core the apple and grate over the potatoes. Add the parsley, horseradish and seasoning to taste. Mix together well.
3 Heat 2tbsp of the duck fat in a frying pan over a medium heat. Place one-quarter of the fritter mixture in the hot fat and pat it down into a thin pancake shape about 10cm in diameter. Cook over a low to medium heat for about 4 minutes or until golden brown on both sides, turning once. Lift the fritter out of the pan with a fish slice and place on a greased large baking sheet. Repeat with the rest of the mixture to make three more fritters, adding more duck fat when needed.
4 Place the fritters in the oven and cook for 10–12 minutes until crisp and piping hot.

COLCANNON
SERVES FOUR

500g floury potatoes (King Edward, Maris Piper
 or Desirée), peeled and cut into chunks
250g Savoy cabbage, shredded
2tbsp whipping or double cream

1 Put the potatoes into a saucepan of salted cold water. Cover and bring to the boil, then simmer for 15–20 minutes until tender.
2 Meanwhile, lightly steam the cabbage for 3–4 minutes until tender. Drain the potatoes well, then return to the pan. Crush and mix with the cabbage, cream and seasoning to taste. Serve hot.

TO MAKE 4 COLCANNON PATTIES
1 Heat 1tbsp vegetable oil until hot in a large non-stick frying pan and fry 1 large sliced onion until soft and beginning to brown. Mix the onion into the colcannon. Shape into four patties.
2 Heat 2tbsp vegetable oil in the frying pan until hot, then add the patties and fry over a medium to high heat for 4–5 minutes until well browned and crisp underneath. Turn them over carefully and fry for another 4–5 minutes. Serve straightaway.

INDEX OF PAINTINGS

pages 11, 128–9 & 171
Joachim Beuckelaer, active 1560–1574
The Four Elements: Earth, 1569
Oil on canvas, 157.3 x 214.2 cm

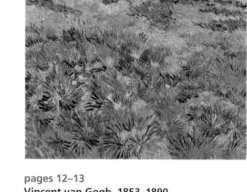

pages 12–13
Vincent van Gogh, 1853–1890
Long Grass with Butterflies, 1890
Oil on canvas, 64.5 x 80.7 cm

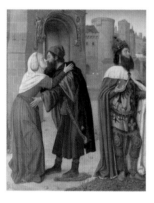

page 25
Master of Moulins (Jean Hey), active 1483
or earlier – about 1500
*Charlemagne, and the Meeting of Saints Joachim
and Anne at the Golden Gate*, about 1500
Oil on oak, 72 x 59 cm

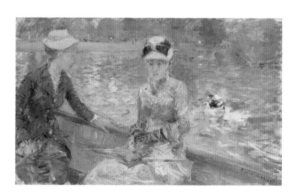

page 29
Berthe Morisot, 1841–1895
Summer's Day, about 1879
Oil on canvas, 45.7 x 75.2 cm

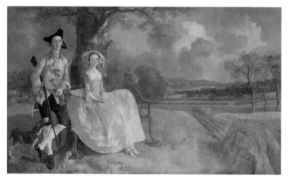

page 35
Thomas Gainsborough, 1727–1788
Mr and Mrs Andrews, about 1750
Oil on canvas, 69.8 x 119.4 cm
Bought with contributions from the Pilgrim Trust, The Art Fund,
Associated Television Ltd, and Mr and Mrs W. W. Spooner, 1960.

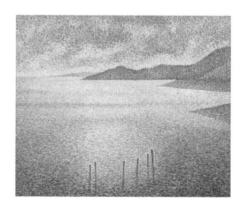

page 39
Théo van Rysselberghe, 1862–1926
Coastal Scene, about 1892
Oil on canvas, 51 x 61 cm

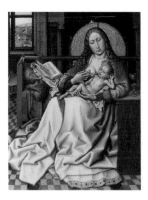

page 45
Follower of Robert Campin, 1378/9–1444
The Virgin and Child before a Firescreen, about 1440
Oil with egg tempera on oak with walnut additions,
63.4 x 48.5 cm

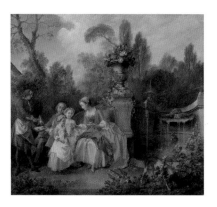

page 49
Nicolas Lancret, 1690–1743
*A Lady in a Garden taking Coffee with
some Children*, probably 1742
Oil on canvas, 88.9 x 97.8 cm

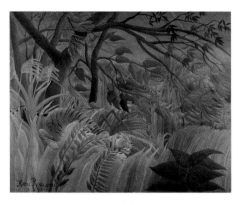

page 55
Henri Rousseau, 1844–1910
Surprised!, 1891
Oil on canvas, 129.8 x 161.9 cm

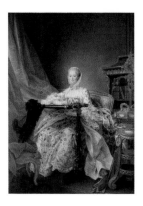

page 61
François-Hubert Drouais, 1727–1775
Madame de Pompadour at her Tambour Frame, 1763–4
Oil on canvas, 217 x 156.8 cm

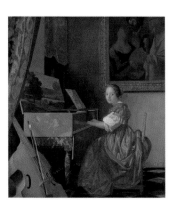

page 65
Johannes Vermeer, 1632–1675
A Young Woman seated at a Virginal, about 1670–2
Oil on canvas, 51.5 x 45.5 cm

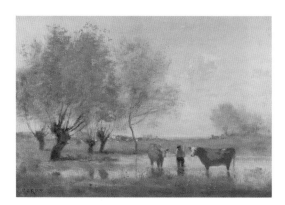

pages 68–9
Jean-Baptiste-Camille Corot, 1796–1875
Cows in a Marshy Landscape, probably 1860–70
Oil on canvas, 24.1 x 34.9 cm

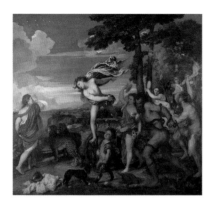

page 73
Titian, active about 1506–1576
Bacchus and Ariadne, 1520–3
Oil on canvas, 176.5 x 191 cm

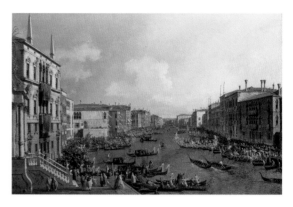

page 79
Canaletto, 1697–1768
A Regatta on the Grand Canal, about 1740
Oil on canvas, 122.1 x 182.8 cm

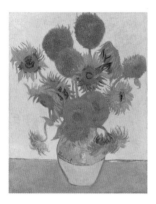

page 93
Vincent van Gogh, 1853–1890
Sunflowers, 1888
Oil on canvas, 92.1 x 73 cm

page 99
Aelbert Cuyp, 1620–1691
*River Landscape with Horseman
and Peasants*, about 1658–60
Oil on canvas, 123 x 241 cm

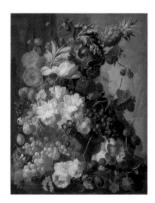

page 105
Jan van Os, 1744–1808
Fruit and Flowers in a Terracotta Vase, 1777–8
Oil on mahogany, 89.1 x 71 cm

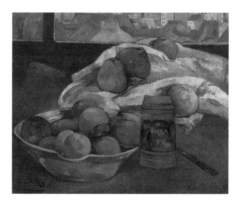

page 113
Paul Gauguin, 1848–1903
Bowl of Fruit and Tankard before a Window, probably 1890
Oil on canvas, 50.8 x 61.6 cm
Bequeathed by Simon Sainsbury, 2006

page 117
Pieter Claesz, 1597/8–1660
Still Life with Drinking Vessels, 1649
Oil on oak, 63.5 x 52.5 cm

page 121
Jan van Os, 1744–1808
Fruit, Flowers and a Fish, 1772
Oil on mahogany, 72.2 x 56.7 cm

page 133
Pieter de Hooch, 1629–1684
A Musical Party in a Courtyard, 1677
Oil on canvas, 83.5 x 68.5 cm

page 143
Joachim Beuckelaer, active 1560–1574
The Four Elements: Water, 1569
Oil on canvas, 158.5 x 215 cm

page 151
Peter Paul Rubens, 1577–1640
A View of Het Steen in the Early Morning, probably 1636
Oil on oak, 131.2 x 229.2 cm

page 159
Jan Jansz. Treck, 1605/6–1652
Still Life with a Pewter Flagon and Two Ming Bowls, 1649
Oil on canvas, 76.5 x 63.8 cm

page 167
Follower of Quinten Massys, 1465–1530
Saint Luke painting the Virgin and Child, about 1520?
Oil on oak, 113.7 x 34.9 cm

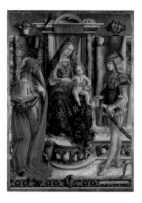

page 175
Carlo Crivelli, about 1430/5–about 1494
La Madonna della Rondine (*The Madonna of
the Swallow*), after 1490
Egg and oil on poplar, 150.5 x 107.3 cm

page 187
Simon Vouet and studio, 1590–1649
Ceres and Harvesting Cupids, probably 1634–5
Oil on canvas, 145.5 x 188 cm

page 190–1
Claude-Oscar Monet, 1840–1926
Lavacourt under Snow, about 1878–81
Oil on canvas, 59.7 x 80.6 cm

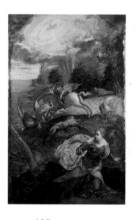

page 195
Jacopo Tintoretto, 1518/19–1594
Saint George and the Dragon, about 1555
Oil on canvas, 158.3 x 100.5 cm

page 203
Claude-Oscar Monet, 1840–1926
The Thames below Westminster, about 1871
Oil on canvas, 47 x 72.5 cm

page 211
Hendrick Avercamp, 1585–1634
A Winter Scene with Skaters near a Castle, about 1608–9
Oil on oak, 40.7 x 40.7 cm

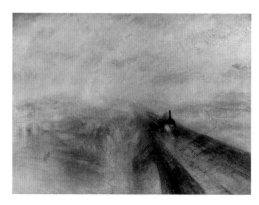

page 217
Joseph Mallord William Turner, 1775–1851
Rain, Steam, and Speed – The Great Western Railway, 1844
Oil on canvas, 91 x 121.8 cm

page 221
Francisco de Goya, 1746–1828
The Duke of Wellington, 1812–14
Oil on mahogany, 64.3 x 52.4 cm

page 231
Follower of Rembrandt, 1606–1669
A Seated Man in a Lofty Room, early 1630s
Oil on oak, 55.1 x 46.5 cm

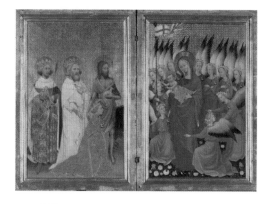

page 235
English or French (?)
The Wilton Diptych, about 1395–9
Egg on oak, 53 x 37 cm
Bought with a special grant and contributions from Samuel
Courtauld, Viscount Rothermere, C.T. Stoop and The Art Fund, 1929.

page 239
Andrea Mantegna, about 1430/1–1506
The Introduction of the Cult of Cybele at Rome, 1505–6
Glue on linen, 73.7 x 268 cm

page 245
Luis Meléndez, 1716–1780
Still Life with Oranges and Walnuts, 1772
Oil on canvas, 61 x 81.3 cm

COOK'S NOTES

All of the recipes in this book have been professionally tested in a domestic kitchen using readily available equipment, metric measurements and a fan oven where applicable. For the very best results, the following notes will be useful.
• Before starting to cook, read the recipe through carefully from start to finish, to familiarise yourself with the ingredients and their preparation, and the order of events in the method. Make sure to read the recipe introduction as well, because it may contain information that you will find helpful.
• Prepare all the ingredients before you start cooking, unless their preparation is given in the method – in other words, follow the recipe as it is written. The success of a recipe can depend on something as simple as this.
• Use the ingredients and equipment sizes specified, and do not substitute others.

INGREDIENTS
• Best results will be obtained if organic meat, poultry and dairy produce are used.
• Unless otherwise stated, eggs are large in size, and vegetables and fruit are medium in size.
• Butter is unsalted unless otherwise stated.
• Panko breadcrumbs are used throughout the book as a coating for deep-fried food. There is nothing to compare with them for crispness and lightness as they will not soak up too much oil and make the coating heavy. You can get panko crumbs at Japanese stores, specialist food shops and some supermarkets.
• Vegetable oil is specified for cooking because it can be heated to high temperatures without burning, and its light flavour does not mask other ingredients in a dish. British cold-pressed extra virgin rapeseed oil is the choice for salad dressings and for sprinkling over hot food before serving. It has a delicate, nutty flavour, is low in saturated fat, and contains omega 3, 6 and 9 as well as vitamin E.

OVEN TEMPERATURES
Temperatures given in recipes are for a fan oven, which should be preheated to the correct temperature before the food is placed inside. If you do not have a fan oven, use the following table of equivalent temperatures for conventional, Fahrenheit and gas.

fan 110°C/conventional 130°C/250°F/gas ½
fan 120°C/conventional 140°C/275°F/gas 1
fan 130°C/conventional 150°C/300°F/gas 2
fan 140°C/conventional 160°C/325°F/gas 3
fan 160°C/conventional 180°C/350°F/gas 4
fan 170°C/conventional 190°C/375°F/gas 5
fan 180°C/conventional 200°C/400°F/gas 6
fan 200°C/conventional 220°C/425°F/gas 7
fan 210°C/conventional 230°C/450°F/gas 8
fan 220°C/conventional 240°C/475°F/gas 9
fan 240°C/conventional 260°C/500°F/gas 10

CONVERSION CHARTS
If you prefer to work in imperial measures rather than metric, follow these charts, but do not mix the two. For spoon measures, use a standard metric set of measuring spoons, levelled.

VOLUME MEASURES
1.25ml	¼tsp
2.5ml	½tsp
5ml	1tsp
15ml	1tbsp
25ml	1fl oz
125ml	4fl oz
150ml	5fl oz/¼ pint
300ml	10fl oz/½ pint
450ml	15fl oz/¾ pint
500ml	16fl oz
600ml	1 pint
750ml	1¼ pints
900ml	1½ pints
1 litre	1¾ pints
1.2 litres	2 pints
1.5 litres	2¾ pints
2 litres	3½ pints
2.5 litres	4½ pints
3 litres	5¼ pints

WEIGHTS
10g	¼oz
15g	½oz
20g	¾oz
25g	scant 1oz
30g	1oz
100g	3½oz
125g	4½oz
150g	5½oz
175g	6oz
200g	7oz
250g	9oz
300g	10oz
350g	12oz
400g	14oz
450g	1lb
500g	1lb 2oz
600g	1lb 5oz
750g	1lb 10oz
800g	1¾lb
1kg	2¼lb
1.25kg	2¾lb
1.5kg	3lb 3oz
2kg	4½lb
2.5kg	5½lb
3kg	6½lb
5kg	10½lb

LINEAR MEASURES
3mm	⅛in
5mm	¼in
1cm	½in
2cm	¾in
2.5cm	1in
5cm	2in
10cm	4in
20cm	8in
30cm	12in

INDEX OF RECIPES

Acknowledgements

Thanks are due to the entire team at the National Dining
Rooms to whom Shaun Gilmore was not just a boss but
also a friend and mentor. In particular, thanks to Kris
Kirkham, Chef at The National Dining Rooms and food
photographer, who stepped in with Yosef Edri and Jozef
Koncek to prepare the food for the photographs.

Oliver Smith, Chef at Inn the Park, and Tim Payne also
created some of the recipes, and Jennifer Meakin of Not
Just Food and Jayne Cross did the recipe testing.

Visar Kavazi created the cocktails and Jacek Paszkowski
prepared them for the photographs.